AMERICA
FROM SPACE

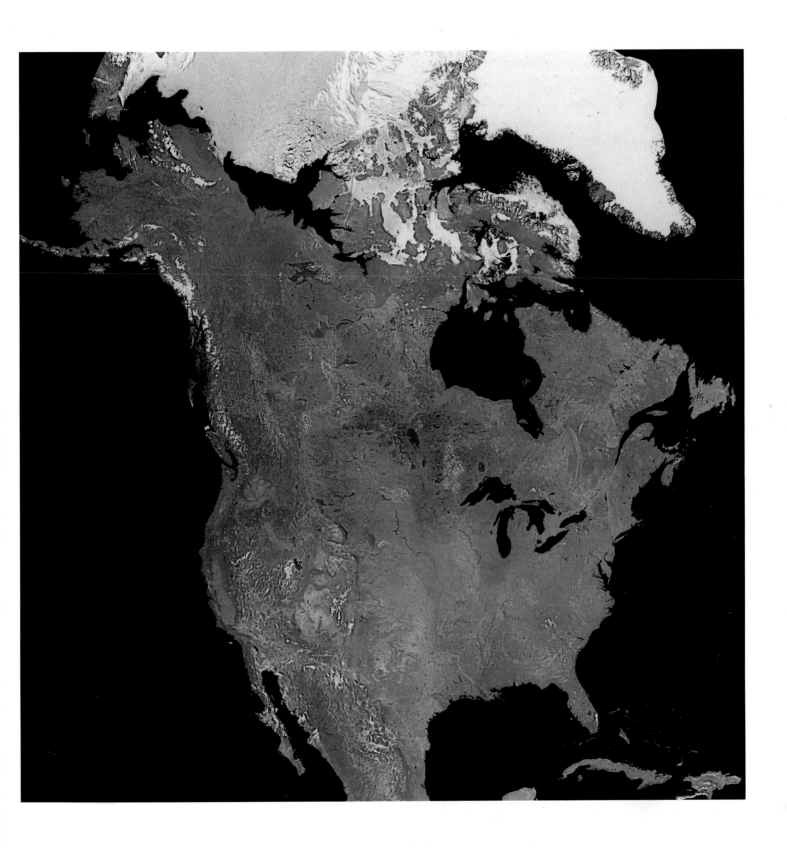

THOMAS B. ALLEN

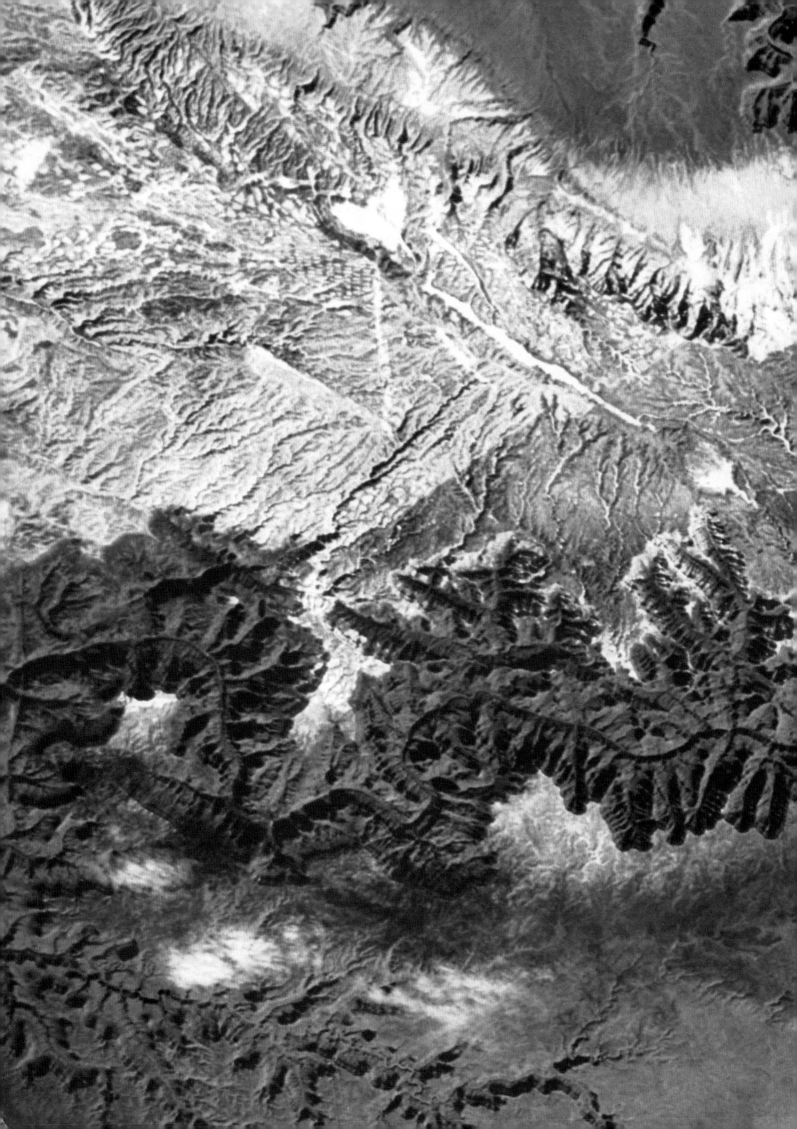

AMERICA
FROM SPACE

FIREFLY BOOKS

A FIREFLY BOOK

PUBLISHED IN CANADA IN 1998 BY
Firefly Books Ltd.
3680 Victoria Park Avenue
Willowdale, Ontario
Canada M2H 3K1

PUBLISHED IN THE UNITED STATES IN 1998 BY
Firefly Books (U.S.) Inc.
P.O. Box 1338, Ellicott Station
Buffalo, New York 14205

Cataloguing in Publication Data

Allen, Thomas B.
 America from space

ISBN 1-55209-280-1

1. United States —Photographs from space. I. Title

E161.3.A44 1998 917'.30022'2 C98-930979-7

PRODUCED BY
 Charles O. Hyman, Visual Communications, Inc., Washington, D.C.

DESIGNED BY
 Kevin R. Osborn, Research & Design, Ltd., Arlington, Virginia

PRINTED AND BOUND IN CANADA BY
 Friesens, Altona, Manitoba

The publishers acknowledge the financial support of the Government
of Canada Through the Book Publishing Industry Development
Program for our publishing activities.

[PAGE 1]
CONTINENTAL VIEW
Portrait of North America,
created from a mosaic of satellite
images. The islands of Nassau,
Cuba, and Haiti-Dominican
Republic appear off Florida.

[PAGES 2–3]
A GRAND WINTER
Winter clutches the Grand
Canyon, which appears as
wrinkled terrain along the
Colorado River. The high plateau
surrounding the canyon, usually
dry, is whitened by snow.

Table of Contents

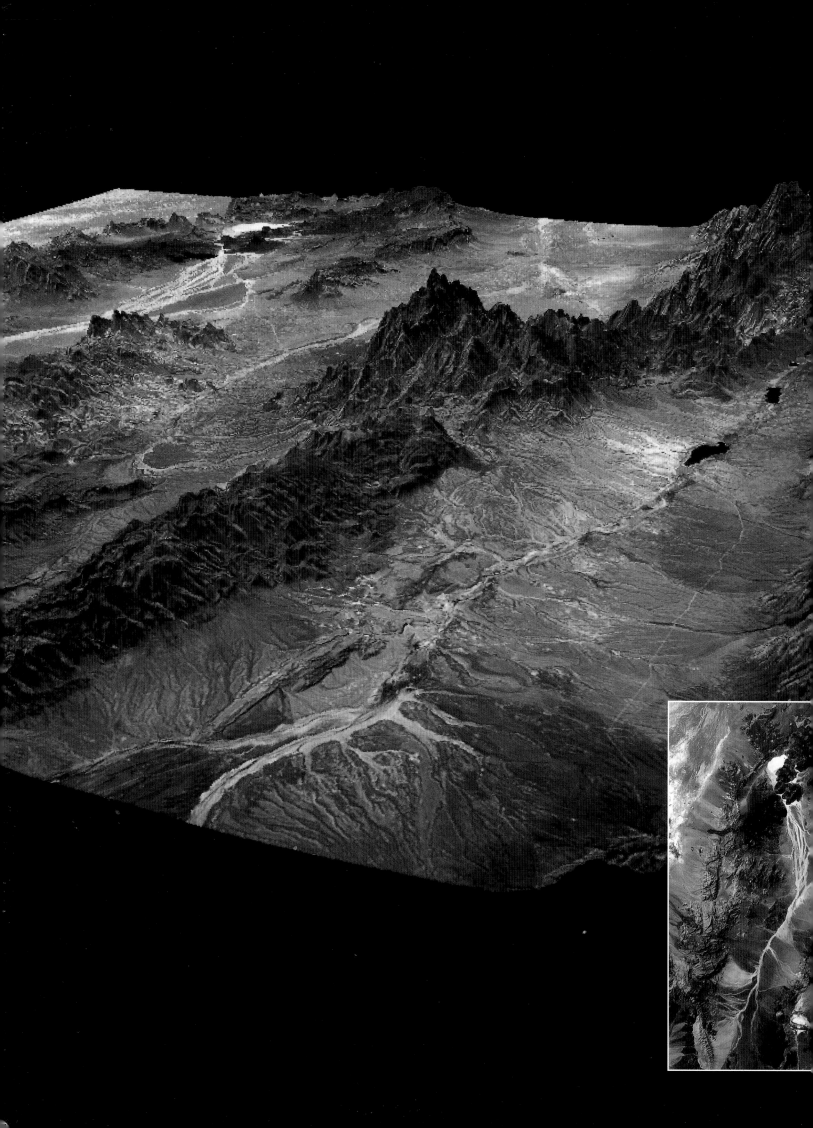

Introduction

WHEN YOU LOOK at a map, whether one showing highways or one showing cold fronts, you almost certainly are looking at a by-product of satellite or airborne imagery. When you see images of clouds or weather systems on the television screen, you are also seeing images produced by the data from meteorological satellites. "Remote sensing" is the name that scientists have given to this gathering of data from a distance — usually from a satellite orbiting above Earth. The sensing includes the use of radar or infrared imagery.

Remote sensing has become a multibillion-dollar international industry that provides new perspectives and enormous amounts of data to urban planners, scientists, engineers, and weather forecasters — to name but a few of the beneficiaries.

To view the United States from space, this book principally relies upon satellite images. The images look like color photographs. But they are actually computer-generated digital images obtained by satellite-sensing systems.

Other images in this book are photographs taken by astronauts in the Space Shuttle, orbiting 115 to 250 miles above the United States. These photos are the work of a human eye and mind: Someone looked down upon the United States and snapped a shutter. Astronauts are usually assigned sites to be photographed, for photos from the relatively close Shuttle orbit can give analysts precise data that satellite images may not be able to provide. An astronaut photograph of the Grand Canyon, for example, gave geologists the information they needed to map some 20 previously unrecognized fault systems.

Also among the views on these pages are photographs taken from aircraft. Sometimes these aerial photographs are the only look-down views available for certain places, such as cities that are not on orbital routes that satellites or the Shuttle follow as they pass over the United States. A satellite in orbit over the poles, for instance, may make an image of New York City in one orbit and the area around Omaha on the next.

Many of the satellite images in this book were produced by Landsat satellites, which have continuously supplied global land-surface images since 1972. The ongoing Landsat program has been phenomenally successful. By the time Landsat 1 was retired in 1978, for example, it had acquired more than 300,000 images whose quality and data exceeded all expectations.

[PAGES 6–7]
3-D VALLEY
Railroad Valley, Nevada, appears in three dimensions via a merger of satellite imagery and land-elevation data. Geologists read color patterns for clues to mineral deposits.

[PAGES 8–9]
NIGHT PORTRAIT
America shines at night in this composite of images, collected from 231 orbits. Clusters of lights along the East and West Coasts show how cities coalesce into a megalopolis.

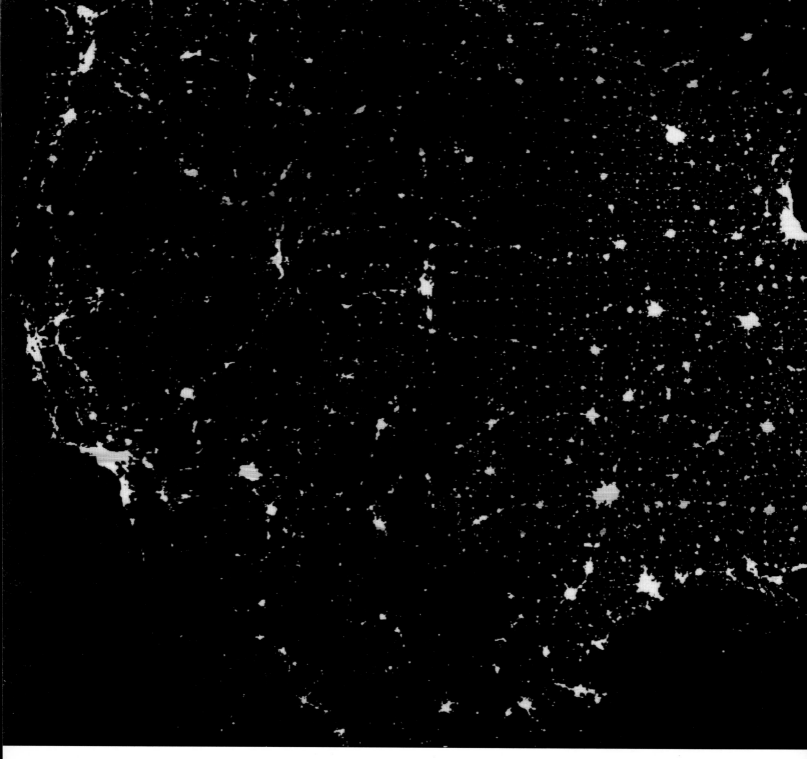

From then on, satellite imagery became an indispensable tool for scientists.

Meteorologists had already learned the value of satellites from the first weather satellite, called Nimbus, which was launched in 1964. Never before had anyone been able to see weather patterns on such a huge scale.

Landsat satellites, launched by the National Aeronautics and Space Administration (NASA), produce stunning images from heights up to 540 miles. Each image can reveal a large portion of Earth — about 13,600 square miles. It is as if someone were looking down from space through a powerful telescope capable of seeing objects as small as 36 yards square.

A single Landsat image can do what a week of field work once did. In that single image geologists, for example, can get a broad understanding of an area and then pinpoint the potential best places for detailed on-site examination. Similarly, engineers can examine great expanses of terrain to find the best potential routes for pipelines, highways, and power lines.

A Landsat satellite circles Earth on a 16-day cycle, making a total of 233 orbits (or 14 $\frac{1}{2}$ orbits a day) before it returns to the same location. The steady, predictable orbit means that Landsat imagery provides a dependable and economic system for monitoring major changes. The data from the Landsat spacecraft provides a record that reveals a quarter century of change upon the planet.

Landsat's images provide information meeting the broad and diverse needs of business, science, education, government, and national security. Landsat data has been used to estimate timber losses in the U.S. Pacific Northwest, measure soil moisture, calculate snow-water equivalence, and assess forest cover.

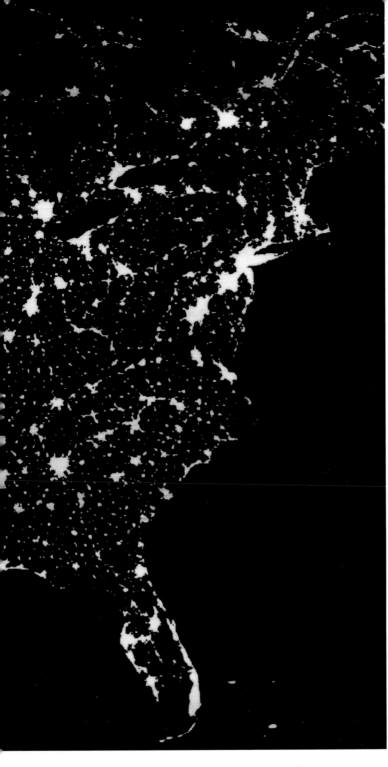

Mississippi and Missouri Rivers to areas 500 miles south of St. Louis. Satellites supplied the Federal Emergency Management Agency with almost real-time images. They not only helped to direct emergency crews to flooded areas but also aided in planning for the future. By studying the images, engineers could decide on the rebuilding of dikes and levees. A less dramatic use of satellites was discovered by Pennsylvania state officials who used images to develop an inventory of abandoned mines.

A Landsat satellite, with its battery-charging solar panels fully extended, is about the size of a passenger van. The Landsat sensors, like ordinary cameras, record visible light reflected from objects on Earth. The sensors also record the amount of near-visible infrared radiation reflected by the objects. But, instead of producing an image by exposing the recorded light directly onto photographic film, the satellite divides the reflected radiation into as many as seven spectral bands — blue, green, red, and four additional bands in the infrared, which is outside the visible spectrum at its red end and has a wavelength between about 700 nanometers and one millimeter.

The satellite then electronically records the radiation levels in each band. Every object on Earth absorbs and reflects light waves in different ways. This is often called an object's spectral signature. Thus, the satellite's system is theoretically able to distinguish all types of ground cover through their spectral signatures.

"In other words," says a description of satellite operations, "the data that go into a Landsat image do not merely distinguish rocks from trees or soil from snow but can separate diseased trees from healthy ones, clear water from murky or dry soil from wet, because each reflects light in a different pattern." This is achieved because each 13,600- square-mile image is composed of 252 million separate radiation readings — seven for each of the 36 million separate picture elements (pixels) that form the scene.

Only three of the seven spectral bands are typically used to produce an image. Since each object reflects differently in each band, the selection of bands is based on what surfaces and features are to be highlighted in the image. The colors in the image often are unrelated to the colors as recorded by the human eye. This is basically because invisible infrared light has no color. Thus, it must be assigned a color in order to be represented in the image. Satellite specialists call these "false colors." Red may indicate urban areas in some images or forests in other images. Bodies of water may be black and vegetation may appear in varying shades of gray or green. Finally, the satellite converts the data into an electronic signal and relays it

Other uses of the data include the monitoring of strip-mining reclamation or the development of wetlands; the plotting of population changes in and around metropolitan areas; the measure of water quality in lakes; and the surveillance of logging sites for compliance with forestry regulations. Landsat images also have been used by law firms to gather legal evidence and by the fast-food restaurants to estimate community growth sufficient to warrant a franchise. One Landsat program focuses on land-use change in the rapidly growing southwestern United States.

Satellite images are used for keeping watch on the weather and to provide data for agricultural commodity forecasts. Satellites have also been extensively used during natural disasters. The great flood of 1993 — one of the worst in American history — inundated a vast region, from the sources of the

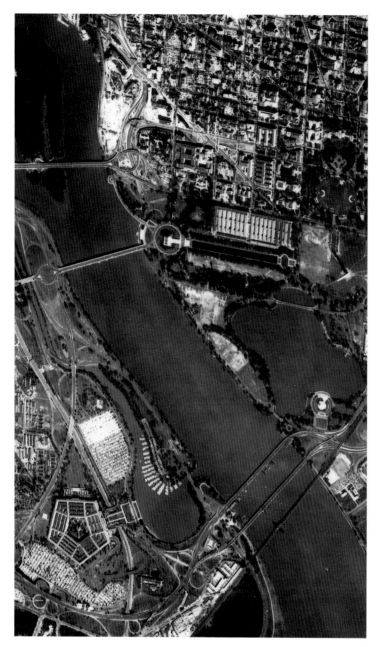

SPY IN THE SKY

In an early view of Washington by U.S. surveillance satellites, the capital gets its picture secretly taken. Satellite images, shown to only a handful of high-level officials, were among the most closely guarded secrets of the Cold War. Recent releases of satellite images are being used by researchers to get a historical record of such environmental issues as the shrinking of the Aral Sea.

CLOSER AND CLOSER ...

As satellites get better and better, views get sharper and sharper. In a demonstration of state-of-the-art views, Space Imaging EOSAT produces this look-down at Denver (right). Note how clear are the details in the sports stadiums (compared to the Pentagon image above). Objects only three-feet long can be differentiated from each other in what is called one-meter resolution. In previous images, resolution was about 20 feet.

to receiving stations on the ground.

In 1985, EOSAT, a private Maryland-based company, took over from the U.S. Government the marketing of Landsat data. Customers may buy images in the form of color transparencies or as digital data on computer-compatible tapes that may be used in image-analysis and processing systems.

The SPOT (*Systeme Pour l'Observation de la Terre*) system from France produces color images that can show images as small as 22 yards (or 11 yards in black and white images) in comparison to Landsat's ability to show objects no larger than 36 yards square. SPOT satellites, which first went into orbit in 1986, were launched as a commercial venture, not as a government activity. SPOT, whose charges are much higher than Landsat's, produces images that cover less than one-quarter the size of a Landsat image.

Technological differences between the two systems influence customers' decisions. Landsat scans a swath 110 miles wide, compared to SPOT's widest swath of 70 miles. But SPOT's sensors can be directed to record scenes 285 miles east or west of the orbital track. This wide-looking capability means that SPOT can be manipulated to produce stereoscopic pairs of images. Such images can then be used to make small-scale topographic maps.

By putting the data in different formats, a computer can show an image in various ways. Heights of mountain ridges may be emphasized or transformed into three-dimensional models. Using data collected from different parts of the spectrum, the computer can exaggerate levels of darkness and light, producing an image with sharp contrasts. Specialists then analyze the images designed for their specific work. Geologists may use one kind of image to look for clues to subterranean minerals, while urban planners study another kind to observe contrasts in population densities.

U.S. satellite imagery and photographs taken by NASA's Space Shuttle astronauts have been primarily devoted to mapping and environmental monitoring. The latest use of Landsat satellites is the U.S. Global Change Research Program, which is part of a national assessment of global-change issues. The program aims at providing data for an improved scientific understanding of the Earth to assure the availability of future resources essential for human well-being, including water, food, and the ecosystems that sustain those resources. The program also sponsors research that seeks to understand the effects of changes in land cover, climate, ultraviolet radiation at the Earth's surface, and other environmental phenomena. Such scientific knowledge is essential for informed decisions on environmental issues and for the health of future generations.

Civilian remote-sensing satellites face constraints from governmental concerns about privacy and national security. U.S. satellite imagery began as a government monopoly, developed after the shooting down of the U-2 spy plane over the Soviet Union on May 1, 1960. The first U.S. spy satellite, the Corona, on its first photographic mission over the Soviet Union, photographed 1.6 million square miles of Soviet territory — more coverage than had come from all 24 U-2 spy plane flights over the Soviet Union.

Spy satellite imagery remained top secret. The National Reconnaissance Office, the U.S. agency responsible for spy satellites, was so clandestine that its very existence was classified until 1992. Now many of these secret images can be seen because, soon after the end of the Cold War, the United States began releasing thousands of spy satellite images.

SPOT began to break into what had been a governmental monopoly in 1986, when ABC News, the first news organization to buy satellite time, ordered from SPOT images that showed the disaster at the Soviet nuclear plant in Chernobyl. Eleven years later, news coverage was seen as the primary purpose for another commercial satellite, EarlyBird 1, which was launched by EarthWatch, Inc., a company formed in 1995 by the merger of the commercial remote sensing efforts of Ball Aerospace & Technologies Corp. and WorldView Imaging Corp.

Image orders — such as a request from a news organization for a look at NATO troops in Bosnia — are sent to EarlyBird via uplink to the satellite. As the satellite passes over Bosnia, it takes and stores the requested image until the satellite forwards it to the next available ground station for processing. The company maintains high-latitude ground stations in Alaska and Norway and a mid-latitude ground station in Colorado. Under U.S. law, the government can black out EarlyBird, or other commercial satellites, whenever officials believe that the images would threaten national security.

Like other commercial satellites, EarlyBird 1 and its successors will earn their keep by selling images not only to news organizations but also to land developers, oil and gas explorers, urban and transportation planners, and industries in need of geographic data.

Remote sensing yields up so much information that consumers of the data could be swamped by it. But the newest systems combine microprocessors, high-resolution display terminals, integrated graphics, and data-base software to produce a powerful tool known as the geographic information system (GIS). With little training, a consumer using GIS can make a personal package of remote sensing data with a few keystrokes.

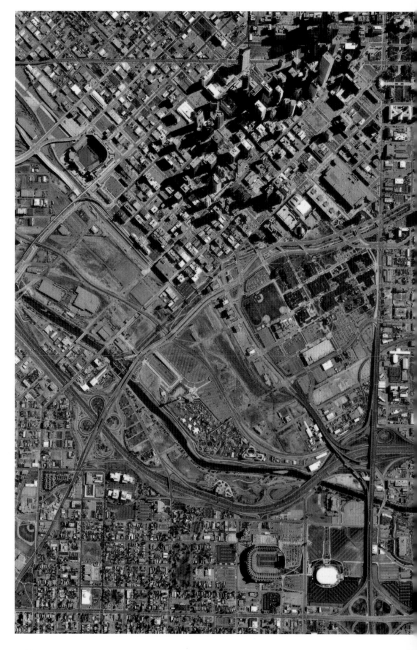

All it takes is following the GIS rules for extracting, displaying, and plotting a map based on any combination of data.

Visualization of data has opened a new dimension in how we look at Earth. In 1910, when the U.S. Census first used the term "metropolitan district," politicians had no way of illustrating this new term. In the 1960s, when the concept of "megalopolis" first became popular, aerial photographs could show some examples of the phenomenon. Now satellite imagery can show, in one big image, the idea of an unbroken span of city and suburbs hundreds of miles long.

"Life is like a landscape," Charles Lindbergh wrote after his historic solo flight across the Atlantic. "You live in the midst of it, but can describe it only from the vantage point of distance." Satellite portraits of the United States give us a new vantage point, a new way of seeing and understanding our country.

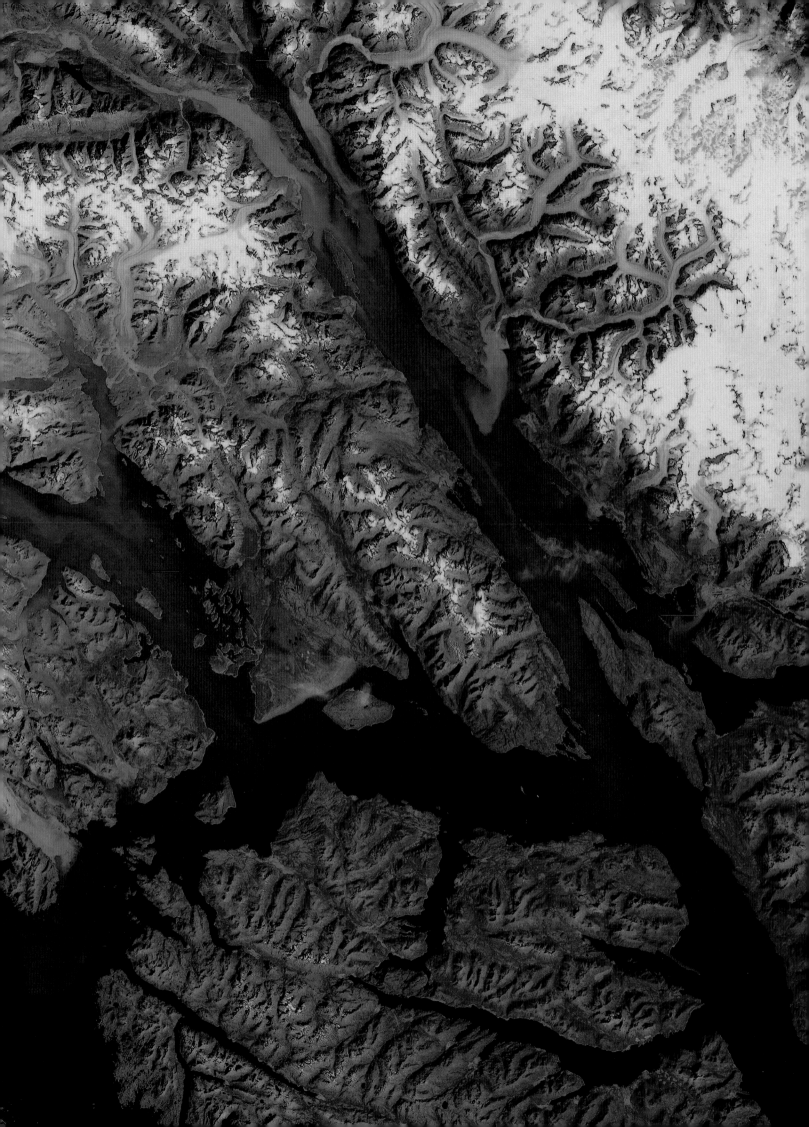

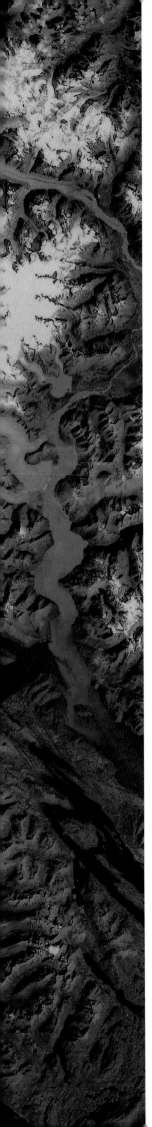

The Fire and Ice

THE TWO youngest stars on the U.S. flag represent Alaska, a land that was born as ice, and Hawaii, a land that was born in fire. Each state owes its splendors to the shaping of its land by powerful geologic forces — glaciers and earthquakes in Alaska, volcanoes in Hawaii.

Alaska is a place of immensity: 3 million lakes, 10 major river systems, 17 of America's tallest mountains, including the great massif of Mount McKinley, at 20,320 feet the highest point in North America. Hawaii is a paradise of tropical and subtropical wonders: waterfalls higher than Niagara, endless beaches, luxuriant valleys bursting with the colors of wild flowers and birds, many of them found nowhere else in the world.

Glaciers as thick as 3,000 feet carved the basins for most of Alaska's millions of lakes, and glaciers still shape Alaska. One of them, Taku Glacier, is a river of ice that moves about 500 feet a year as it flows from the huge Juneau ice field. At the edge of the glacier, in Taku Inlet near Juneau, sand and silt and splintered forests pile up. Eventually, the glacier will seal off the inlet from the sea. When the glacier recedes, it will leave in its wake the mountains that its grinding passage has molded. Earthquake fault lines, visible from space, scar Alaska's 656,424 square miles of rugged terrain. The Denali Fault — where tectonic plates meet and cause a quake when one passes under the other — crosses much of Alaska's southern tier. Such plate activity, as deep as 400 miles below the surface, triggered Alaska's Good Friday quake in 1964, North America's strongest recorded earthquake.

From the island of Hawaii, where volcanoes still ooze lava, the Hawaiian Islands stretch northwestward across 1,300 miles of the Pacific. The islands emerged from the bottom of the sea, at a "hot spot" in the Earth's mantle, where magma pushed through the seafloor and began the long process of building volcanic islands that jut from the sea. On the Big Island of Hawaii are two of the world's most active volcanoes: Mauna Loa and Kilauea, whose name means "spreading, much spewing" in the native Hawaiian language. The highest mountain on Hawaii, Mauna Kea, rises 13,796 feet from the ground. But it becomes the tallest mountain on Earth when it is measured to its roots, 20,000 feet below the sea. Barren of life when they emerged from the sea, the islands most likely received their lush and exotic flora from seeds carried on the wind, from the droppings of migrating birds blown off course, and from the Polynesians who first settled in the islands around 750 A.D.

KLONDIKE GATEWAY

Lynn Canal, a deep fiord 80 miles long, provides an ocean highway from Juneau to the Klondike, scene of the great gold rush of the 1890s. Juneau, Alaska's capital, is the bluish gray patch at center right. Glaciers, in light blue, web the Coast Mountains. The fiord flows into Frederick Sound and Chatham Strait, a passage to the Gulf of Alaska. Tongass National Forest, the nation's largest, spreads across the ridged land to the south.

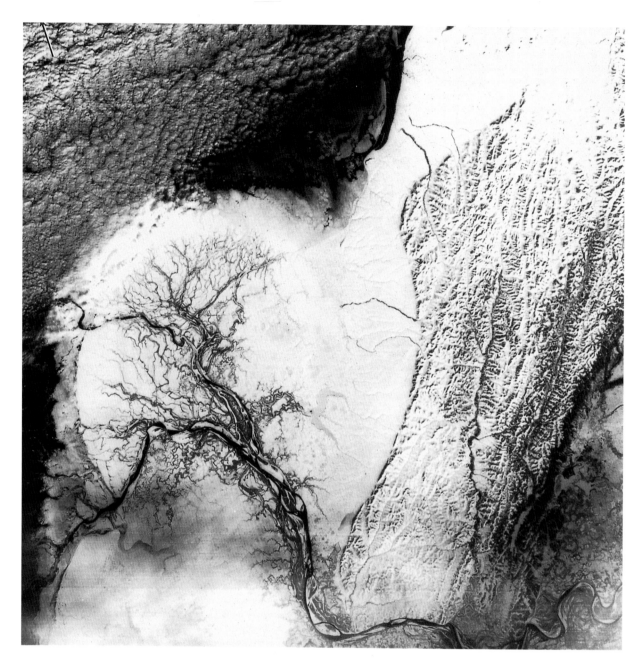

ICY WATERCOLOR

Complex natural forces paint a striking still life in blue and white. Snow dusts the flatlands delta of the Yukon River as it enters Norton Sound, off the Bering Sea. The river's branches have formed a filigree upon the delta, which is enhanced by a nearly perfect semicircle of sea ice by currents. Large channels have been cut through the ice. Spruce and fir forests grow in the valleys of the meandering river, but tundra covers most of the flatlands.

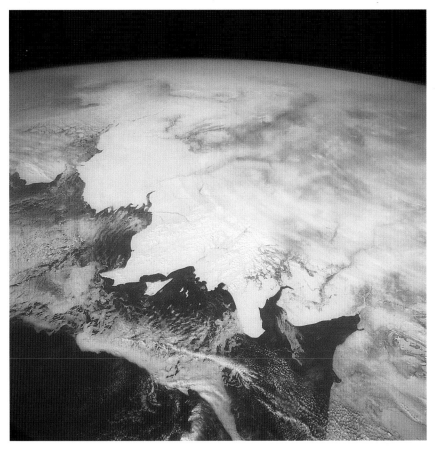

TOP OF THE WORLD

The ice-capped Earth curves around the northern coast of Alaska in an image looking north from Bristol Bay, in the foreground. The southern shore of the bay is the Alaska Peninsula, from which are strung the Aleutian Islands. Nunivak Island, home of musk oxen, is just below the horizon. Researchers use such images, taken months apart, to track ice drifting from the coastal ice pack. Alaska's 6,640-mile coastline is longer than the coastlines of all the Lower 48 states.

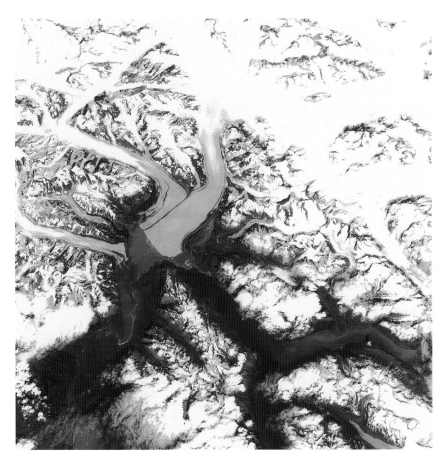

GALLOPING GLACIER

The light blue lobes of mighty Hubbard Glacier push their way into the dark blue waters of Russell Fiord at the head of Yakutat Bay, Alaska. Red fringes mark the boundary of icy sea and snowy land. Alaskans call Hubbard the Galloping Glacier because in spring it sometimes can move ten times its normal rate of nearly two miles a year. In 1986 Hubbard corked the fiord, turning it into a part-time lake and trapping seals and porpoises.

WILDEST ALASKA

Katmai National Park and
Preserve, a wilderness of fire and
ice, spreads across 4,090,000 acres
on the Alaska Peninsula, the state's
wildest coast. Forested areas, such
as the jagged coastline of Shelikof
Strait, appear in bright red.
Within the park are 15 active
volcanoes. One erupted in 1912,
sending so much ash into the air
that it masked the sun and lowered
global temperatures. A legacy of
the eruption is the Valley of Ten
Thousand Smokes — fumaroles
that have since ceased their
steaming. Tufts of clouds glide
across the valley in this image.
Brownish areas are mostly
marshes.

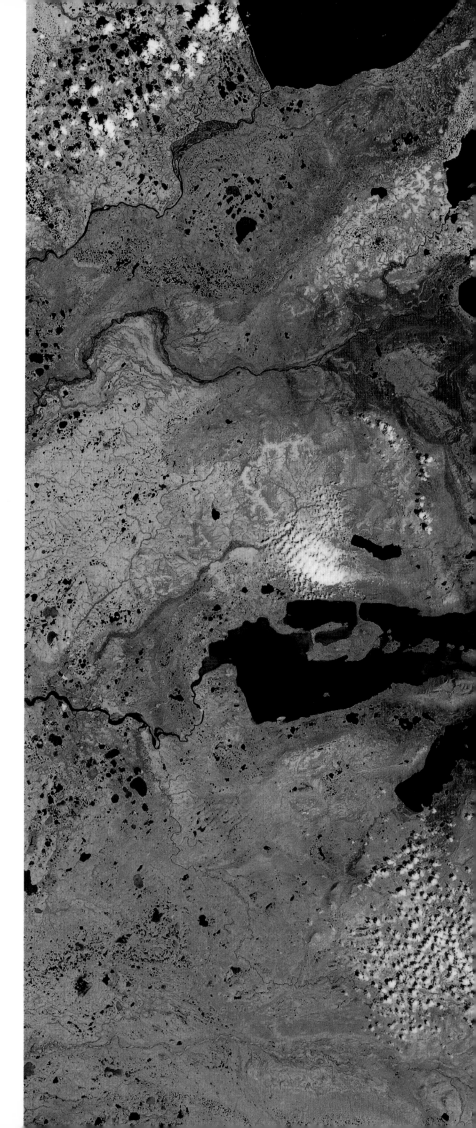

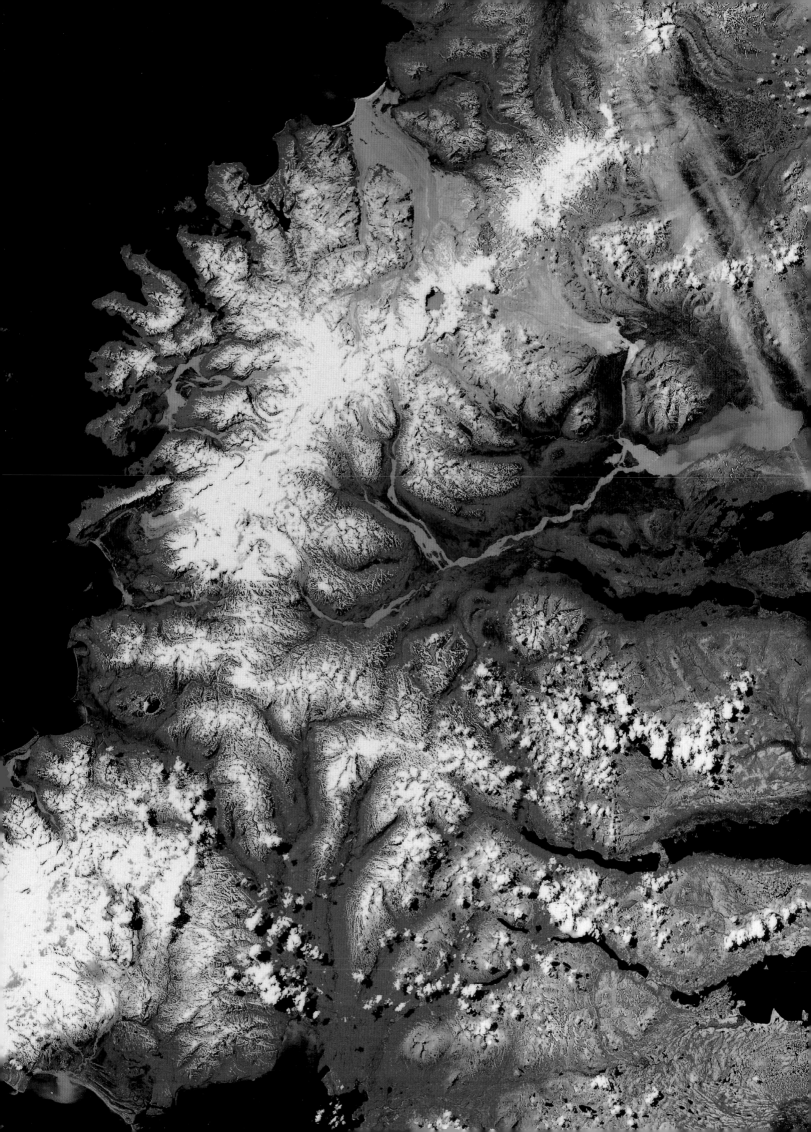

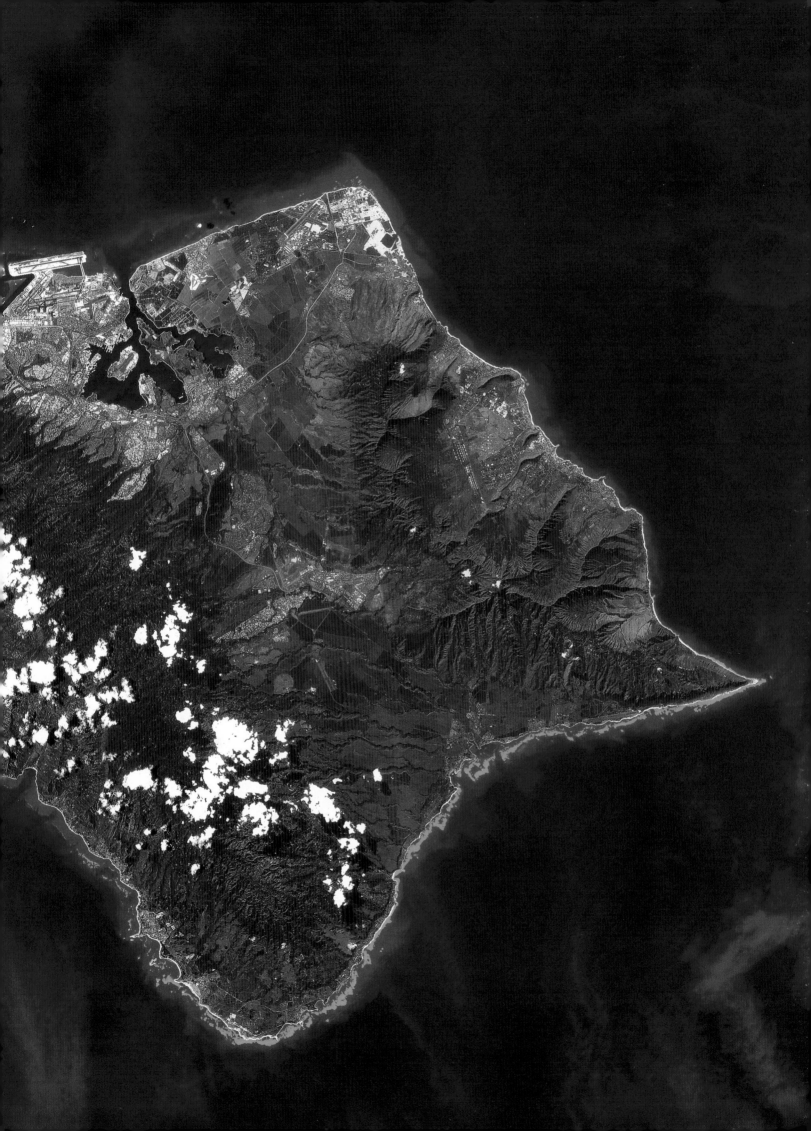

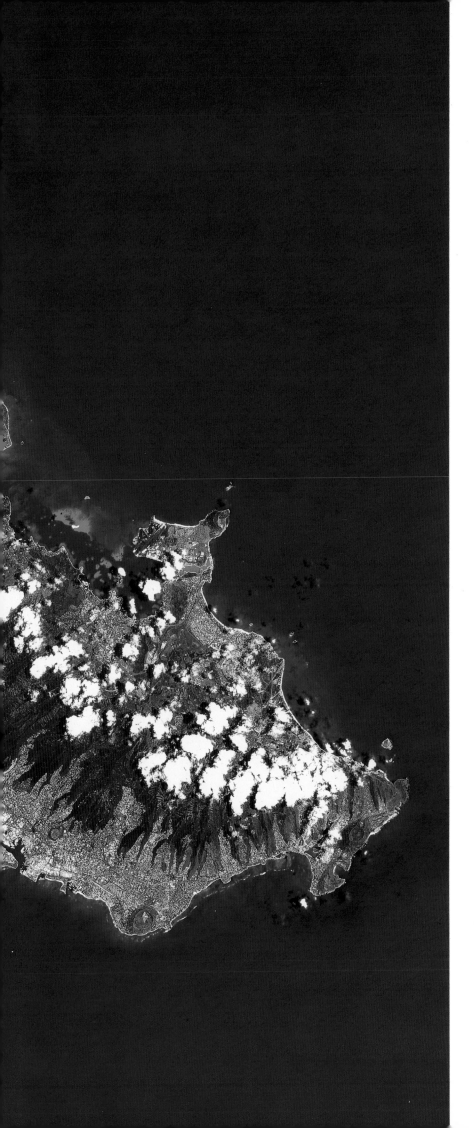

BORN OF THE SEA

In this image, Oahu looks like a solitary island. But it is one of eight big islands among the dozens that form the state of Hawaii and one of more than 130 other Pacific islands created by underwater volcanoes and shaped by wind and rain. Clouds drop rain on Oahu's green mountains; brown areas get little rain. The city of Honolulu is at the bottom of the image. The rectangular piece of land in front of Honolulu is the international airport. The fan-like bay is Pearl Harbor, the U.S. Navy base bombed by Japanese warplanes on December 7, 1941.

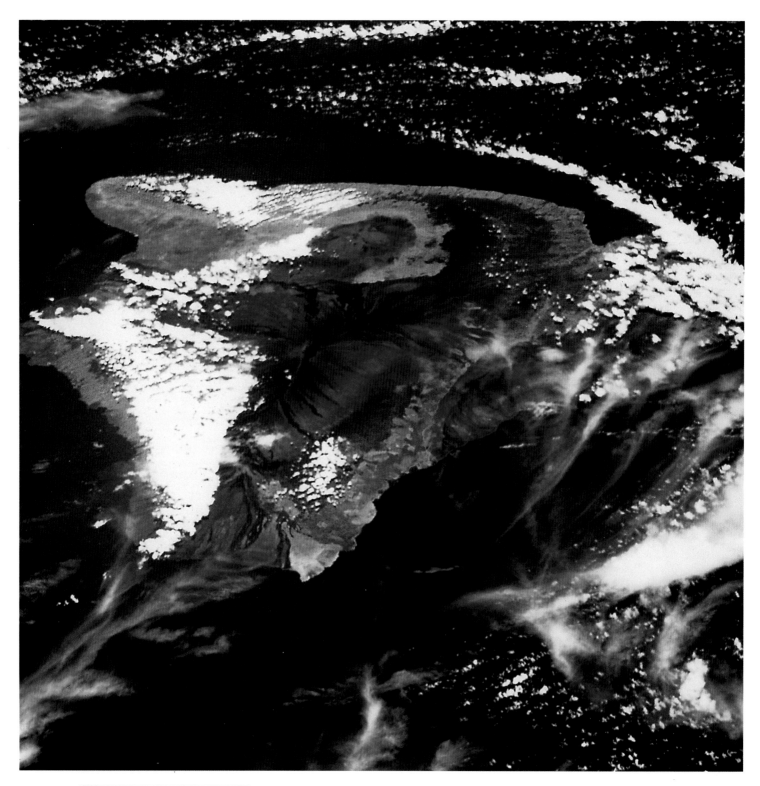

THE BIG ISLAND

Black lava flows darken the terrain of Hawaii, the Big Island. Stripes on slopes mark lava flows. The three major volcanoes that formed the island still exist: Mauna Loa in the foreground, Mauna Kea on the far side of the island, and, to the right, Kilauea, which gives off a small puff of steam almost lost in the cloud front. A wedge of clouds veils the Kona coast, where the English explorer, Captain James Cook, was killed by natives in 1779.

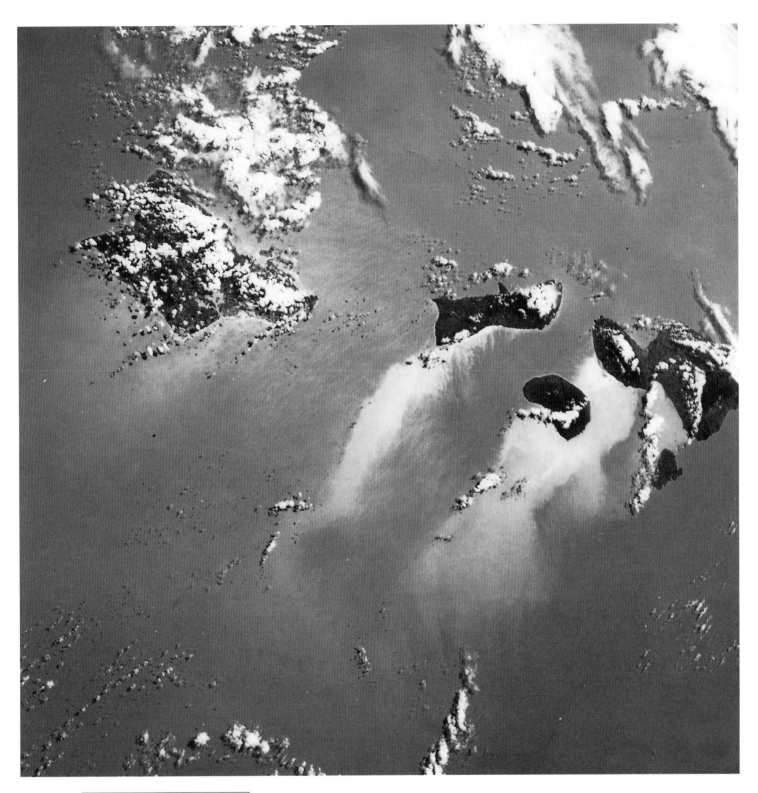

HAWAIIAN ISLANDS

Four of the major islands of Hawaii appear in this astronaut photo taken from the Space Shuttle. From the left, the islands are Oahu, site of the state capital of Honolulu; Molokai, once the site of a leper colony; Lanai, the "Pineapple Island," where plantations cover 25 square miles of rich volcanic soil; and Maui, named for the giant dormant volcano that is now the centerpiece of a national park and a sanctuary for rare flora and fauna. Off Maui is battered Kahoolawe, long a target for U.S. Navy and Air Force bombs.

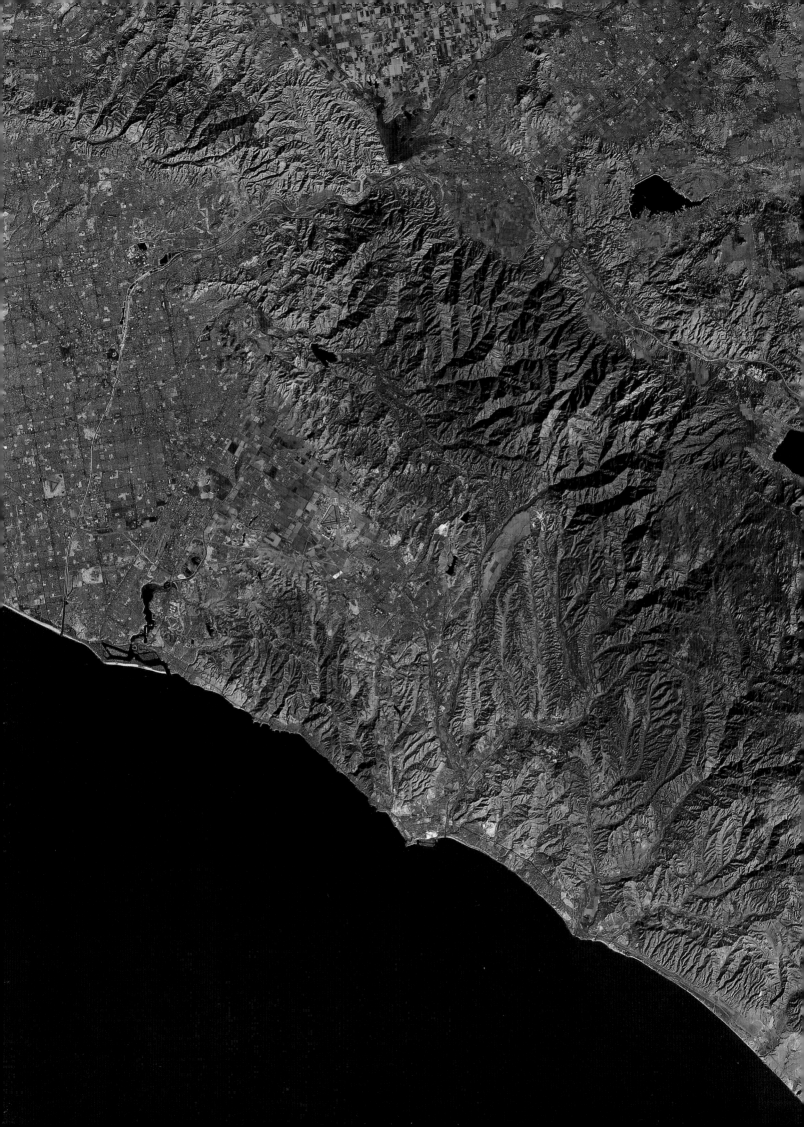

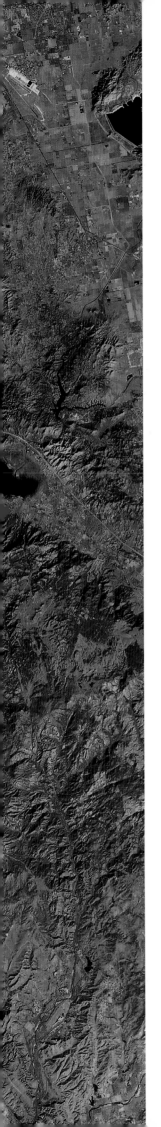

The West Coast

A MOSAIC OF mountains and deserts, forests and farmlands, the U.S. West Coast spans 1,200 miles, from the rain forests of Washington to the sprawling cities of California, the nation's most populous state. Stretched like a rampart along the coast is one of the world's great mountain systems — a chain of peaks that includes the Sierra Nevada, Cascade Range, and the Coast Ranges of California. Winds and moisture climb over the coastal mountains and, as the rising air cools and condenses, snow and rain fall upon western slopes. Snow as high as 100 feet can blanket Mount Rainier in a year. On the lee side, cactus grows along the northeast shore of the Olympic Peninsula, where rainfall averages 10 inches a year.

California encompasses every North American life zone, from arctic to semitropical. Much of its climate resembles the Mediterranean's. As a 19th Century writer observed, California is a place "where the chestnuts of Italy are dropping; where Sicilian lemons are ripening; where the almond trees are shining." Running along the coastal edge of the state for nearly 1,000 miles is a scar called the San Andreas Fault. This fracture in the earth's crust marks the boundary between two great opposing blocks of Earth's crust, the Pacific and North American Plates. Using images from space, geologists have been able to map some 20 previously unrecognized fault systems in the west.

Because the West Coast is a realm with only a slim coastal plain, Pacific depths are near to land, and whales cruise along the coast in sight of people ashore.

Geography has also given California the earth's tallest and biggest trees. From the slopes of California's Sierra Nevada thrust giant sequoias. Along the central coast grow redwoods, close relatives of the giant sequoias. Many of these soaring trees — the tallest giant sequoia is 325 feet, the tallest redwood 385 feet — are ancient, tracing back to the last ice age. They flourish here because the moist air along the coast sustains the lush and humid environment they need.

Here in the Pacific Northwest are most of the primeval forests still left in the Lower 48 states, preserved in national forests and parks. America's only rain forests are in Olympic and Mount Rainier National Parks. The Northwest also is dotted with volcanoes, links in the Pacific Ring of Fire, source of about three-quarters of the planet's active volcanoes.

SOUTHERN CALIFORNIA
South of sprawling Los Angeles, the coast curves inward, forming the Gulf of Santa Catalina. Highlands end at narrow shores. Inland, looking like a long ink blot surrounded by mountainous desert, is the Salton Sea, which has no outlet. It was formed in 1905 when the Colorado River flooded a depression 280 feet below sea level. Along the north side of the sea runs an arm of the complex irrigation system that serves the rich farmlands of the Imperial Valley.

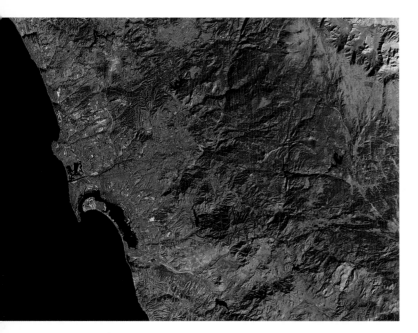

[PAGE 24]
SAN DIEGO
Spreading from a crescent harbor to the mountains, San Diego (in green) ranges in elevation from sea level to 1,591 feet. Beyond its boundaries rise mile-high mountains topped by year-round snow (in blue). San Diego has become California's second largest city and the sixth largest in the nation. The U.S.-Mexican border lies just below the bottom of the image. Portuguese explorer Juan Rodriguez Cabrillo, the first European to trek present-day California, discovered what is now San Diego Bay and claimed the area for Spain on September 28, 1542.

[PAGES 24–25]
TWO NATIONS' COASTS
An astronaut's photo spans much of California and part of Mexico in an image haloed by the horizon. Coastal fog drapes much of the southern shores of California and Baja California, the Mexican peninsula separating the Pacific and the Gulf of California. At the top of the image is California's Central Valley and Sierra Nevada. The mountainous Baja peninsula — 1,220 miles long and 30 to 150 miles wide — has irrigation farming in the north; land becomes desert farther south. Baja's waters support a host of marine creatures, from whales to shrimp. Many of the world's game fish records have been set by deep-sea fishermen casting for trophies off Baja.

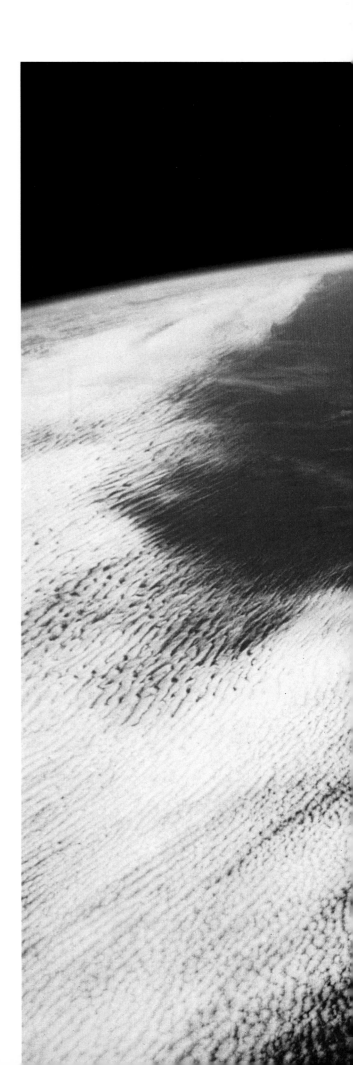

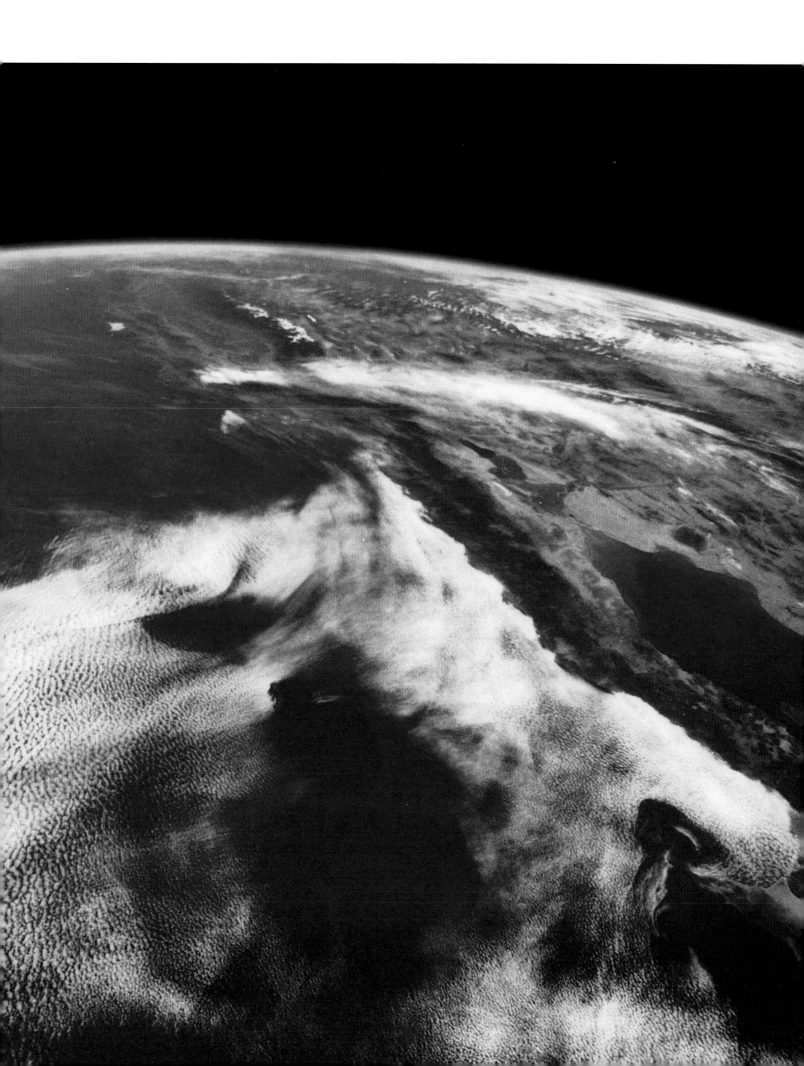

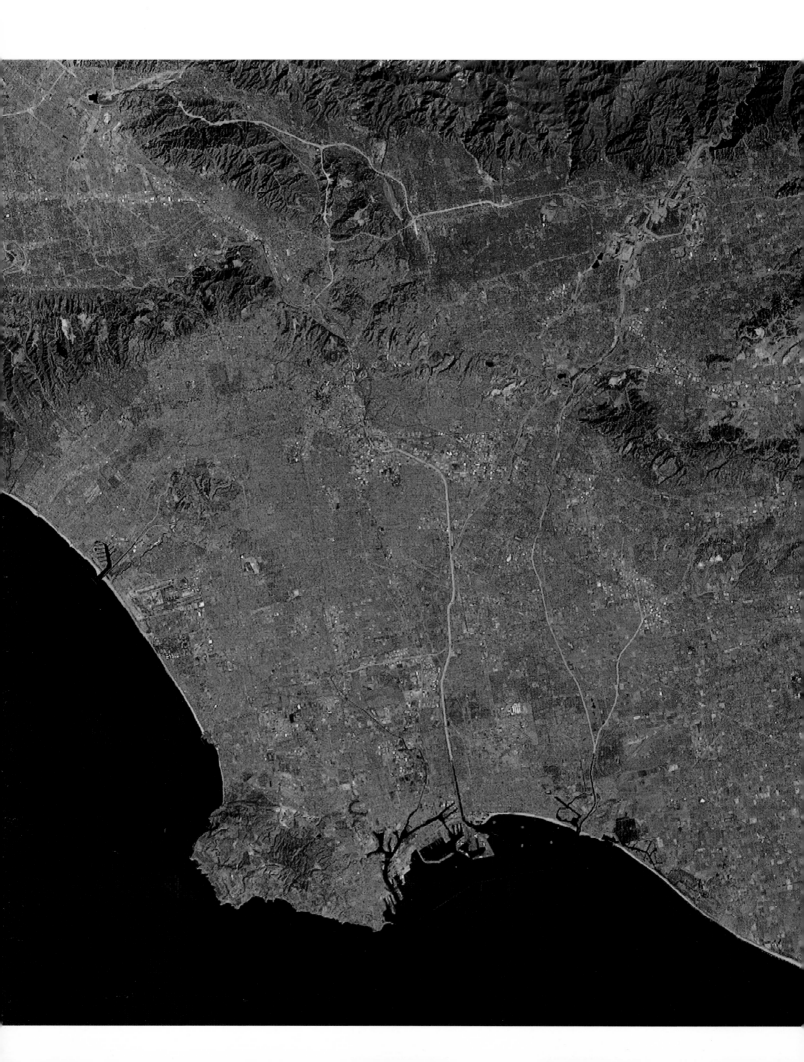

[PAGES 26–27]
LOS ANGELES
Red patches mark parks and other oases in the urban grid of metropolitan Los Angeles, America's second largest city. Los Angeles County, which covers 4,000 square miles, is about four-fifths the size of Connecticut. Freeways connect the far-flung megalopolis in a web that reaches from the coastal communities of Long Beach, and Huntington Beach to Beverly Hills and Hollywood's hills. The Santa Monica Mountains loom like a wall to the north, funneling urban expansion through a narrow pass. The fan of red at right marks an area of forests and farms.

[PAGE 27]
FAULT LINES
Two great fault lines form a huge V in the San Gabriel and San Bernardino Mountains that rise beyond Los Angeles. The Garlock Fault runs roughly east-west; the San Andreas Fault runs roughly north-south, continuing northward. The faults, which mark the boundary of two plates in the Earth's crust, are the source of California quakes. As they try to slide past or over each other, the strain builds and friction increases. When the plates overcome the friction and slip against each other, the jolt produces an earthquake.

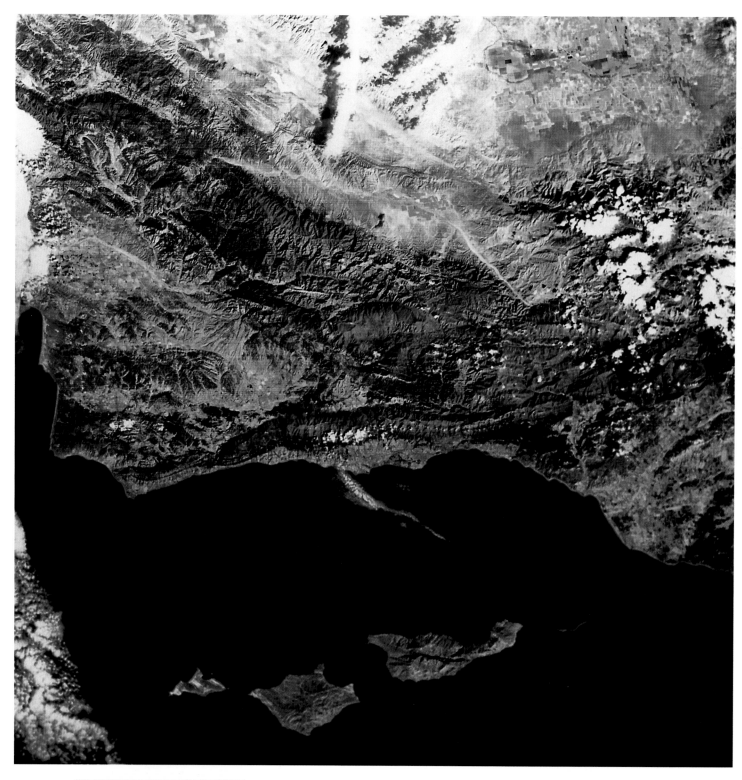

NARROW SHORE

In this view of the California coast, a satellite that analyzed land use produced an image that shows pink in settled areas, bright red for greenery, and light gray for barren lands. Squeezed between the sea and the Sierra Madre Mountains are Santa Barbara, Ventura, and their suburbs. Offshore, the Channel Islands National Park and an underwater sanctuary protect seal, sea lions, and a giant kelp forest. A cloud plume drifts over shore while other clouds graze the mountaintops. Beyond the mountains in the San Joaquin Valley are Bakersfield, Edwards Air Force Base, and clusters of farms and vineyards.

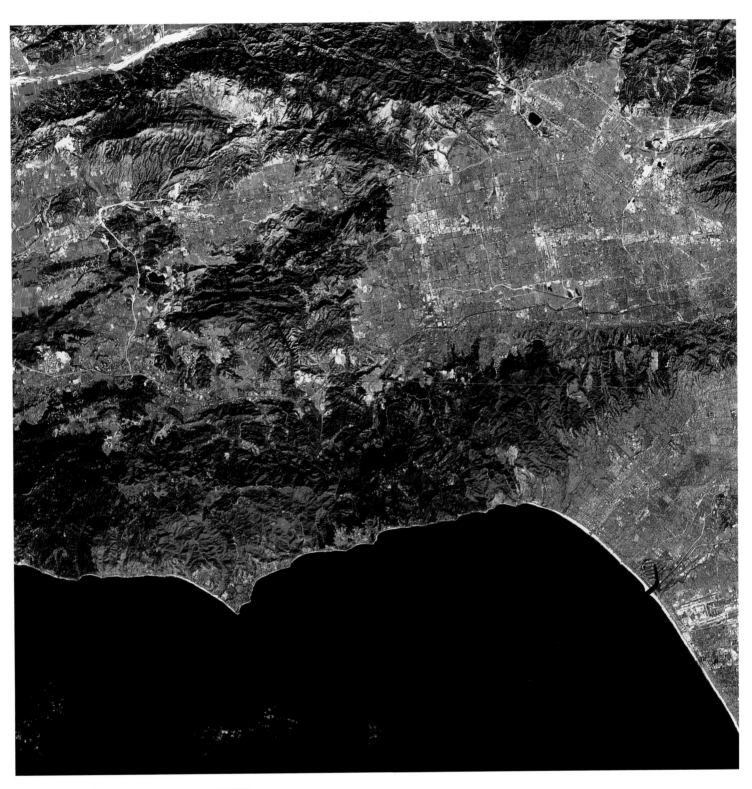

CHARRED SHORE

Blackened patches appear in the wake of disastrous fires along California's drought-stricken coast. Fanned by hot, dry "Santa Ana" winds, fire in November 1993 whipped through nearly 17,000 acres around Malibu, seaside hometown for many movie stars. Street grids indicate settled areas in and around Malibu. The brush fires spawned a firestorm that destroyed 350 homes. But an army of firefighters saved more than 95 percent of the buildings in the path of the flames.

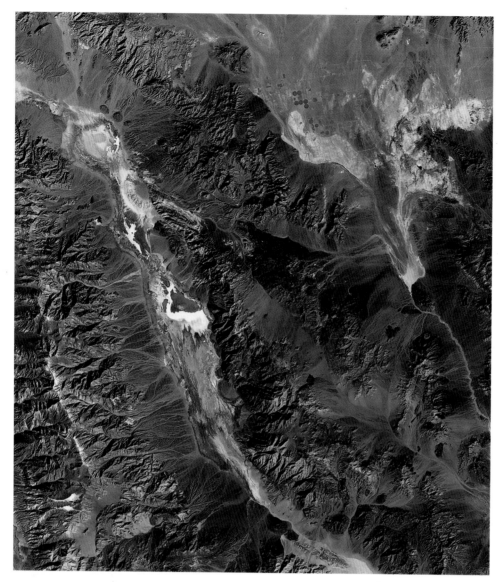

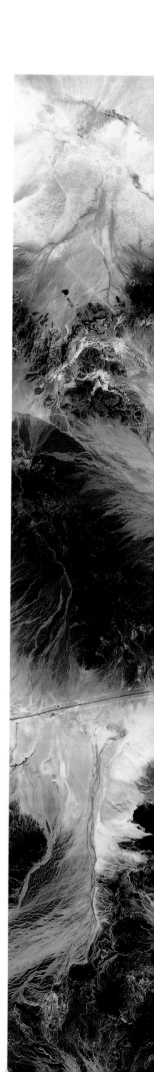

[PAGE 30]

DEATH VALLEY

The lowest, driest, and hottest place in the Western Hemisphere looks like a gray-and-white river squeezed between mountain walls. Peaks rise to 11,000 feet above sea level and the valley floor dips to 282 feet below sea level. Temperatures range from near-freezing to summertime highs topping 130 degrees. Tiny red circles northeast of the valley mark farms with irrigation systems using sprinklers that move in circles. The valley owes its grim name to emigrants who, seeking a short cut to California's gold fields in 1849, were trapped here for more than a month. Many died.

[PAGES 30–31]

LIVING VALLEY

Satellite imagery displays the rich red of agriculture in California's Palo Verde Valley during a two-year experiment in water conservation. The Colorado River, which appears in black, is the source of scarce water in an irrigation system controlled by the Metropolitan Water District of Southern California. The system compensated farmers for letting land lie fallow, saving water that otherwise would have been used to grow crops. By analyzing the reds and other colors and then comparing them to land ownership maps, officials could monitor the farmers who were claiming fallow lands.

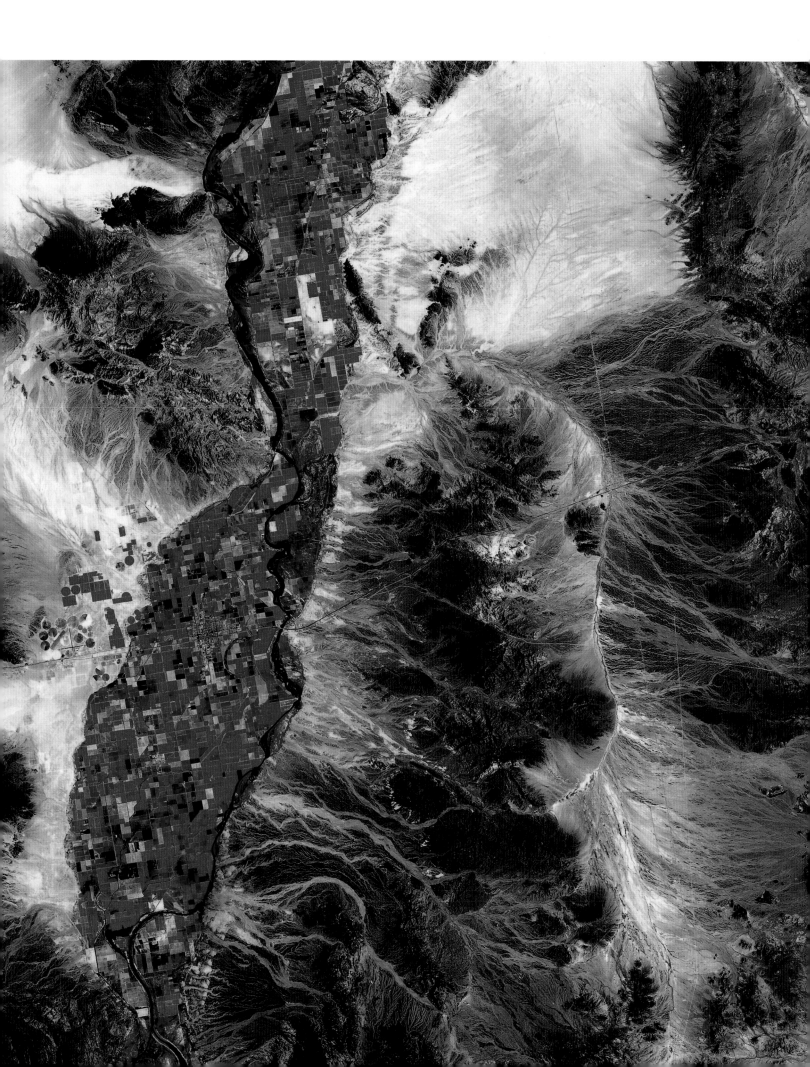

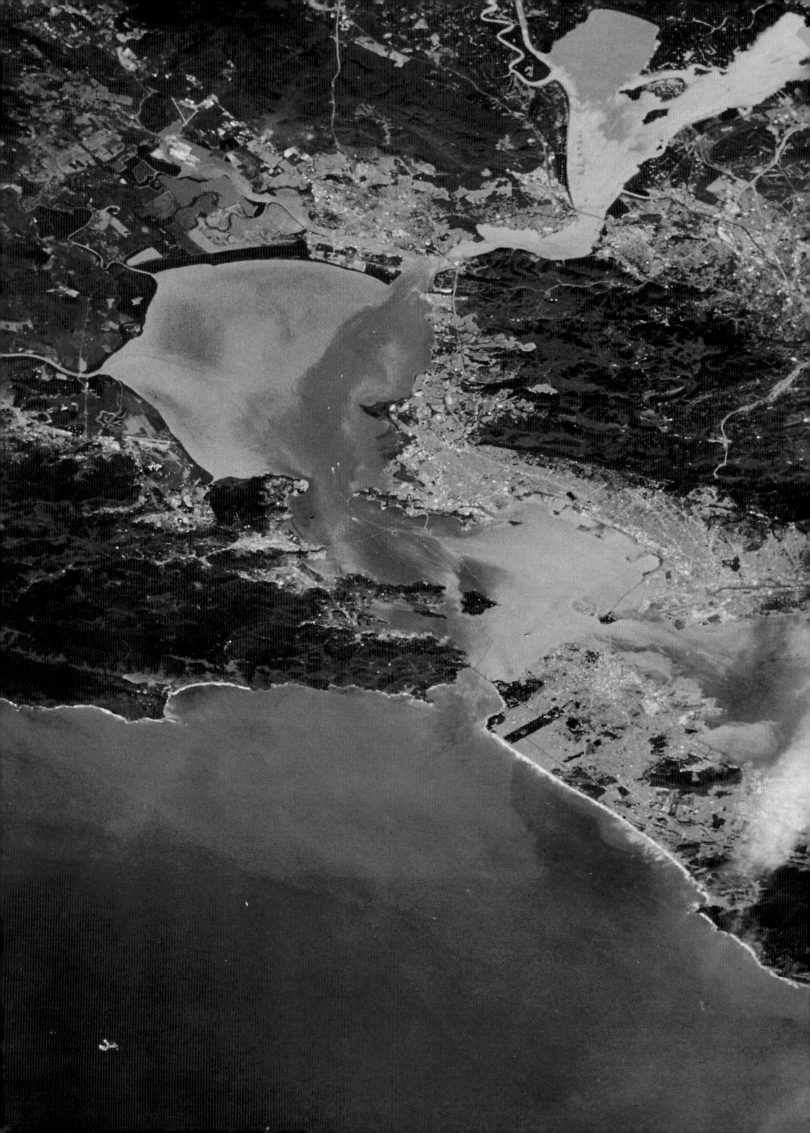

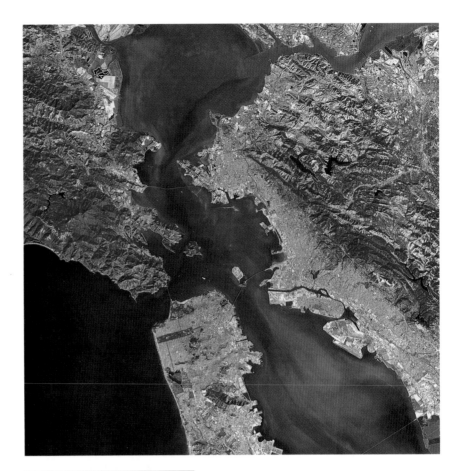

[Page 33]
San Francisco
The steel thread of the Golden Gate Bridge, a 9,266-foot engineering feat, links San Francisco's oblong peninsula with the northern Californian coast; another bridge stretches to Oakland and Berkeley, touching Treasure Island on the way. The angular elements of a port complex edge the shores of what is one of the world's finest natural harbors. Red patches — such as those at the tip of the tightly gridded city and in the mountains opposite — mark parkland and open spaces. More than 6 million people live in the areas shown in light green.

[Pages 32–33]
San Francisco Bay
Narrow clouds drift across San Francisco Bay and graze San Francisco in this spring scene. To the right, winds and currents spread sediment, lightening the color of water along the shore of San Pablo Bay. Berkeley and Oakland rim the shoreline of the bay opposite San Francisco. Salt-evaporation ponds show in varying shades of pink. The alignment of coastal mountains is related to the San Andreas and Hayward Faults on opposite sides of San Francisco Bay.

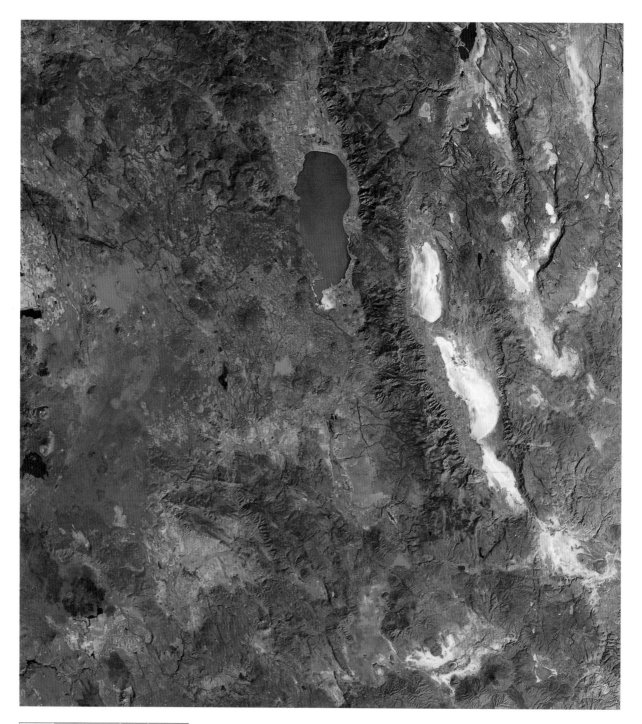

CALIFORNIA LAKES

Lakes come in many shades along the Warner Mountains at the northeast corner of California. The dark blue of long Goose Lake indicates that it is shallow. The California-Oregon border passes through the upper part of the lake. White lakes to the right are alkali lakes, which contain carbonates as dissolved matter. Water in alkali lakes evaporate over time. Traces of blue show pools of water not yet evaporated. The lighter blue patch below Goose Lake is a deep, clear reservoir, as is the oddly shaped blue at left. Red indicates vegetation — forests in the mountains and farmlands where red forms squares.

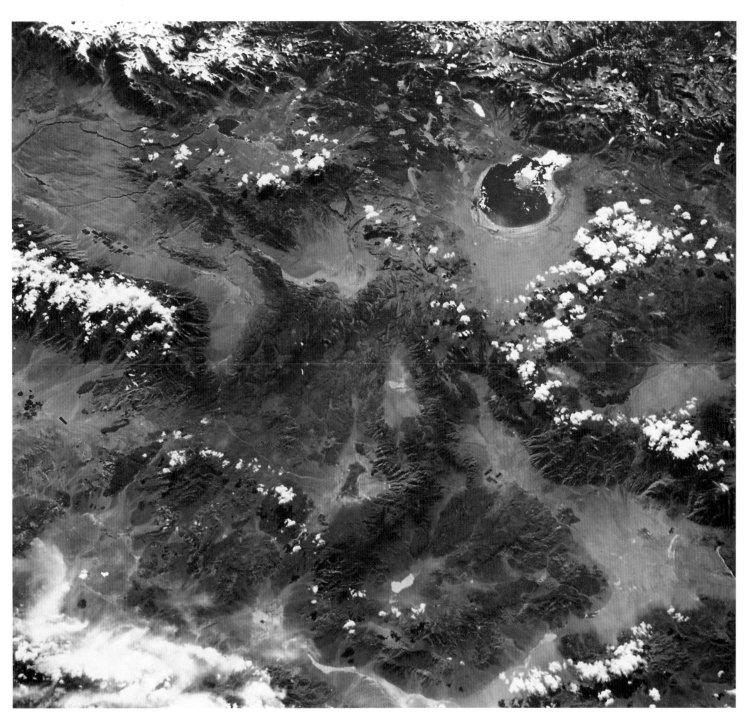

CALIFORNIA DESERTS

Light clouds brush the mountain ranges that frame desert basins around Mono Lake near the California-Nevada border. The lake, an oasis in a dry land, is a habitat for millions of migratory and nesting birds. Mono Lake sits 6,730 feet above sea level in the Mono Basin, a shallow, bathtub-shaped depression formed by the eastern Sierra to the west and rolling volcanic uplands to the north, east, and south. Young, active volcanoes, called the Mono Craters, rise 2,500 feet above a plain strewn with pumice.

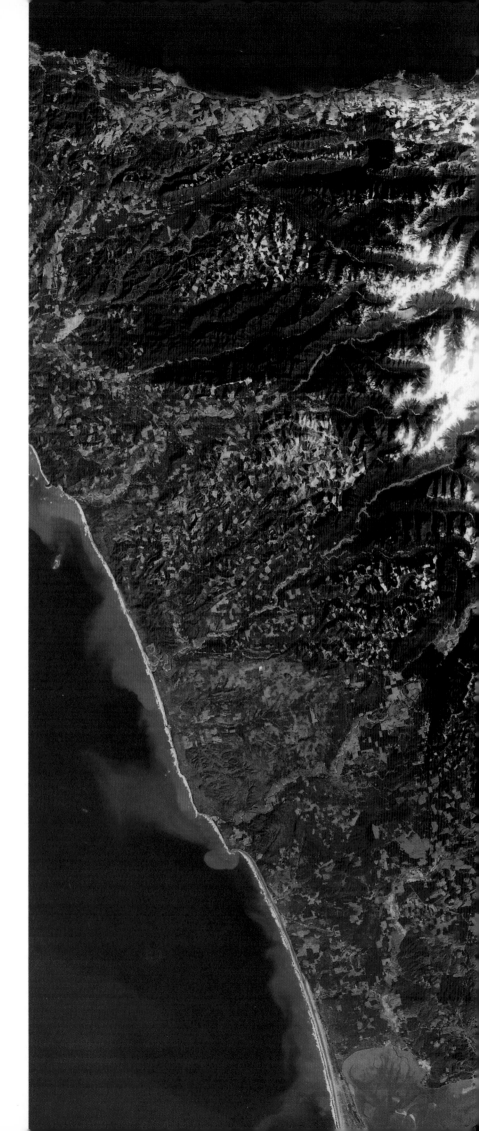

Olympic Peninsula

Snow-covered Olympic Mountains rise from the rain forest of the Olympic Peninsula, on the northwestern tip of Washington — wettest of the Lower 48 states. Humid Pacific air annually carries as much as 14 feet of rain to the forest. Climbing higher, the moisture becomes snow that drapes the summits year-round and adds to the glaciers grinding through the mountains. On the northeast side of the mountains, moisture is scarce in an area known as a rain shadow. In the lower part of the image the Columbia River flows to the sea and clouds dot the western edge of the Cascade Range.

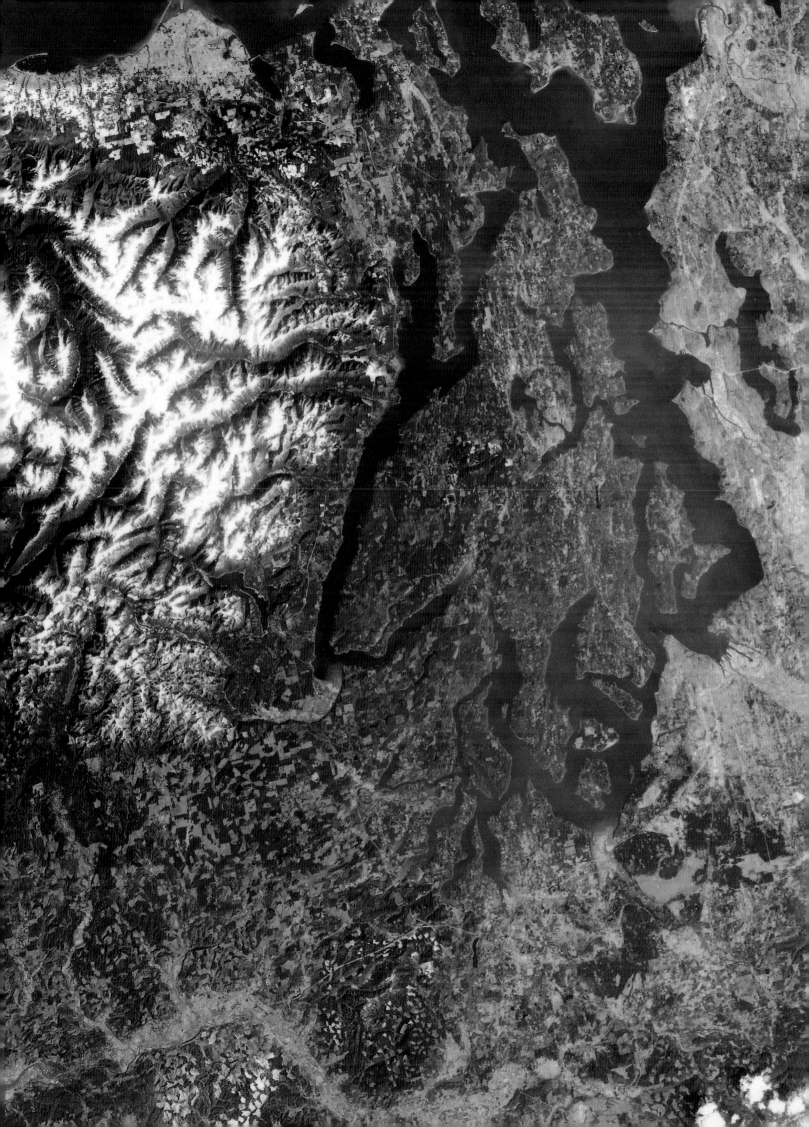

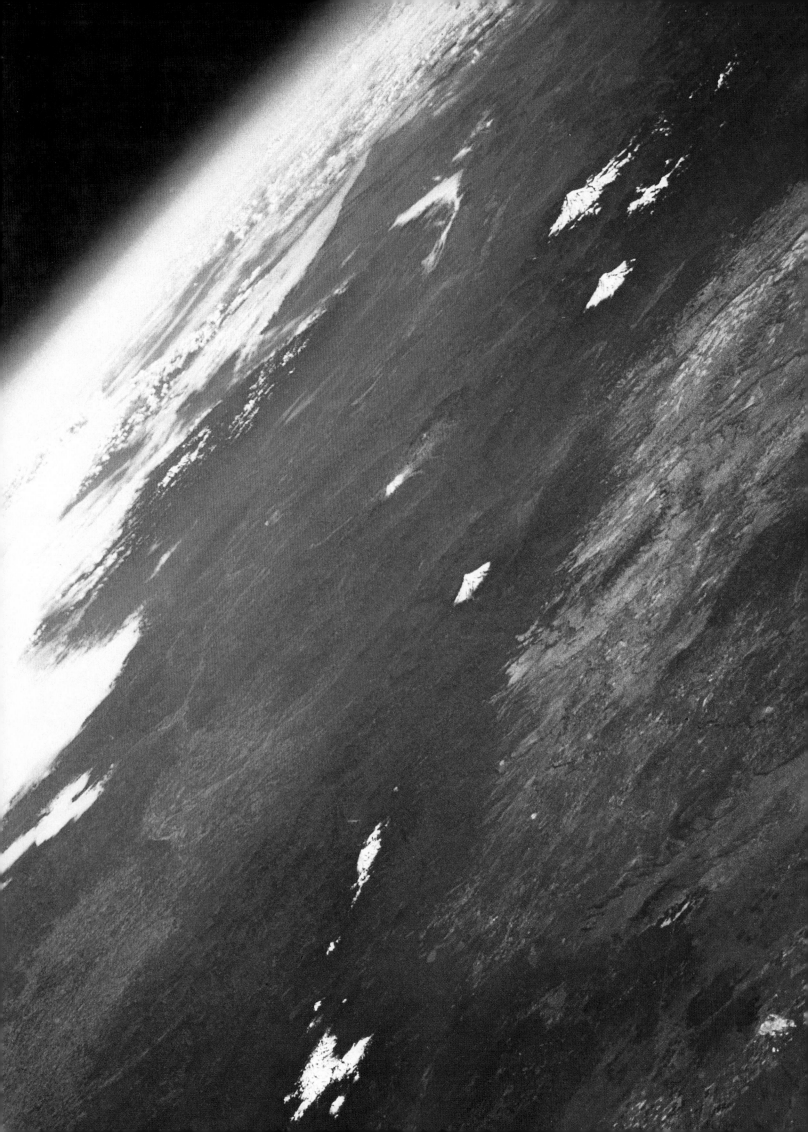

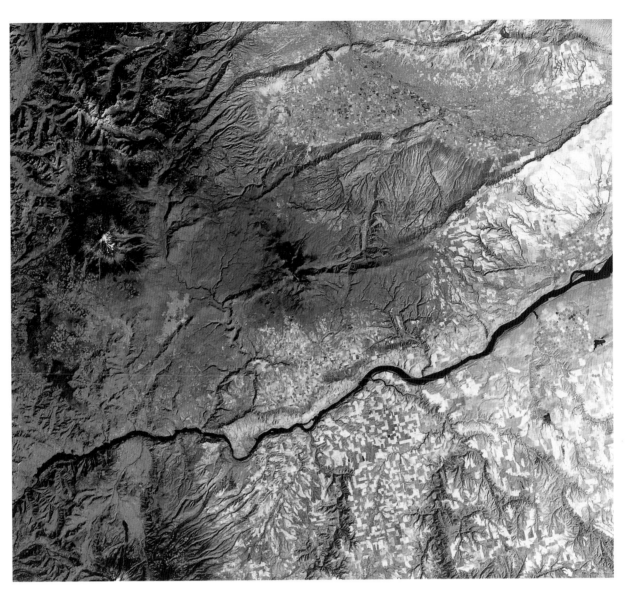

[PAGE 38]

CASCADE RANGE

In this panorama of majestic
beauty, the Cascade Mountains
dominate the landcape of
southern Washington and
northern Oregon. At top right,
snow-draped, glacier-laced Mount
Rainier, a 14,410-foot giant,
crowns the Cascades. Southeast
is snow-covered Gilbert Peak
and 12,307-foot Mount Adams.
To the west, a gray patch marks
Mount St. Helens and the
devastation created by its 1980
eruption. (See pages 40-41.) The
other snowy peaks are Mount
Hood, at 11,235 feet the highest
point in Oregon; Mount Jefferson
(10,497 feet), and the Three
Sisters, each of which rise more
than 10,000 feet.

[PAGE 39]

THE BIG RIVER

Black in this image, the Columbia
River — the Big River, as some
Indian tribes called it — winds
through the mountains, forming
part of the boundary of Washington
and Oregon. A hard-working
waterway since white settlers
arrived, the river has lured farmers
and fishermen, fish canners and
pulp mills, fed by forests that
appear in bright red. Communities
along the river show as red blocks.
On the main stem of the Columbia
and Snake Rivers are 34 dams.
During the summer, because of
heat generated by mills and other
water users, temperature on the
Columbia often exceeds the 65
degrees considered maximum for
salmon, a Columbia treasure.

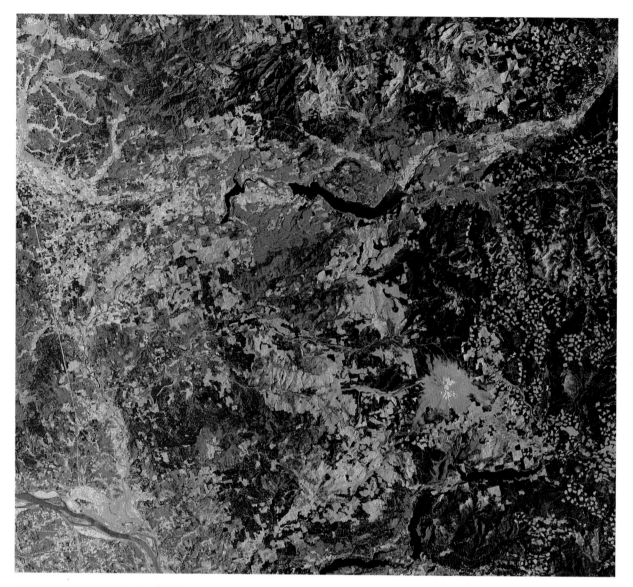

[PAGE 40]

ST. HELENS, THEN

Snow tops Mount St. Helens, which rises 9,677 feet above the Gifford Pinchot National Forest in this 1980 photo. Reds indicate forests and farmland; blues indicate logging areas. Black indicates deep lakes scattered in the region. The Columbia River and lakes appear bluish because they carry sediment. A volcanic mountain, St. Helens had been dormant since 1857. Until 1980 there had not been a major volcanic eruption in the Lower 48 states for 63 years.

[PAGE 41]

ST. HELENS, NOW

On May 18, 1980, molten magma within Mount St. Helens exploded with a force 500 times more powerful than the atomic bomb that destroyed Hiroshima. The explosion tore off a huge piece of the mountain, hurled an enormous cloud of hot `ash skyward, and sent rock and lava hurtling down the slope at 100 miles per hour. Winds up to 275 miles per hour leveled an area of 150 square mile, which scientists call the blast zone. Lava flowed in a fan pattern, felling trees, scorching the earth, and filling in Spirit Lake. A horseshoe-shaped crater remains; within it rises a lava dome 1,000 feet high. In this image, made 11 years after the eruption, faint traces of green show the regrowth of vegetation, especially in protected valleys. Small, rectangular patches are clear-cut areas in logged forests.

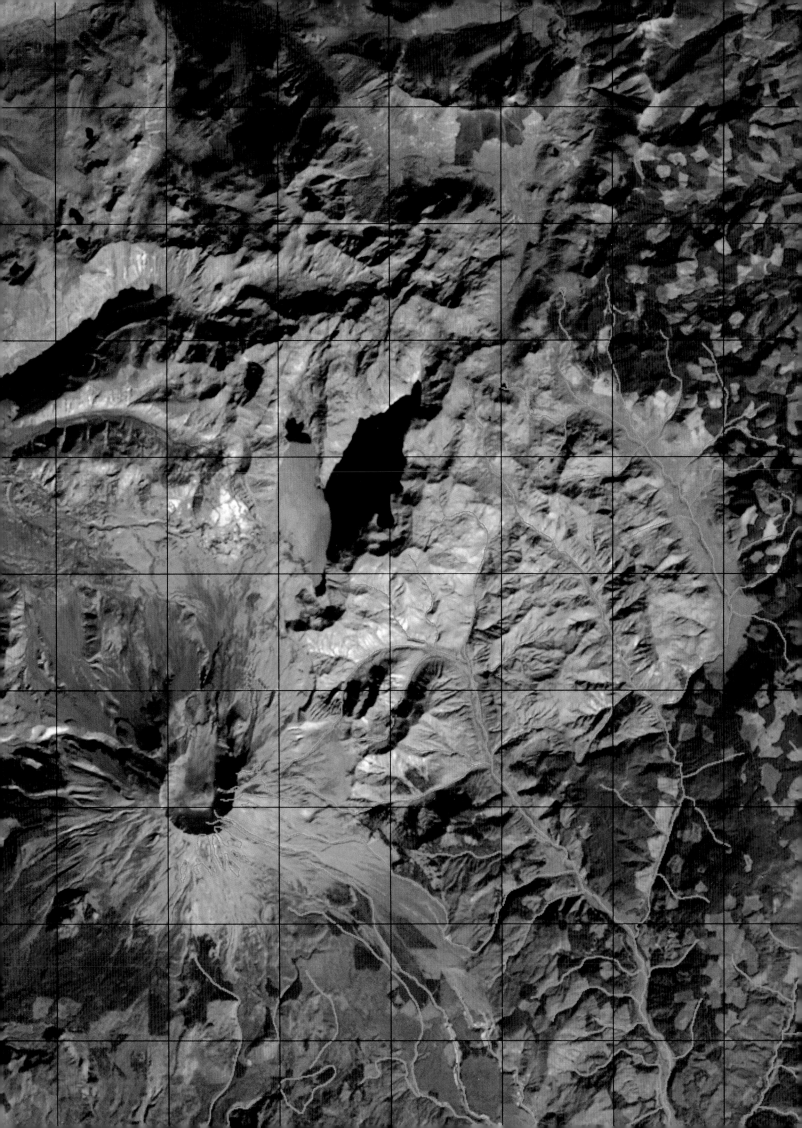

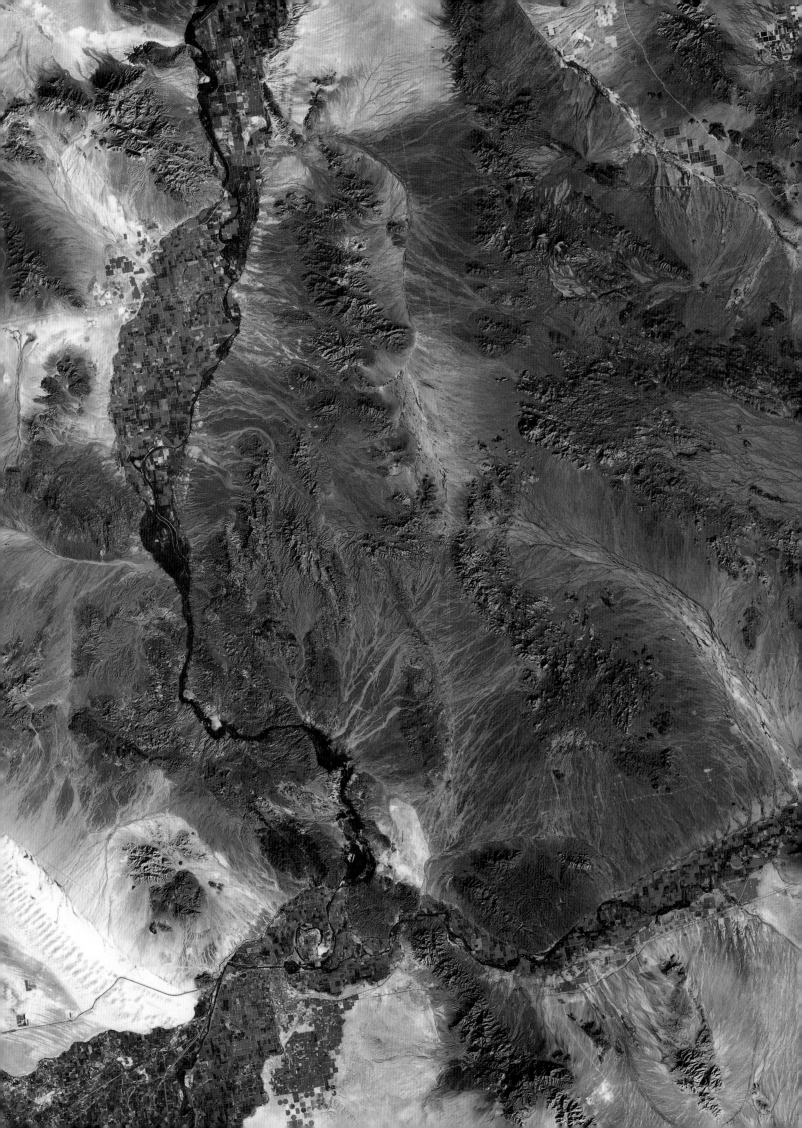

The West

Between the ramparts of the coastal mountains and the snow-crowned Rockies is the American west, a place of legend and history as much as a place of uniquely American geography. This varied land — high land and dry land, Badlands and rich land — lured a variety of people. The earliest had come from Asia, crossing the Bering Strait land bridge and spreading across the west. Their descendants formed tribes and spoke words that would endure as names upon the land: Utah, Wyoming, Oklahoma, Cheyenne, Wichita, Omaha, Dakota. Then came the newcomers.

Until the frontiersmen, the pioneers, and the ranchers began their westering, the land remained little changed from the distant era when America's original people dwelled there alone. The land changed quickly as the newcomers began to put their stamp on it. Towns emerged along the bison trails. Roads and railways criss-crossed the land. Dams throttled the rivers. The west was tamed.

But from the vantage point of space, the human stamp fades and the land takes on the look of the time when it was the wild and wide-open west. Looking down upon it, you see that much of the west was never tamed. Deserts and canyons have defied change and settlement. Immense tracts, never colonized, belong to the federal government: well more than half of Utah and a third of New Mexico and Colorado. People cluster in the west's cities, leaving much of the land yet wild.

The heart of the west is the great Colorado Plateau, a high tableland that centers on the Four Corners, where Utah, Colorado, Arizona, and New Mexico meet. Through it flows the mighty Colorado River, which has been carving canyons for some 10 million years. The plateau, ranging from 5,000 to 13,000 feet above sea level, covers 130,000 square miles. Within its domain are deserts and a rich variety of forests, including hardwoods, spruce, and fir. Natural wonders abound: the Grand Canyon, the Painted Desert, the Black Mesa, and several national parks, including Arches, Capitol Reef, Canyonlands, Mesa Verde, and Petrified Forest.

Texas has its own Edwards Plateau, one of the flattest areas on the continent. Early settlers overcame the lack of landmarks by marking trails with stakes, and it became known as the Staked Plain. When you scanned its vastness, a westerner wrote, "you saw a visitor coming at sunup and watched him all day, and then he didn't get to your place until half an hour late for supper." That was the west, and in many places that still is the west.

A Desert Blooms
Clusters of red mark irrigated lands wrested from the Sonoran Desert by two rivers and a complex of dams and canals. The irrigation system also provides water to Mexico. The Colorado River, flowing north-south and watering farms along the California-Arizona border, meets the Gila River near Yuma, Arizona, at the lower left of the image. The Gila, named for the large lizard of the desert, courses eastward on a 630-mile journey to New Mexico. The Sonoran Desert covers 120,000 square miles in southern Arizona and northern Mexico.

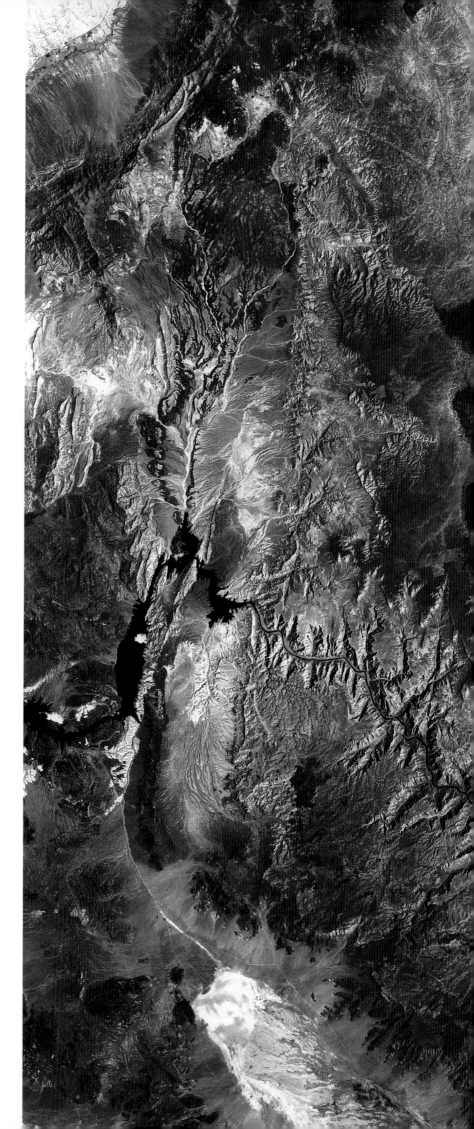

THE GRAND CANYON

Etched in pink rock, the Colorado River twists through its masterpiece as a carver of rock — Arizona's Grand Canyon, more than a mile deep and 18 miles wide. Rock layers show two billion years of earth geology. To the west, Hoover Dam impounds the river, creating broad Lake Mead. Its dark waters at the far left mark the western boundary of Grand Canyon National Park. The canyon emerges from the Colorado Plateau, which has sparse vegetation, showing here in bright green. Volcanic rock and old lava flows appear as darker green; whitish spots are dry lake beds. Space photos revealed a score of previously undetected fault systems.

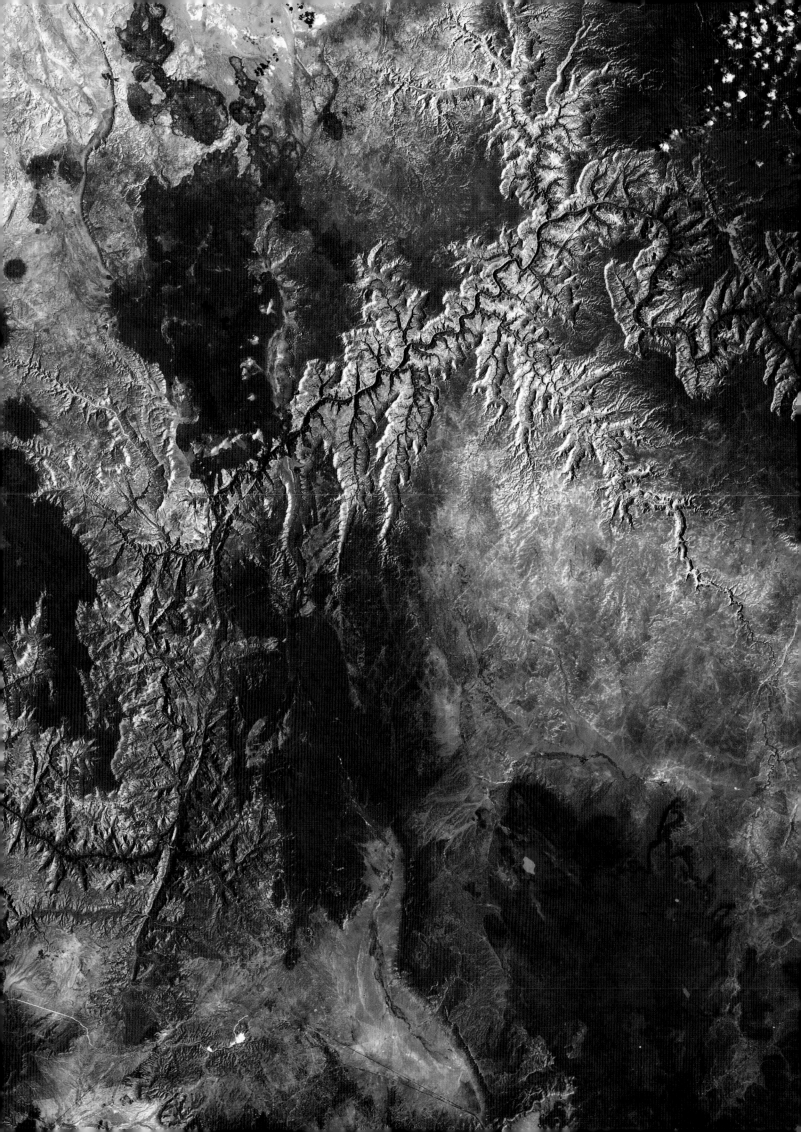

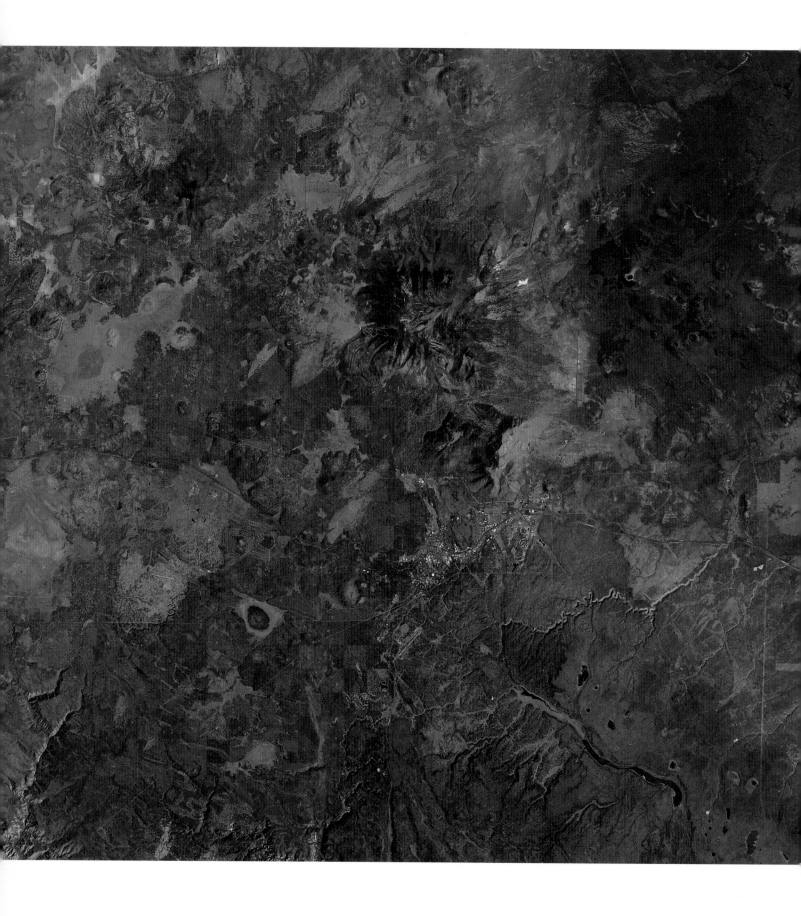

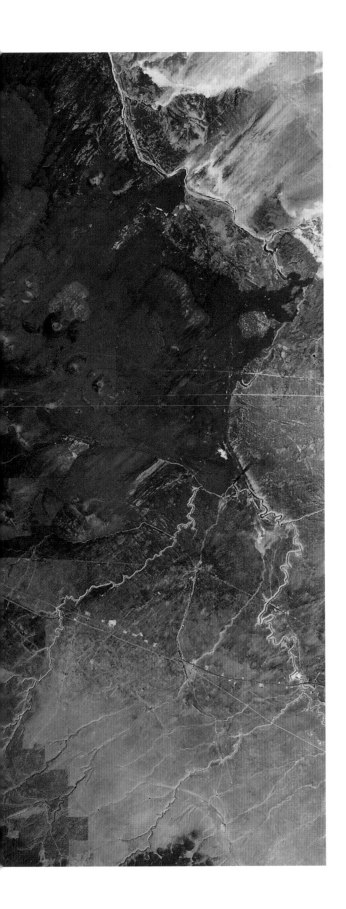

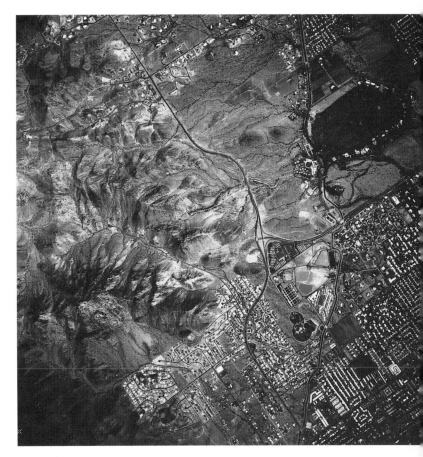

46–47

47

[PAGES 46–47]

CROSSROADS AT FLAGSTAFF

Modern highways, following old canyon trails, converge at Flagstaff, Arizona, a faint string of blue near the center of the image. An oasis for railroad builders heading west in the 1880s, Flagstaff began as a tent town alongside a spring, the only water for miles. North of the city, surrounded by forests (in red), rise the three San Francisco Peaks, at 12,633 the highest in the state. To the east, looking like a large ink blot, are the Painted Desert and the Petrified Forest, whose brilliant colors are due to iron, copper, and manganese in the water that once covered this region.

[PAGE 47]

WATER FOR PHOENIX

From 10,000 feet, an infrared photo shows what keeps Phoenix from going thirsty. The Hohokam people were irrigating the Salt River Valley by about the year 1300. More than 300 years later, settlers dug the first of the canals that led to the founding of Phoenix. Today's Arizona Canal meanders south of a major thoroughfare running through the center of the image. Nearby is a water treatment plant. The largest city in the state, Phoenix is a distribution center for an irrigation region producing cotton, citrus fruits, olives, grapes, and alfalfa.

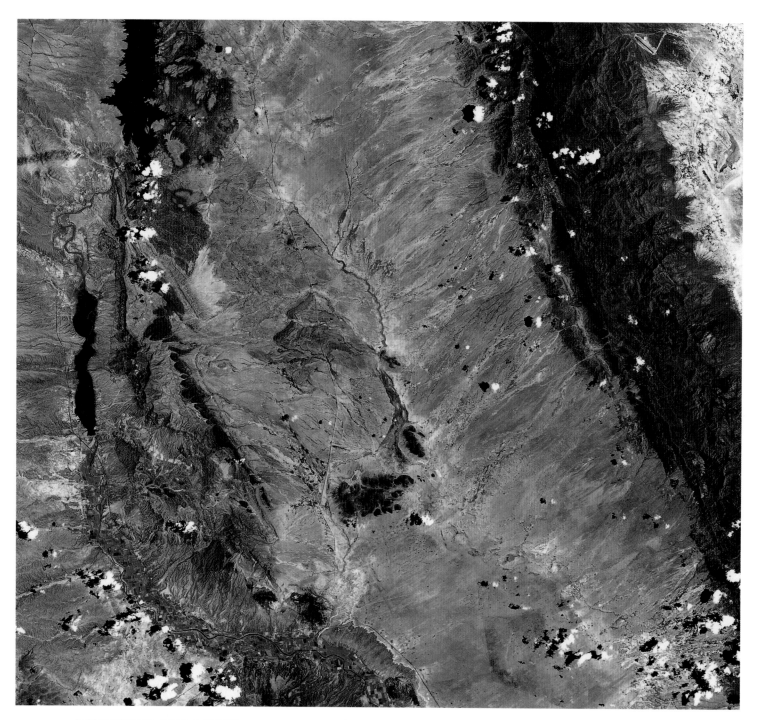

RED FOR RIVERS

A ribbon of red indicates farmland flanking the Rio Grande in New Mexico. South of where the river bulges at the Elephant Butts Reservoir is Truth or Consequences. The town changed its name in a 1950 publicity stunt by the radio and TV show of the same name. Geronimo Hot Springs here memorialize the Apache leader who used the springs as a gathering place for his warriors. To the east, thinner ribbons of red mark the course of small rivers. Slopes, laced with red-bordered streams, show yellow and orange shades that indicate a veneer of vegetation. Puffs of clouds dot the mountainous land with shadows.

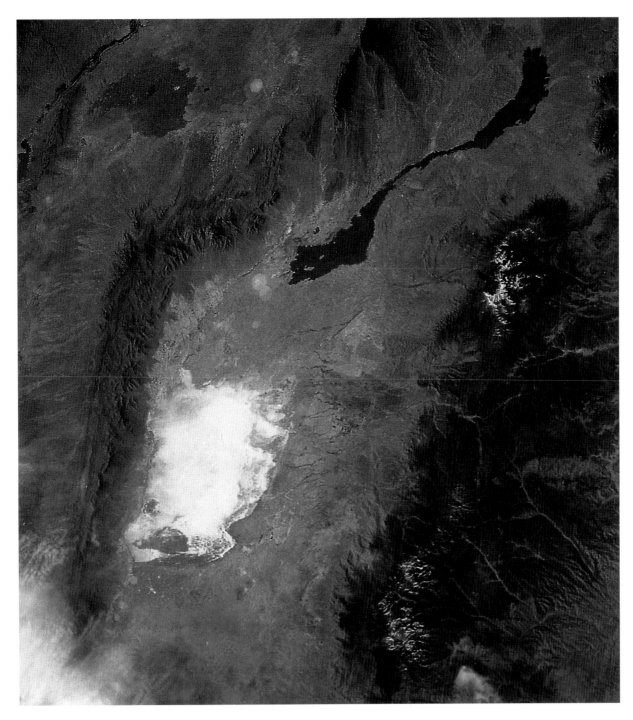

WHITE FOR DUNES

The glare of gypsum granules marks White Sands Missile Range, the New Mexico landing site for the Space Shuttle astronauts who brought back this photo. Within the range is the White Sands National Monument, where visitors see dunes that sometimes reach heights of 50 feet. To the north is the Rio Grande, broadened by reservoirs, and the brown stains of lava fields. To the east is Alamogordo, where an atomic test bomb was first successfully exploded on July 16, 1945. Arching to the west is the gray mass of the San Andres Mountains.

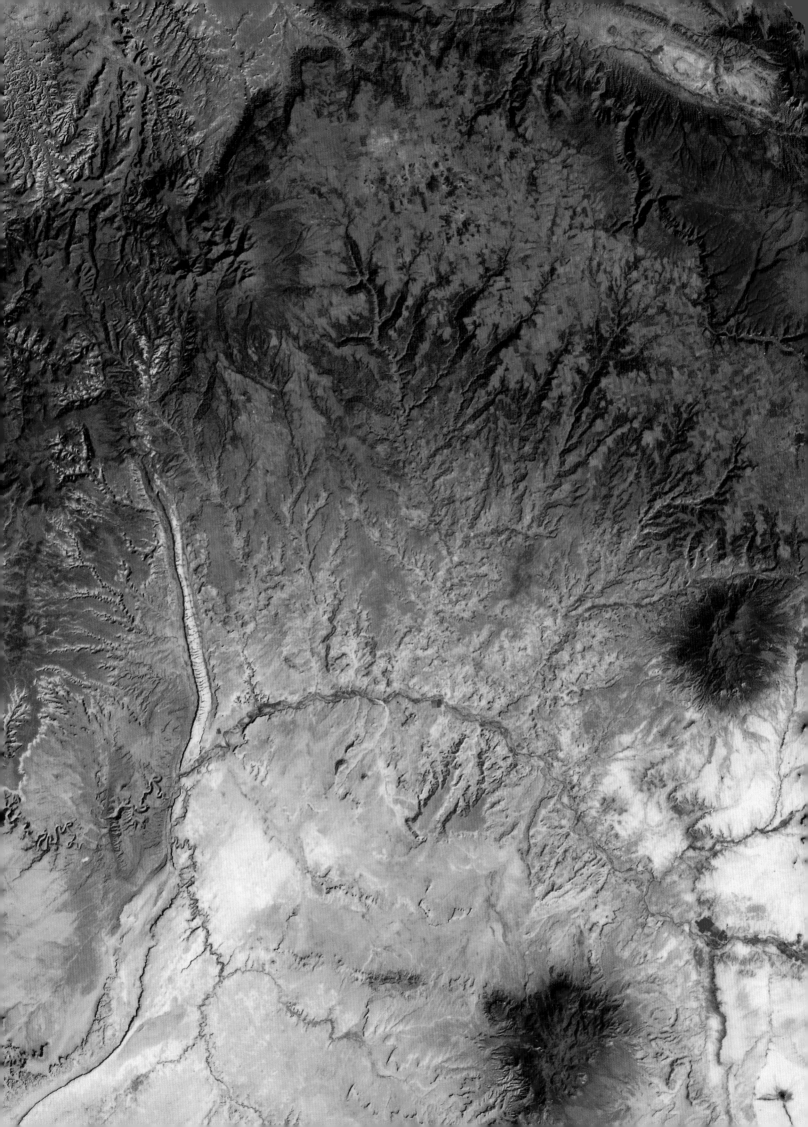

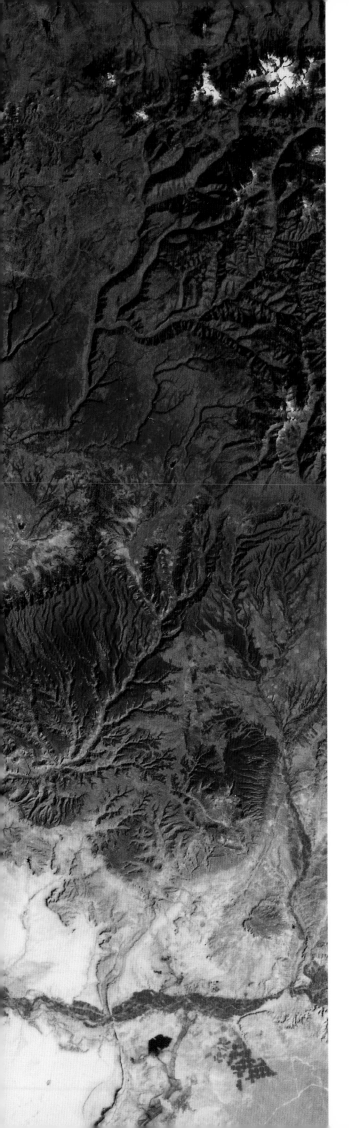

52–53

50–51

[Pages 50–51]

Sacred Landmark

Shiprock — the Navajo call it *Tse'Bit'A*, "rock with wings" — looms at the edge of the Colorado Plateau, which looks like a yellow veil cast upon the mountains of northwest New Mexico. Here, in the Navajo Nation, Shiprock is both a community and a mountain revered as the place where gods created the human race. The mountain was formed by a volcanic vent 27 million years ago, when surrounding land was 2,000 feet higher. The column of lava cooled and the softer earth eroded, leaving a stone pillar 1,700 feet high. The wings are three lava walls 150 feet high and three feet wide. Shiprock, a landmark for both Navajo and pioneer, can be seen for 100 miles.

[Pages 52–53]

A River Tamed

Dams harness the Colorado River as it courses through mountainous terrain. Hoover Dam, near the top of the image, creates Lake Mead, heart of the Lake Mead National Recreation Area — the nation's first. It encompasses nearly 1.5 million acres of desert canyons and plateaus. Farther south is Lake Mohave, created by Davis Dam. In the upper left is the red grid of Las Vegas, Nevada. To the far right, beyond the Black Mountains, is a vast salt flat, created when water evaporates and leaves salt deposits.

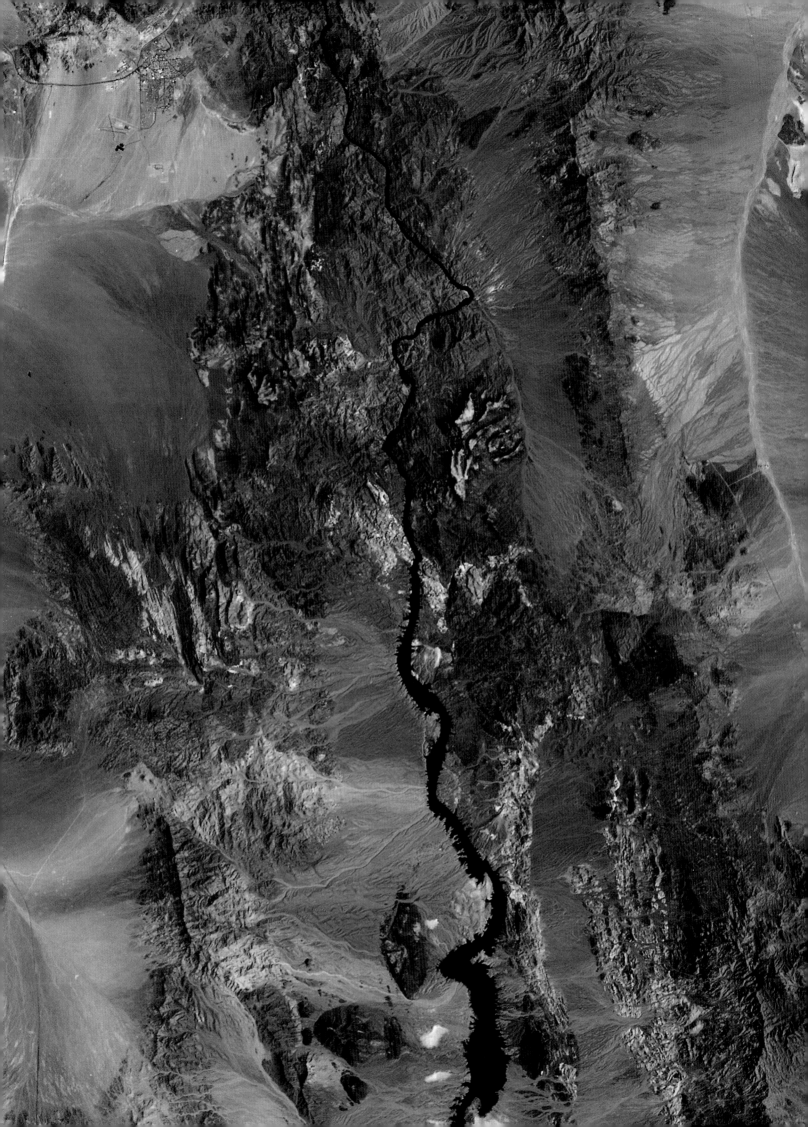

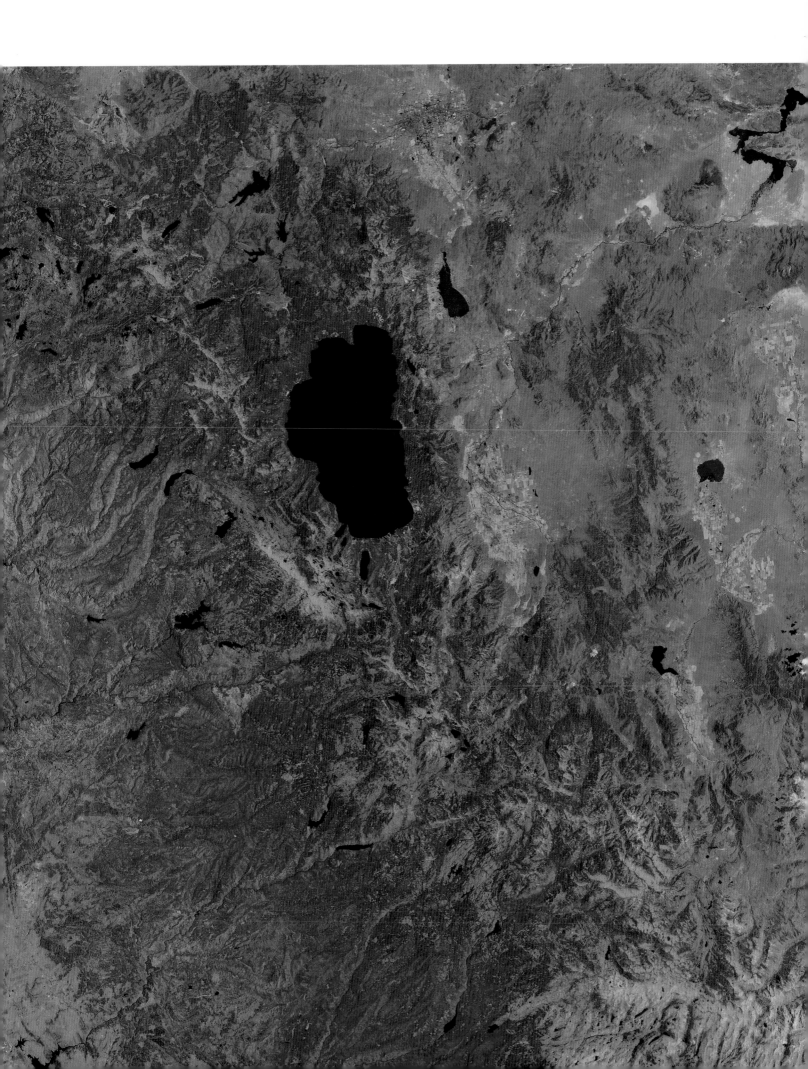

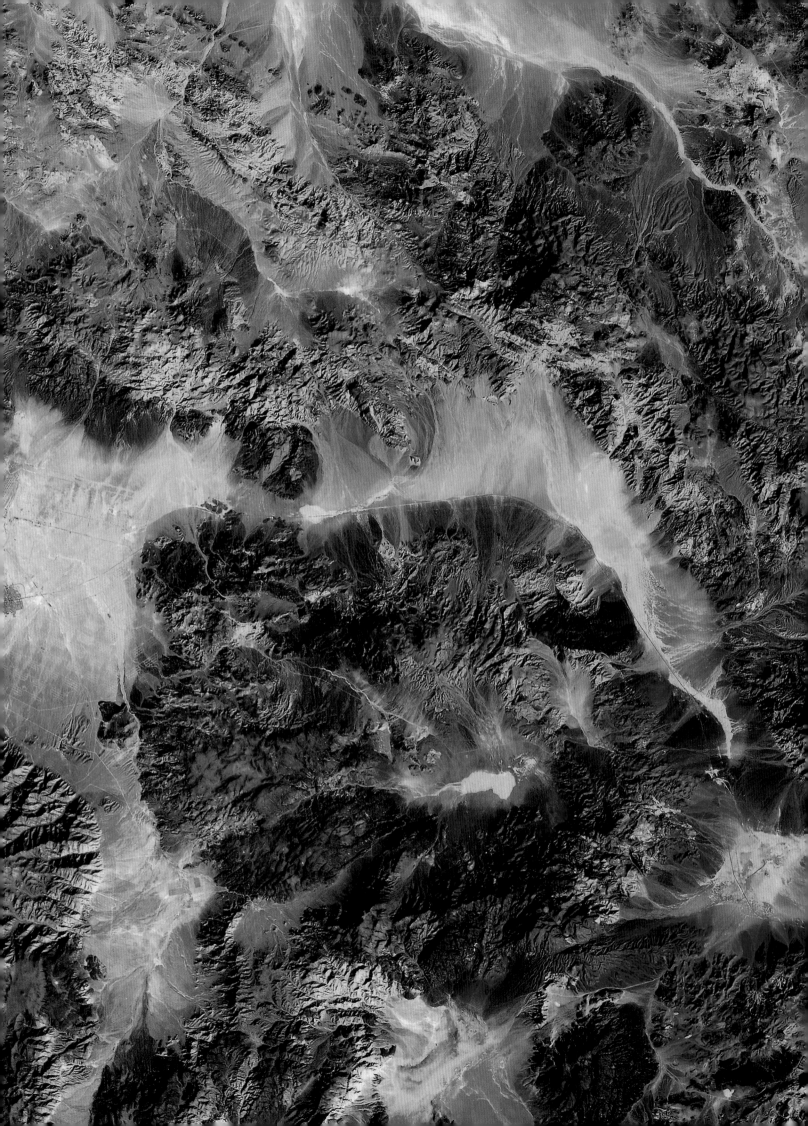

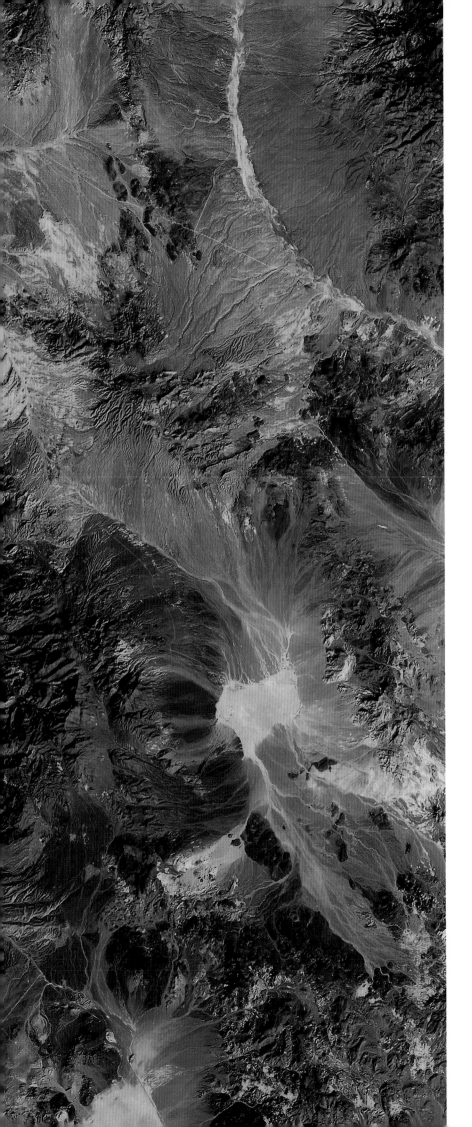

COLORING THE LAND

Swirling colors, produced by
manipulating satellite sensors,
give geologists a map of minerals
around Quartzite Mountain in
Nevada. The 7,766-foot mountain,
at the northern edge of the Mojave
Desert, rises in an area so desolate
that U.S. military gunners use it
for a target range. To analyze the
rock in this hard-to-reach region,
Earth Satellite Corp. used a
format called GeoVue, customizing
spectral bands for a "hue map."
Its colors indicate geologic
formations believed to contain
certain minerals. Here yellows
connote plateaus, whites point to
salt flats, blue flows along trickling
waterways.

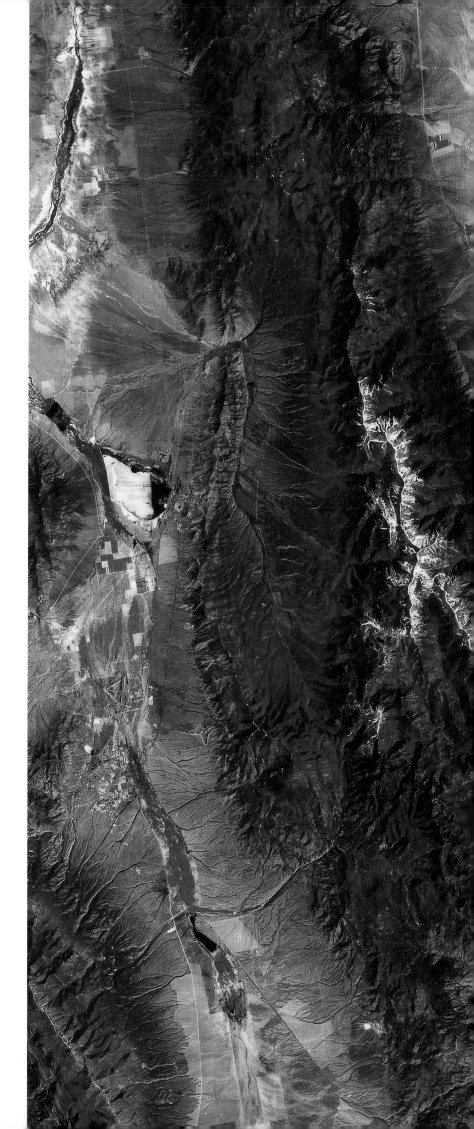

THE GREAT BASIN

Mountains scarred by glaciers rise from deserts in this corner of the Great Basin near the Nevada-Utah border. Most of Nevada lies within the basin, a huge depression that spreads through that state and parts of Idaho, Utah, California, and Oregon. The basin has almost no drainage to the sea. Here, in the Snake Range, the Great Basin National Park encircles peaks ranging from 11,000 to the 13,063-foot, glacier-clad Wheeler Peak. As in the image on pages 56-57, the GeoVue "hue map" technique uses colors to indicate aspects of the terrain. Reds indicate stretches of forest, including scattered stands of bristlecone pines some 3,000 years old.

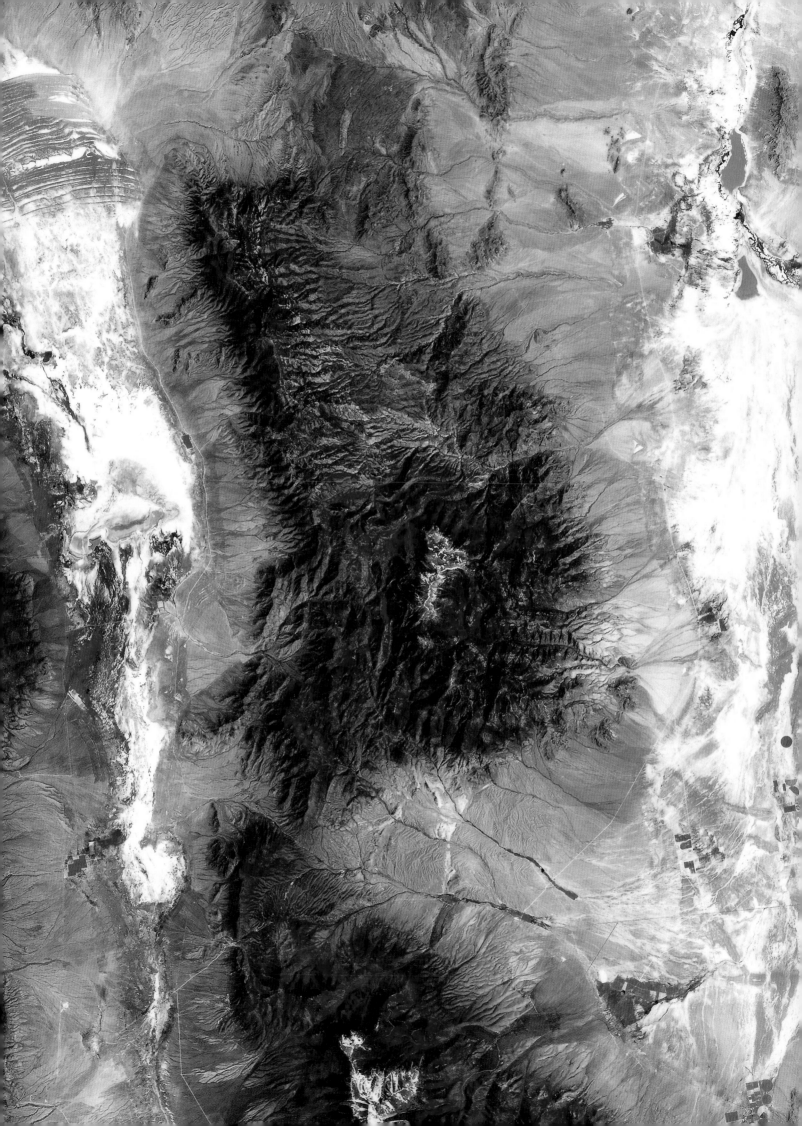

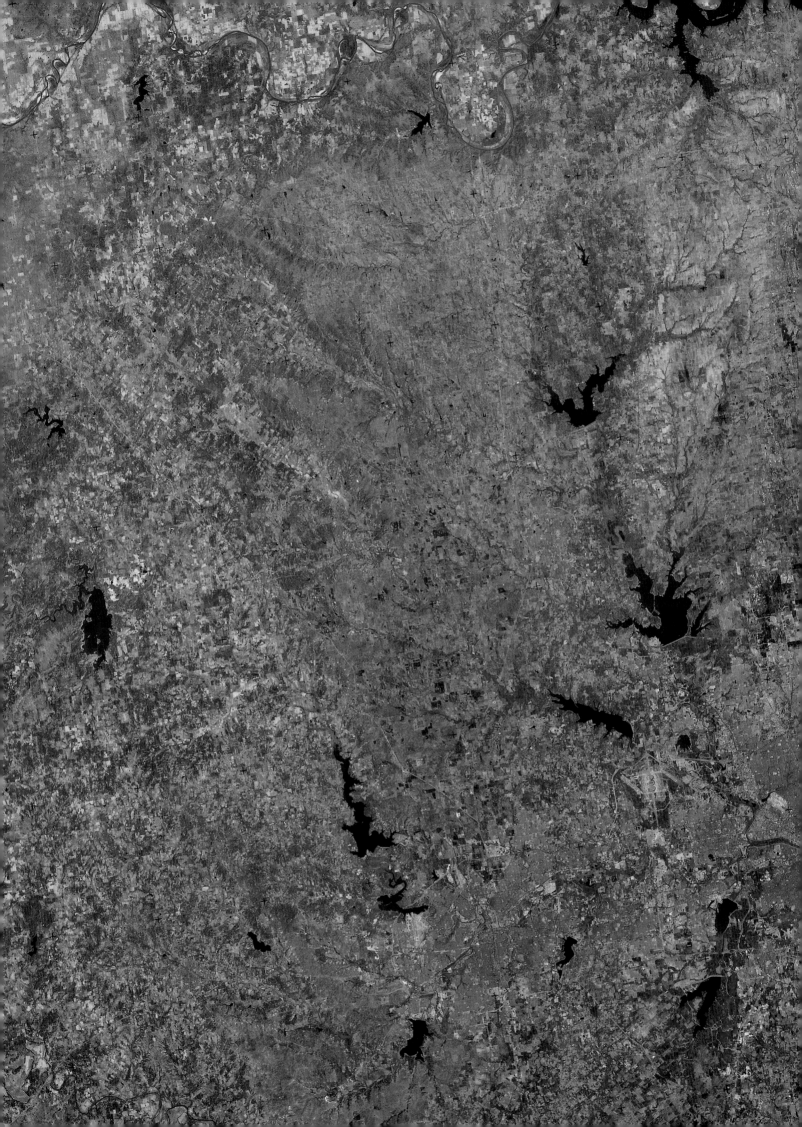

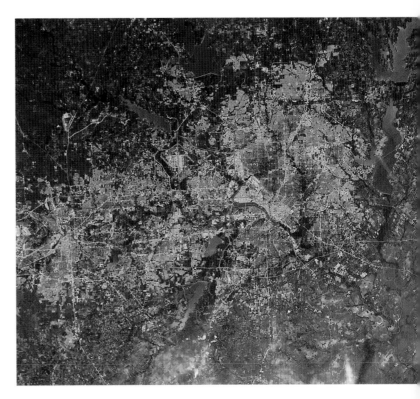

[PAGES 60–61]

METROPLEX, TEXAS

In a satellite portrait of urban spread, the Texas cities of Dallas and Fort Worth form a seamless blob of blue. Dubbed Metroplex, the single urban unit includes Arlington, Grand Prairie, and Irving. A 30-mile gap between the two large cities was filled by developments along highways. Lakes with jagged shores encircle Metroplex and slake its thirst. Dallas, where some say the east ends, is touched by farmlands. Fort Worth looks westward toward mile after mile of rangeland.

[PAGE 61]

MODERN TRAILS

Dallas and Fort Worth, born in the days of cattle trails, now are united by highways and an international airport, which appears near the center of the image. Nearly 20 lakes and reservoirs reflect recent heavy spring rains. The Trinity River arches through Dallas and links with the West Fork Trinity River, which enters Fort Worth. The two cities have a combined population of more than 3.8 million.

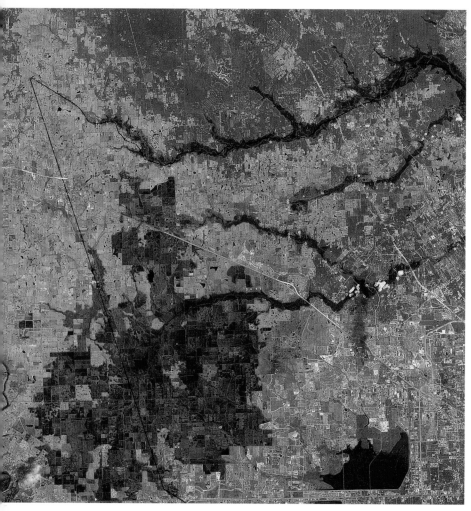

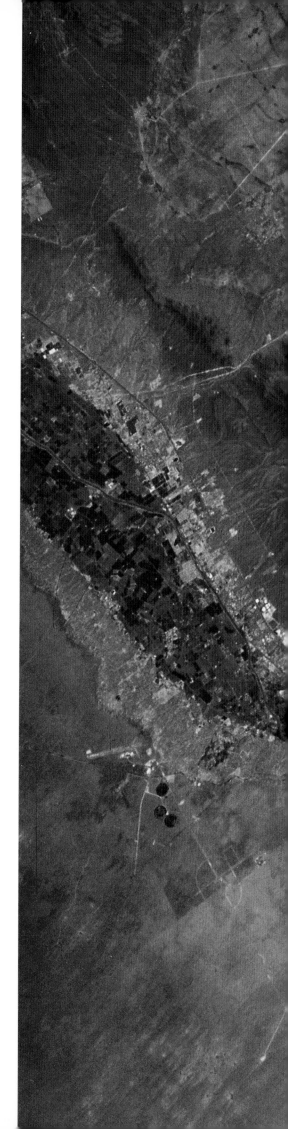

[PAGE 62]
A FLOOD OF CLAIMS

"Geo-coded" images combine data on land use and insurance claims for flood damage in this demonstration of satellite versatility. Federal officials administering flood-damage insurance wanted to track repetitive claims filed from 1976 to 1994 in Harris County, Texas. Earth Satellite Corp. produced this map by first analyzing satellite images that showed changing land use. Then overlaid were plots of land color-coded to show the years when claims were filed. Varying blue and purple shades indicated the frequency of claims within and outside a federally designated flood-hazard area.

[PAGES 62–63]
TALE OF TWO CITIES

The Rio Grande separates two cities and two cultures in a study of contrasts. Juárez, Mexico, is home to more than one million people; El Paso, Texas, has a population of about 400,000. Beyond Juárez are irrigated bottomlands and the Chihuahua Desert; beyond El Paso is a much more extended area of irrigated farmland. Fort Bliss, a wedge-shaped feature in El Paso, is a major employer for Mexicans. The area, colonized in 1598, is one of the oldest European settlements in North America.

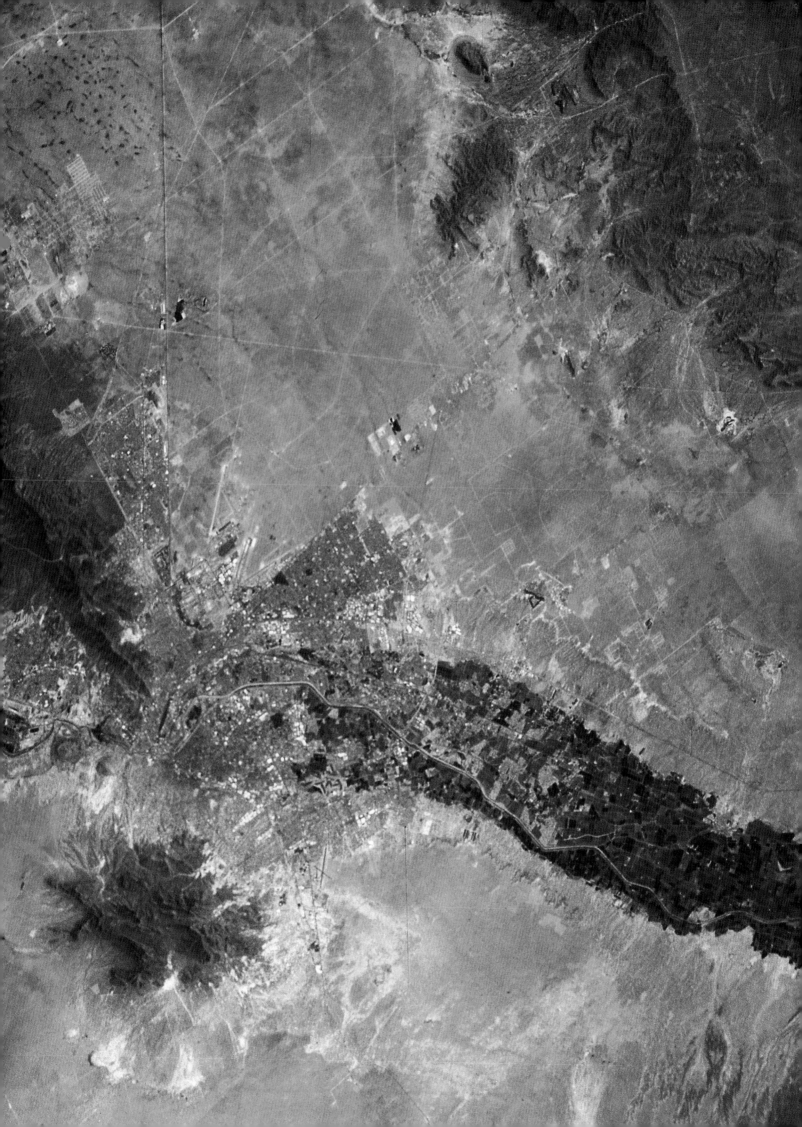

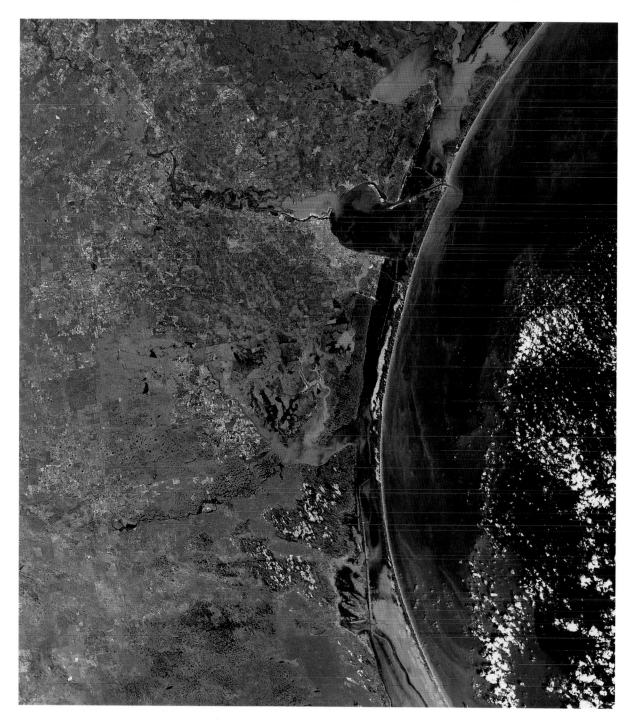

CORPUS CHRISTI, TEXAS

A thin brown barrier against the cloud-flecked sea, Padre Island parallels the Gulf of Mexico shoreline of Corpus Christi. The ever-widening Nueces River opens into broad Corpus Christi Bay. On its southern shore is a U.S. Navy air station. Light shades of blue in river and sea show the burden of sediments. Farmland appears as patches of red. Endangered whooping cranes make their winter home on lands around San Antonio Bay and the north end of Padre Island, at the upper edge of the image.

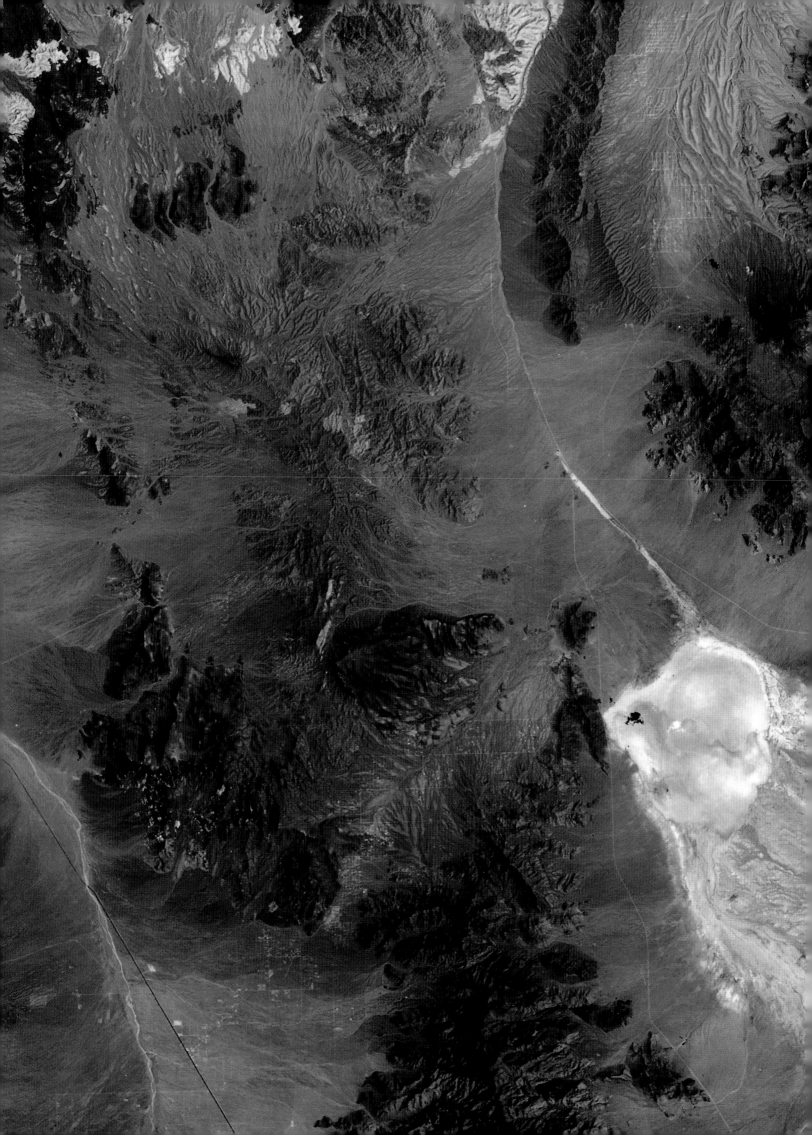

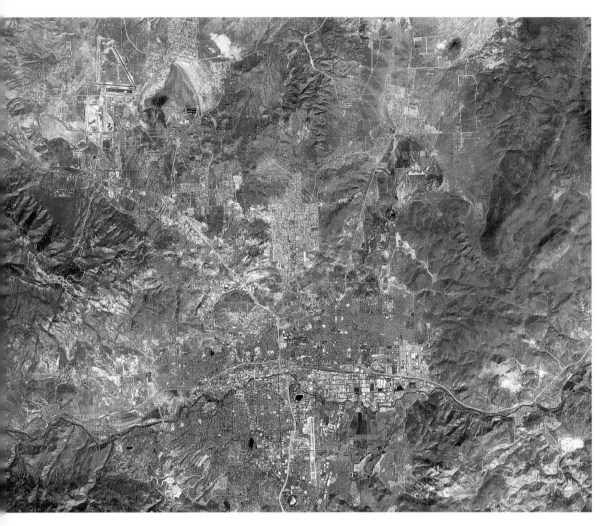

[PAGE 54]

RENO

The Truckee River cuts a path through Reno, Nevada, a city renowned for legal gambling and quick divorces. The greenery — city parks and nearby farms and ranches — contrasts with the stark surrounding mountains, whose gold and silver lured prospectors in the 19th Century. Geography made Reno, which began as a settlement on a river ford along the treacherous Donner Pass route to California. When the railroad came along, the city was laid out in the grid pattern still visible in this image.

[PAGES 54–55]

BLACK LAKE, BLUE SNOW

Lake Tahoe lies like a black hole upon scenic wastelands painted by satellite imagery in surreal colors: blue for snow, light pink for bare soil, black for water (but a natural green for vegetation). The lake, 6,228 feet above sea level, encompasses 193 square miles and shares its shores with California and Nevada. Black water usually indicates depth. Tahoe's deepest spots exceed 1,645 feet. Seen up close, the lake's colors range from pale aquamarine near shore to deep sapphire farther out. The water is so clear that objects on the bottom can be seen even at 75-foot depths.

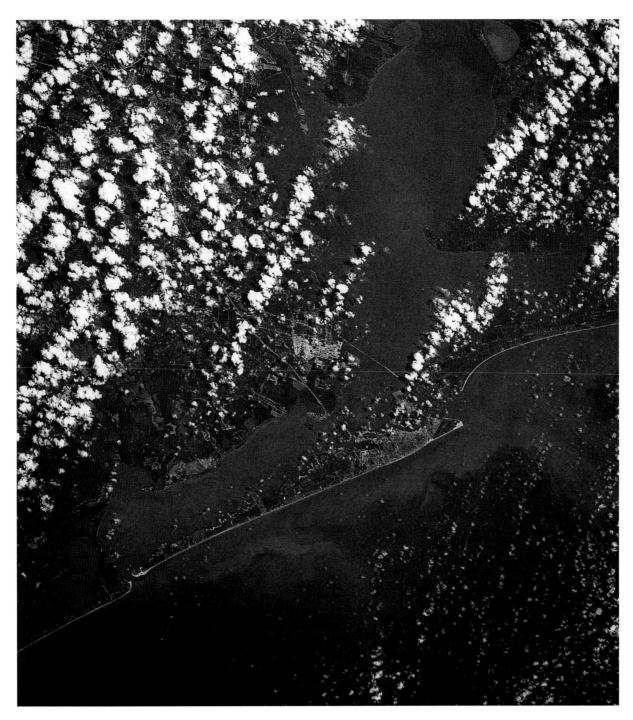

GALVESTON, TEXAS

Clouds sweep over Houston, but Galveston Island and much of the nearby mainland can be seen clearly in this photo by a Space Shuttle astronaut. In the view are Interstate 10 at the lower left, Galveston's two jetties, a causeway, and two bridges. One of the deadliest natural disasters in U.S. history struck here on September 8, 1900, when 115-mile-an-hour winds and a surging sea battered Galveston Island. More than 6,000 people died. Galveston quickly rebuilt and added a seawall that is 6 miles long, 17 feet high, and 16 feet thick.

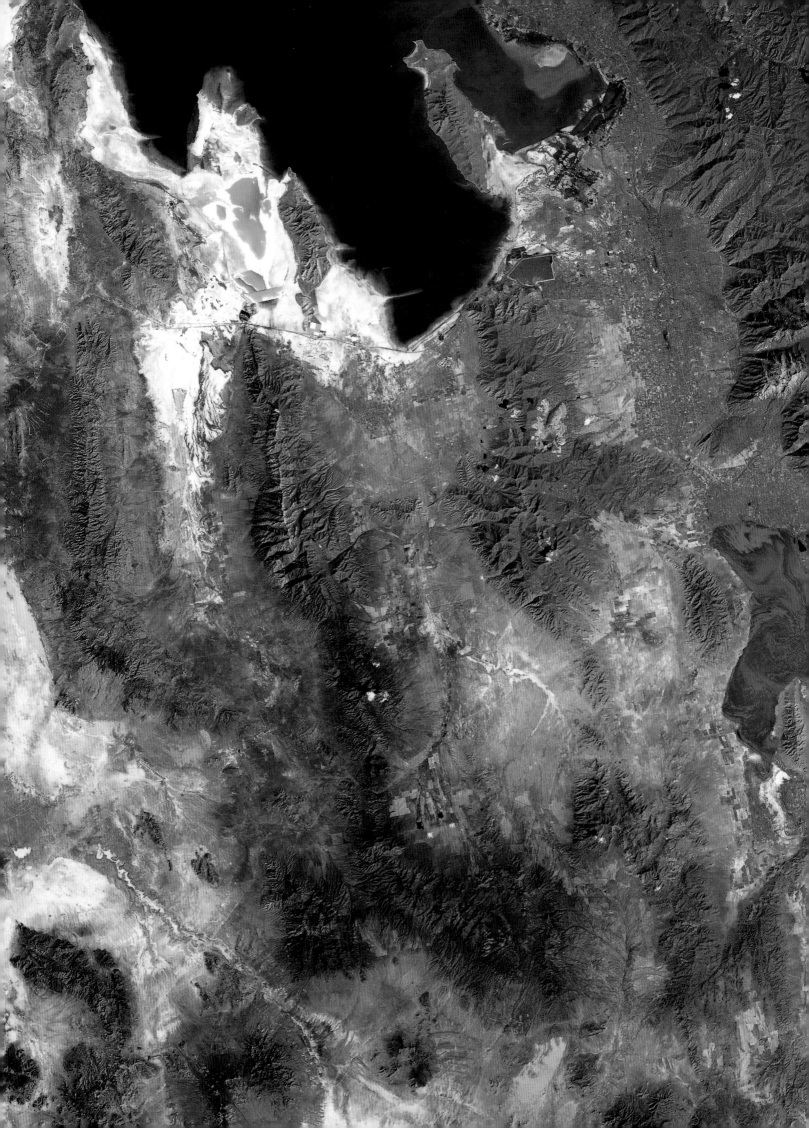

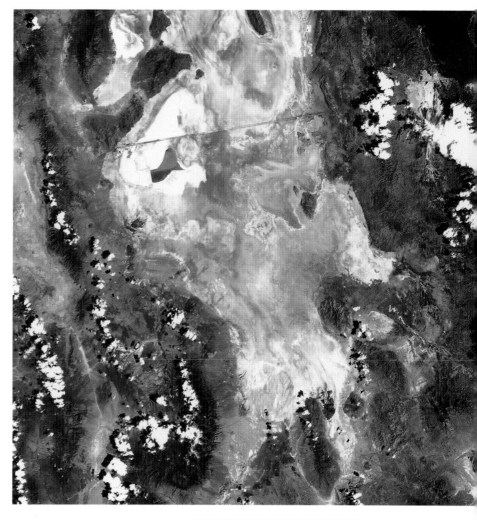

[PAGES 66–67]

SALT LAKE CITY

Squeezed between mountains and
desert, Salt Lake City appears as a
tight grid of red along the flanks
of mountains, where forests also
show up as red. At right center is
Utah Lake, whose shores show red
to indicate a string of cities,
including Orem and Provo.
About 30,000 years ago, a vast
lake, known to geologists as Lake
Bonneville, covered the area. The
Great Salt Lake and Utah Lake are
the few survivors of that wetter
and cooler time. Bonneville is also
the name for the 100-square-mile
salt flat, west of the Great Salt
Lake, where racing drivers set
land speed records.

[PAGE 67]

THE GREAT SALT DESERT

"A vast, waveless ocean stricken
dead," Mark Twain wrote after
crossing the salt flats of Utah in
1861. In the midst of the desert is
the Great Salt Lake, divided by
the faint straight line of an
earthen railroad causeway. Desert
heat causes water in the lake to
evaporate swiftly, leaving behind
salts and minerals that have long
been harvested in evaporation
ponds. Clouds sweep across the
mountains around the lake; some
show the red of forests.

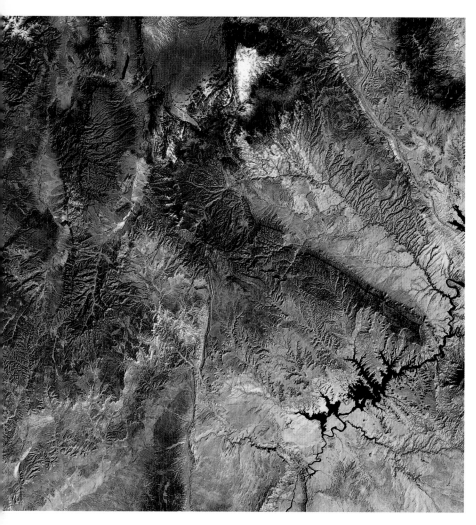

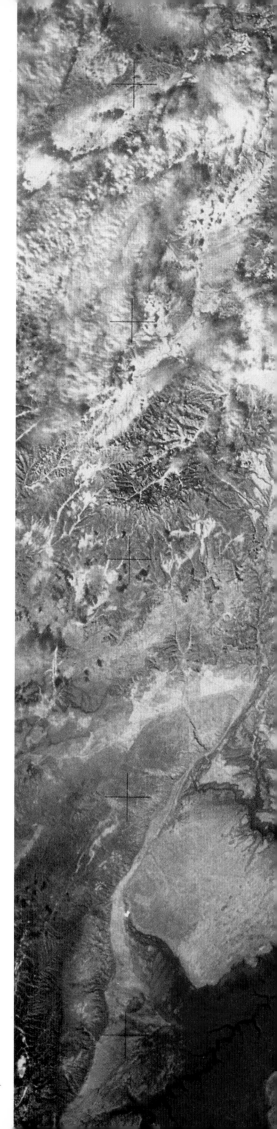

[PAGE 68]

UNCLE SAM'S BACKYARD

Southern Utah appears as a rugged sculpture of canyons and crags in an image consisting almost entirely of U.S. recreational land. Touches of red indicate national forests in this area, 90 percent of which is federally owned. At right, the Colorado River winds through Glen Canyon National Recreation Area, flares into the ragged shores of Lake Powell, and plunges into Marble Canyon, gateway to the Grand Canyon. The smaller Escalante River curves into the 1.7 million acres of the Grand Staircase-Escalante National Monument, the largest in the Lower 48. To the west is Bryce Canyon National Park and Zion National Park; to the north is Capitol Reef National Park.

[PAGES 68–69]

CANYONLANDS

Winter white drapes the canyon country around Lake Powell, on the Utah-Arizona border. The lake is named for John Wesley Powell. In 1869 he led the first expedition down the Green-Colorado river system from Green River, Wyoming, through Glen Canyon and later through the Grand Canyon. The stretch of the Colorado River shown here includes Canyonlands National Park, north of Lake Powell, and part of Grand Canyon National Park. The river falls 2,300 feet through the 277-mile-long canyon.

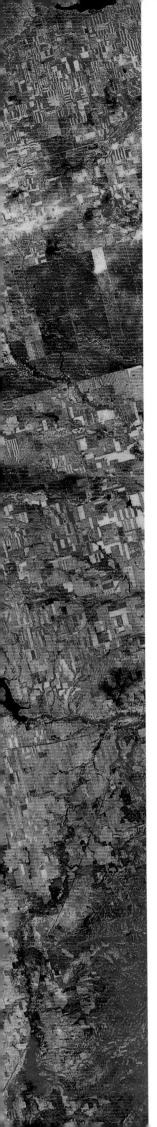

The Rockies

MEASURED IN geologic time, the Rockies are young, their origin tracing back to about 65 million years ago. Testifying to the youth of the Rockies is the jagged skyline, for these are peaks still not smoothed by erosion. An uplifting of the Earth's crust mainly formed the Rockies, which were later reshaped by glaciers. Most of the uplifting happened within the last 10 million years. And the Rockies are still lifting, at the rate of about one foot every 300 years.

The mountains, a formidable barrier between east and west, were not explored until the 19th Century. When one of those early explorers, U.S. Army Captain Zebulon Pike, saw the Rockies for the first time in 1806, he estimated that they were only 15 miles away. Actually, the mountains, including what would become 14,110-foot Pikes Peak, were 120 miles away.

The Rockies, the crest of the continent, pass through six states and two Canadian provinces, stretching for 1,900 miles from Santa Fe, New Mexico, to the Liard River in British Columbia. Within the Rockies are more than a dozen U.S. and Canadian national parks.

The Rocky Mountains form part of the Great, or Continental, Divide, which separates rivers draining into the Atlantic from those flowing toward the Pacific. The Divide is dramatized by little Two Ocean Creek in Wyoming. A drop of water from that Wyoming creek may flow westward, entering the Snake River watershed and ultimately the Pacific Ocean. Or a drop may enter the watershed that includes the Mississippi River and ultimately reach the Gulf of Mexico, where it mingles with the Atlantic Ocean.

The mountains sustain several life zones, for with each thousand feet of altitude comes an average 3.5-degree drop in temperature, along with changes in humidity and soil acidity. Climbing a peak in Utah, you start in forests of piñon and juniper. Next, along the mountain streams, will be willows, birches, and cottonwoods. Higher up, you find yourself in the cool green of blue spruce and ponderosa pine. Then come the lodgepole pines, which once provided Indians with frames for their lodges. At about 7,000 feet, Douglas fir thrust to the sky. At 10,000 feet, hardy spruces are stunted and increasingly rare. Finally, beyond tree line, flowering plants and grasses produce a scene resembling the arctic tundra. And then, as you near the peak, come the eternal snows that crown the Rockies.

BORDER LINE
As if drawn by a ruler, the border between the United States and Canada shows up vividly in this image. The line is apparent because it is formed by the differing ways in which people use the land whether it be grazing cattle in the Canadian provinces of Alberta and Saskatchewan or growing wheat in Montana. The color of the checks indicates the state of vegetation: red for growing crops, white for harvested fields, light green for fields left fallow. Canadian rangeland is dark green. This stretch of the border — the 49th parallel — lies on the Great Plains, fed by the rivers and streams of the Rocky Mountains.

BATTLEFIELD

The courses of rivers form what look like giant arrowheads in the rugged land where General George Armstrong Custer made his famous last stand. The Little Bighorn meets the Bighorn at the inverted V in the lower center of the image. Near here in 1876 in what is now Montana, Sioux and Cheyenne wiped out Custer and his entire detachment of more than 200 men. At the cloud-crossed inverted V to the north, the Bighorn joins the Yellowstone River. Red squares along the rivers, bulging around Billings, Montana, at left, indicate farms and ranches. Red tint to the east marks the Custer National Forest.

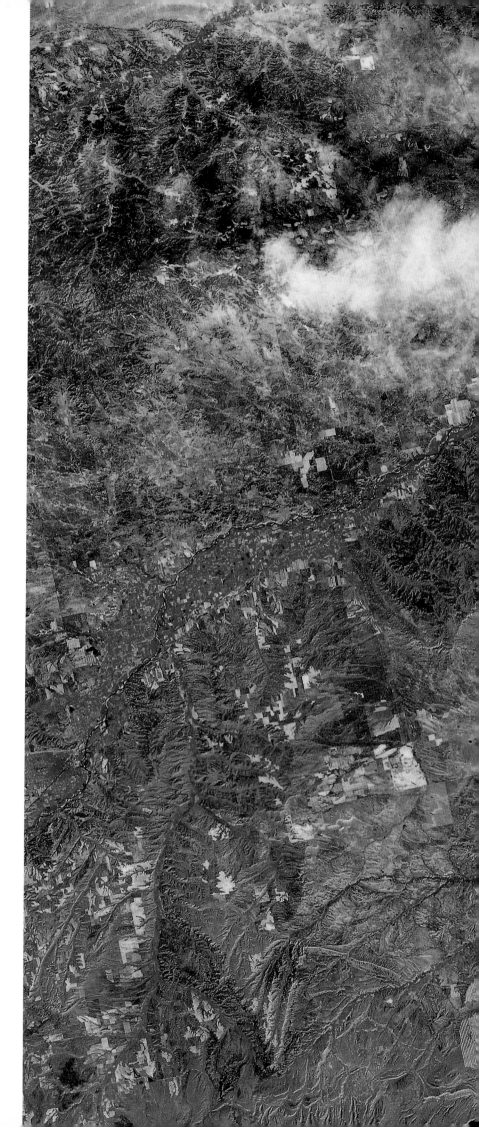

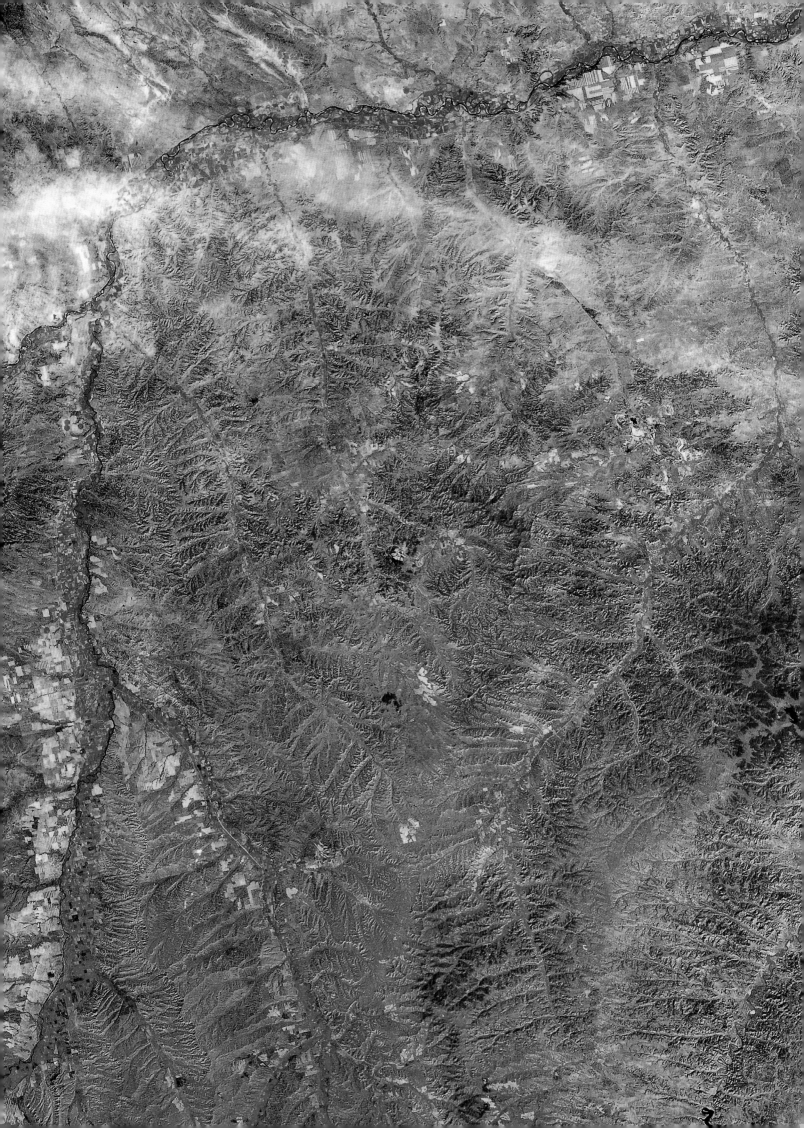

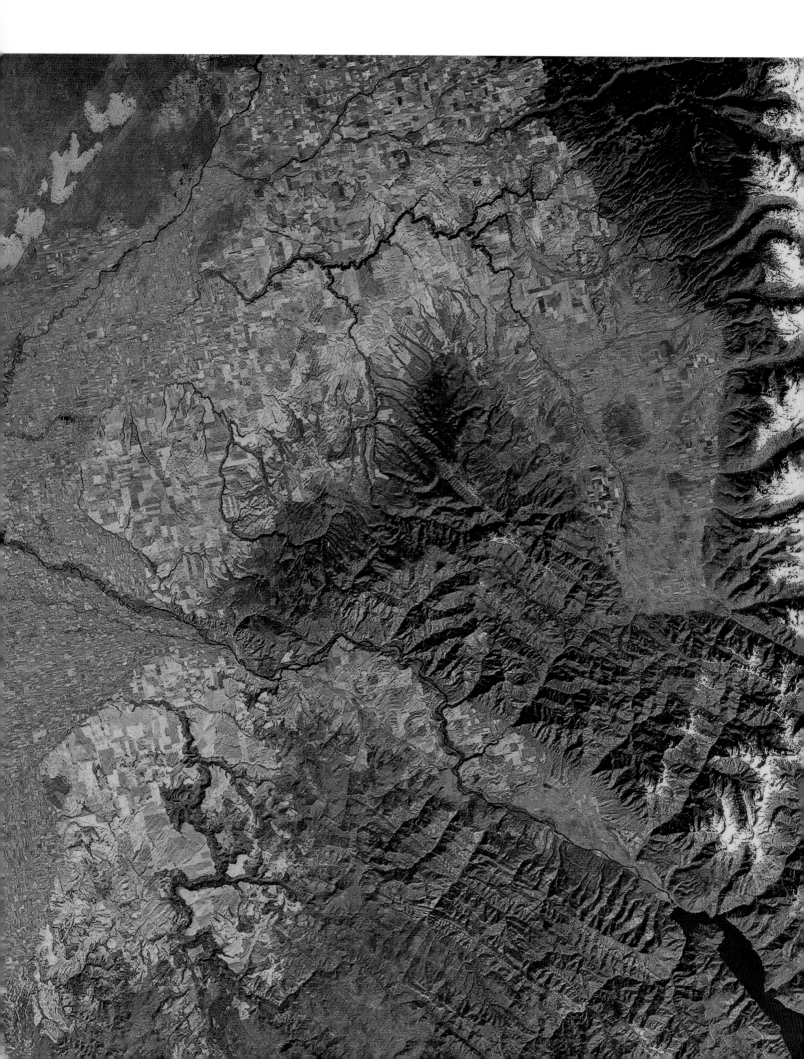

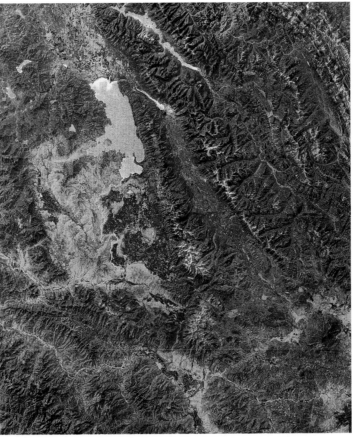

[PAGE 75 TOP]
MOUNTAIN REALM

Ridges and rivers converge on Missoula, once a frontier mining town in western Montana, now a center for Rocky Mountain skiing. Satellite sensors are adjusted to pinpoint rock formations for geologists. Tightly coiled ridges dominate the image; yellows mark lower land. Flathead Lake appears in lavender. Missoula lies at the confluence of the Bitterroot River and Clark Fork, which flows out of the 30-mile-long lake. Northwest of the lake is Hungry Horse Reservoir, flowing through the Flathead Range southwest of Glacier National Park.

[PAGE 74]
ON THE TRAIL

The rich land of the plains flows like a red wave toward the snow-topped Aspen Range (at far right). Lighter red indicates fields not under cultivation. Bear River cuts a crooked course around Soda Springs, Idaho, once a stopover on the Oregon Trail. Here some emigrants left the main trail and headed west to California on another trail, the Hudspeth Cutoff. Cold springs that feed the terraced pools and creeks deposit high concentrations of travertine (calcium carbonate), giving the area a unique geology.

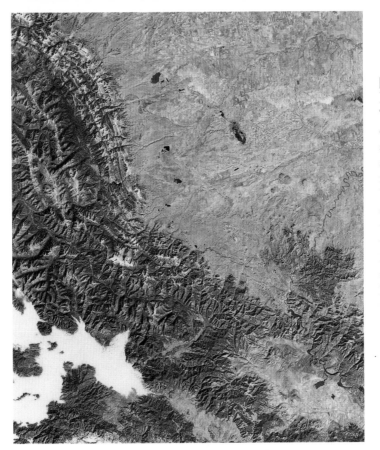

[PAGE 75 BOTTOM]
ROCKIES RIVERWAY

The meandering Missouri River cuts across the greenish plains and enters the Rockies, flowing southward into a string of lakes near Helena, a onetime gold boomtown that became the capital of Montana. Snow covers the highest mountains to the west, part of the high wall of the Rockies. Clefts in the mountains opened the way westward. Near Helena, the Missouri flows through the Gates of the Mountains, a series of canyons named by westering explorers Lewis and Clark.

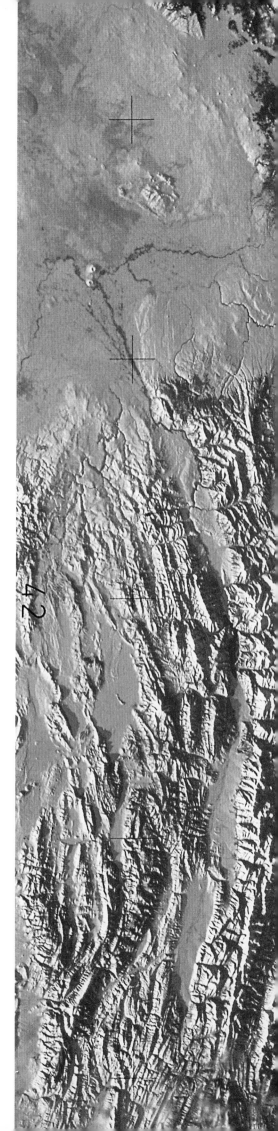

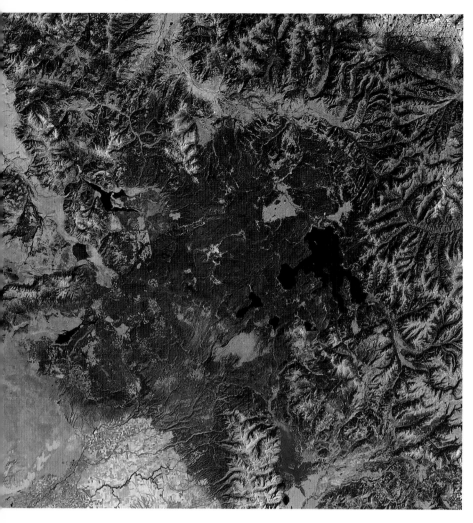

[PAGE 76]

YELLOWSTONE NATIONAL PARK

The lava plateau that forms much of Yellowstone appears dark in the center of this portrait of the world's first national park, founded in 1872. Yellowstone Lake — the largest in North America above 7,000 feet — appears like a black blot. A volcanic explosion some 600,000 years ago formed the plateau, which contains nearly two-thirds of the world's active geysers and hot springs. The Yellowstone River appears as a light blue line flowing southward from the lake. The Continental Divide, the ridge of mountains that separate rivers flowing east and west, zigzags through the park.

[PAGES 76–77]

WINTER IN WYOMING

One-third of Wyoming and bits of Idaho and Montana appear in this astronaut photo of a snow-covered western wilderness. Yellowstone National Park appears darker in contrast to the surrounding mountains. The Absaroka Range courses east of sprawling Yellowstone Lake. The Wind River Range rises along a northwest-southeast line, and the elongated Bighorn Mountains stretch farther to the east. South of Yellowstone Lake lies Grand Teton National Park and its Teton Range, which rises 7,000 feet.

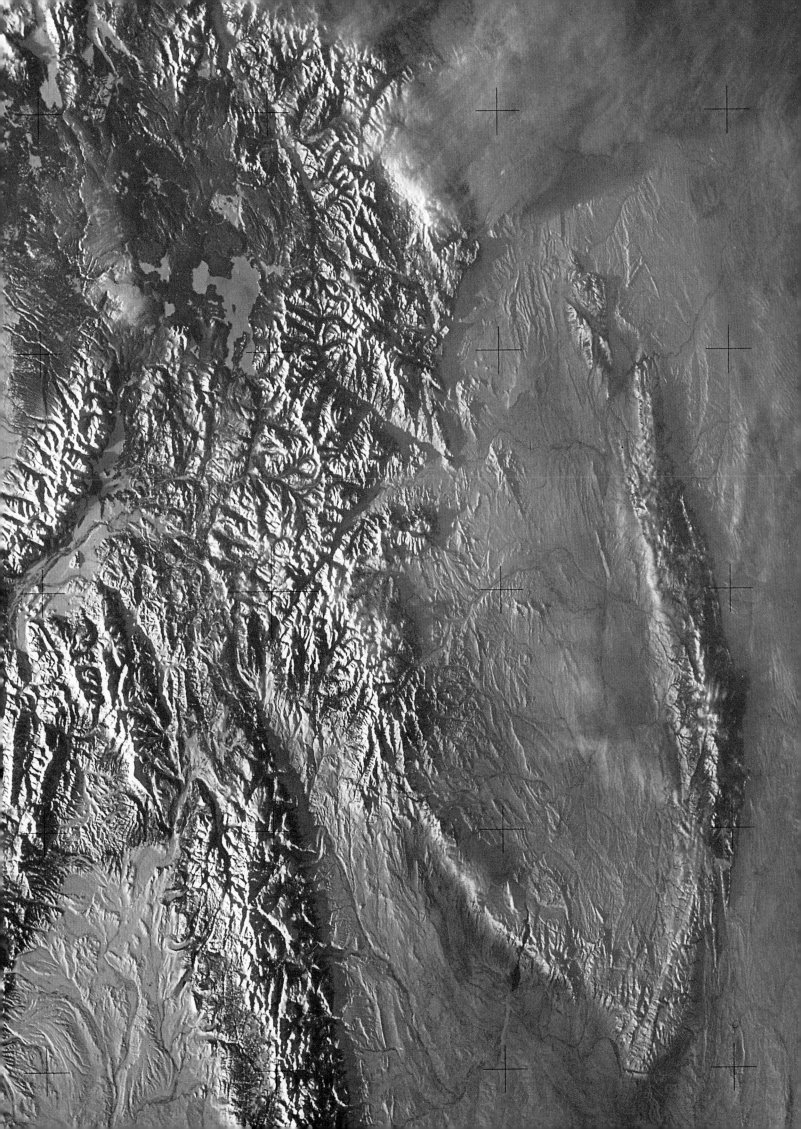

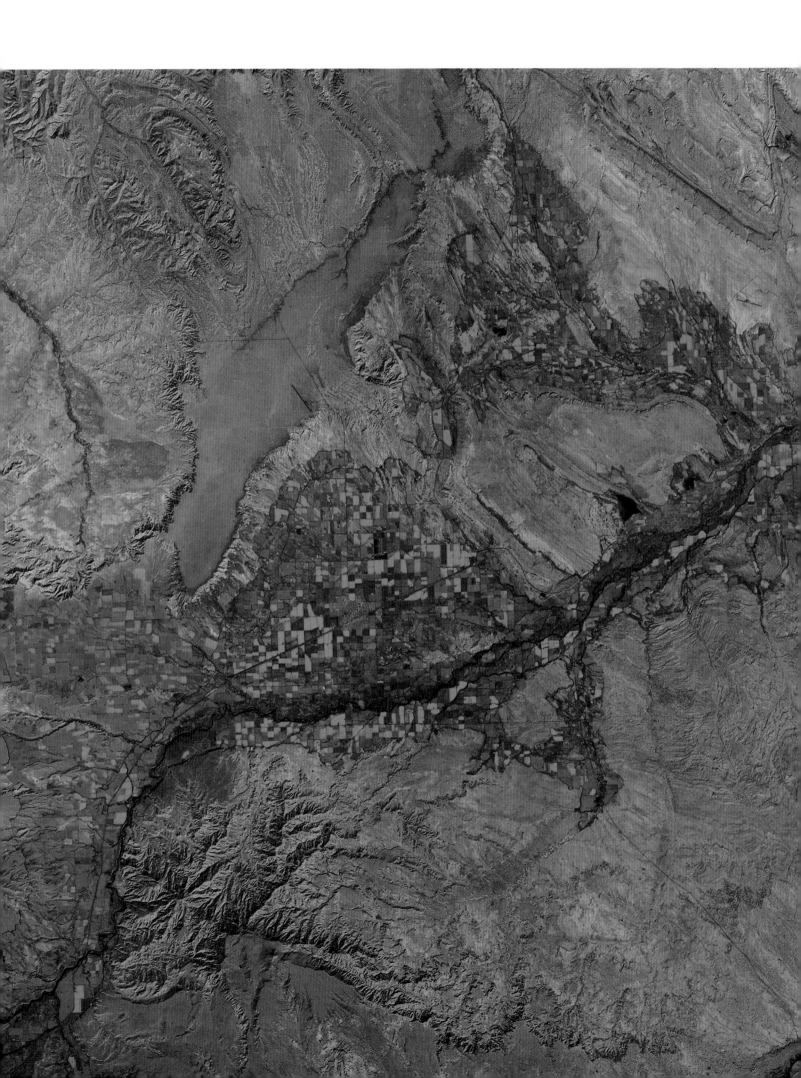

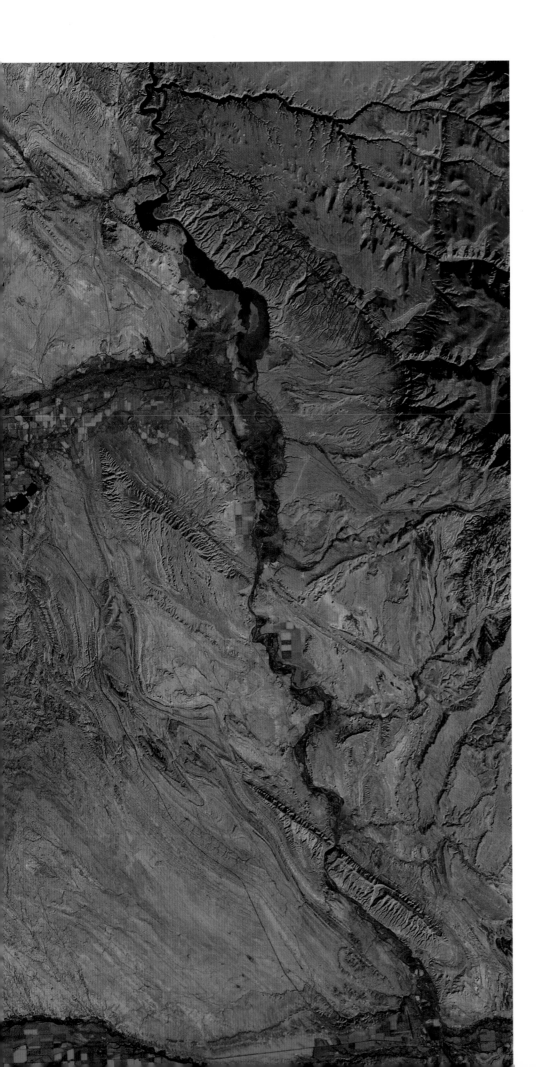

READING ROCKS
To survey geologic structures and rock distribution in Wyoming's Bighorn Basin, image-processing specialists created a view that emphasizes subtle spectral variations among exposed rocks. Earth Satellite Corp. used a format called GeoVue (see page 57) for this image of an important oil and gas area. Sheep Mountain, the long hill at the lower right, is a classic example of an anticline, a "wrinkle" in layered sedimentary rocks. A bright yellow area marks an oil field. Orange at upper left shows a mesa. Irrigated fields appear in muted shades of red, purple, and blue. Spectacular canyons etch the western flanks of the Bighorn Mountains at upper right.

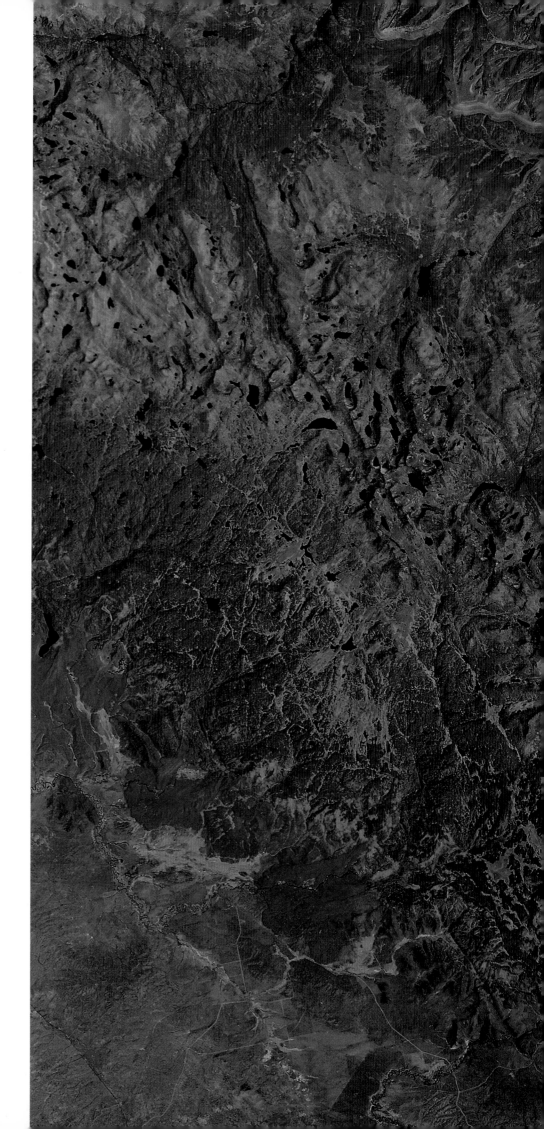

MOUNTAINS OF THE WIND

GeoVue, the image manipulation technique described on page 57, produces a line from "America, the Beautiful" by creating purple mountains' majesty. Deep purple shades indicate mountain ranges, interlayered with low-lying yellowish canyons. Wyoming's Wind River spawns a string of black-hued lakes. The soaring Wind River Range dominates a domain shaped by earthquakes, volcanoes, glaciers, wind, and water. The nation's westward expansion flowed through South Pass at the southern end of the Wind River Range.

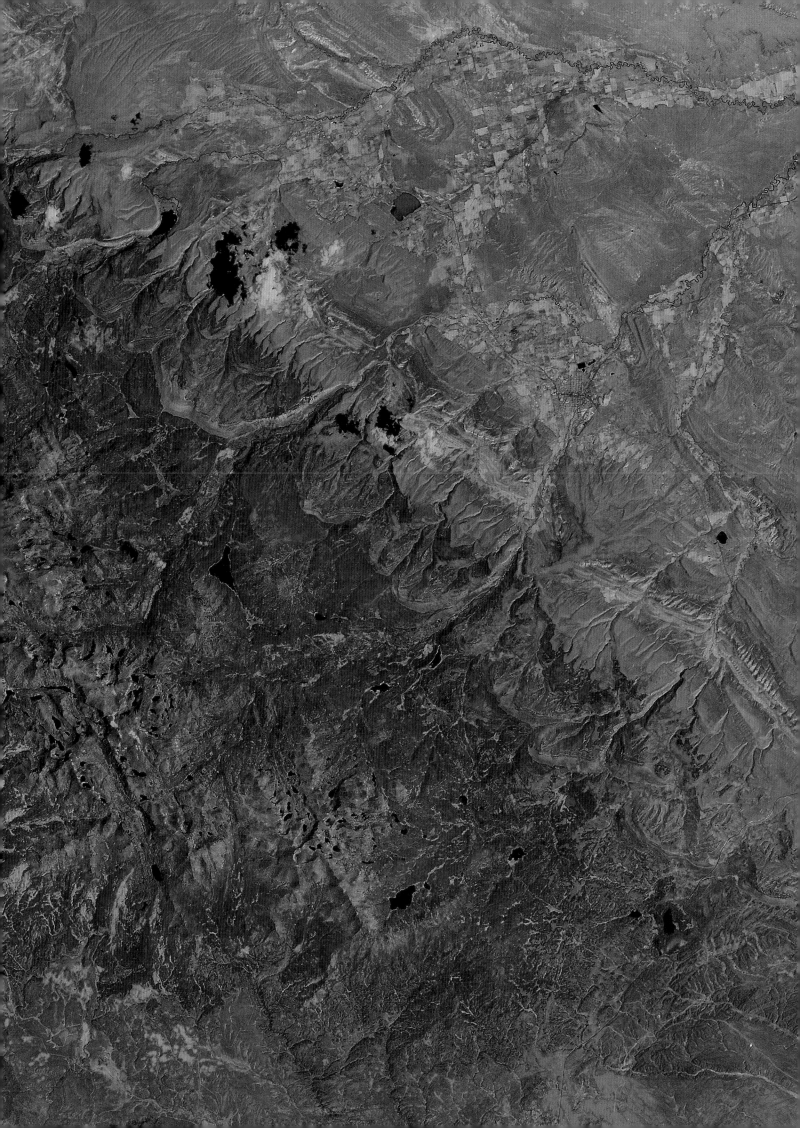

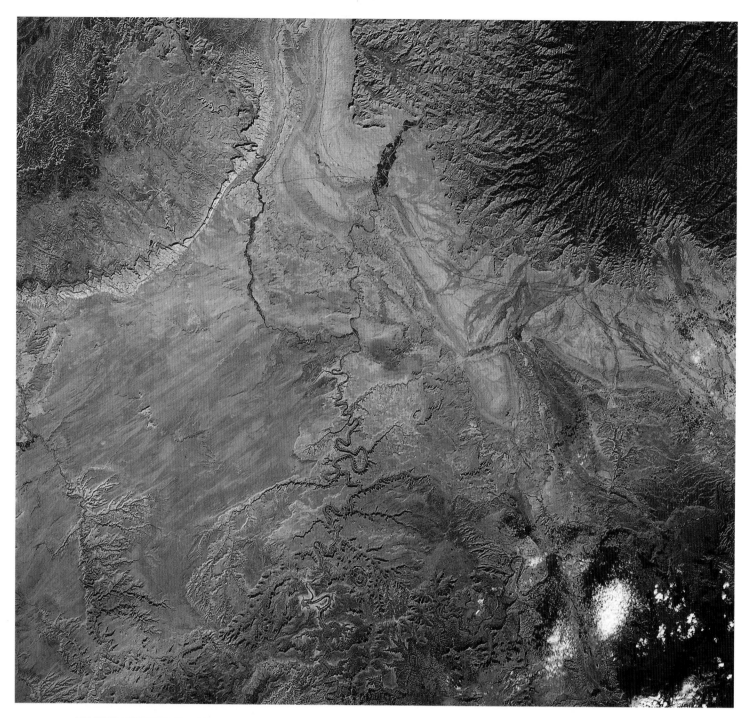

A TINTED LAND

Colors reflect the rich geology around Moab, Utah. Deep-red rocks formed in deserts 200 million years ago. Lighter rock indicates marine sediments; darker rock marks volcanic La Sal Mountains near the Colorado border. The Green River flows southward from the top to the bottom of the image. The Colorado River courses southwestward from the right center. The two rivers join in Canyonlands National Park, one of the best places in the world to see the results of geologic processes. Moab is on the Colorado near Arches National Park, a wonderland of spires, pinnacles, and giant balanced rocks, carved by eons of erosion.

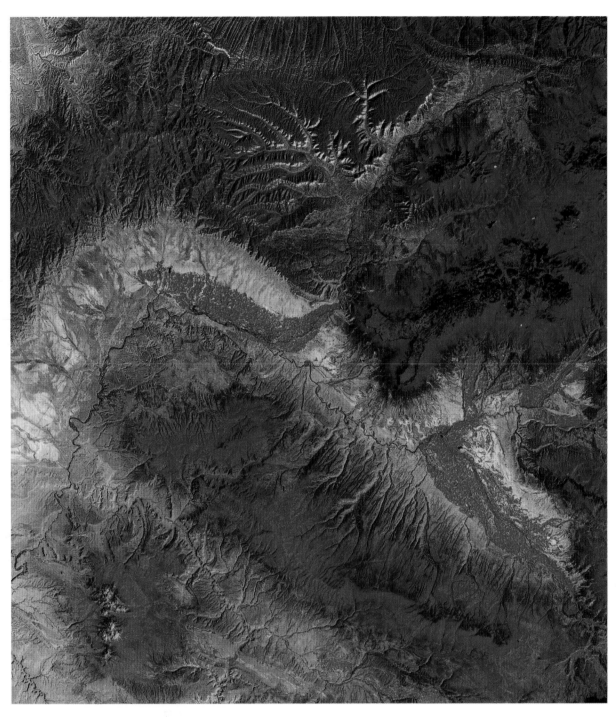

COLORADO HIGHLANDS

The Colorado River winds across the Grand Mesa, the world's largest flat-topped mountain, forming a great curve in southern Colorado. Here, where the Gunnison River meets the Colorado, is the site of Grand Junction, a frontier trading post that became a key water distribution center. The irrigation system created a farming region, shown as a red arc paralleling the curve; a red patch downstream also indicates farmland. As the Colorado twists off to the west, at the lower left side of the image, it crosses into Utah.

ROCKY HAVEN

A vast gray area, laced by red-shaded springs, marks a place in the Rockies that has long drawn people. Ute Indians had their summer hunting grounds here. Mountain men trapped for furs here in the early 1800s. Pioneer families began arriving in 1875, the year before Colorado became a state. They named their town Steamboat Springs because the spring's chugging sound reminded them of a steamboat. Now skiers enjoy the slopes and muscle-soothing hot springs.

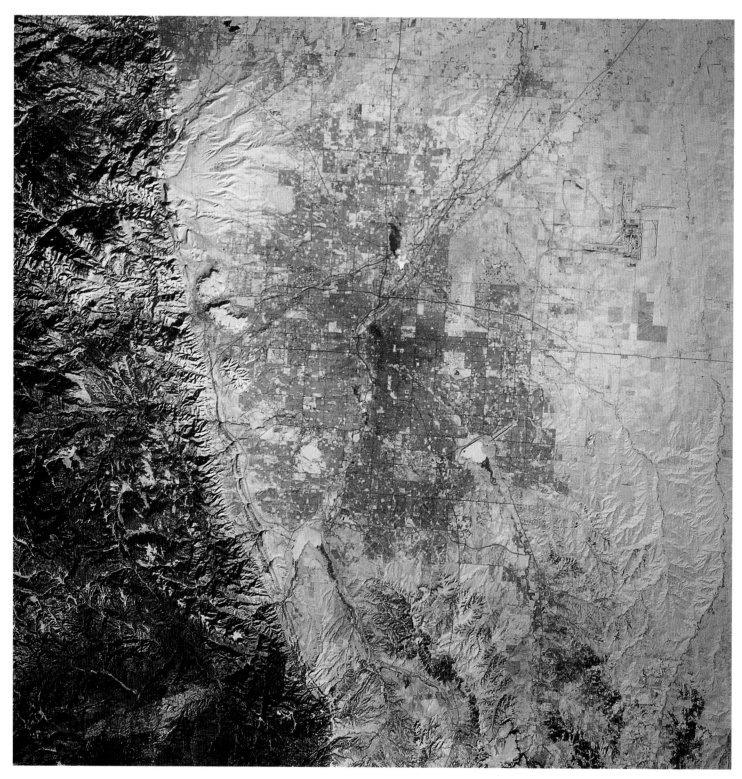

ROCKIES WHITESCAPE
Snow blankets Denver and the foothills of the Rockies in this astronaut photo of the "Mile High City." Denver International Airport appears in the right corner; below it and to the left are the snow-covered runways of the closed Stapleton Airport.

Due west of Denver and against the Rockies is Golden, a gold mining camp that became a city. Northwest of Denver is Boulder and to the northeast is Brighton, on the South Platte River.

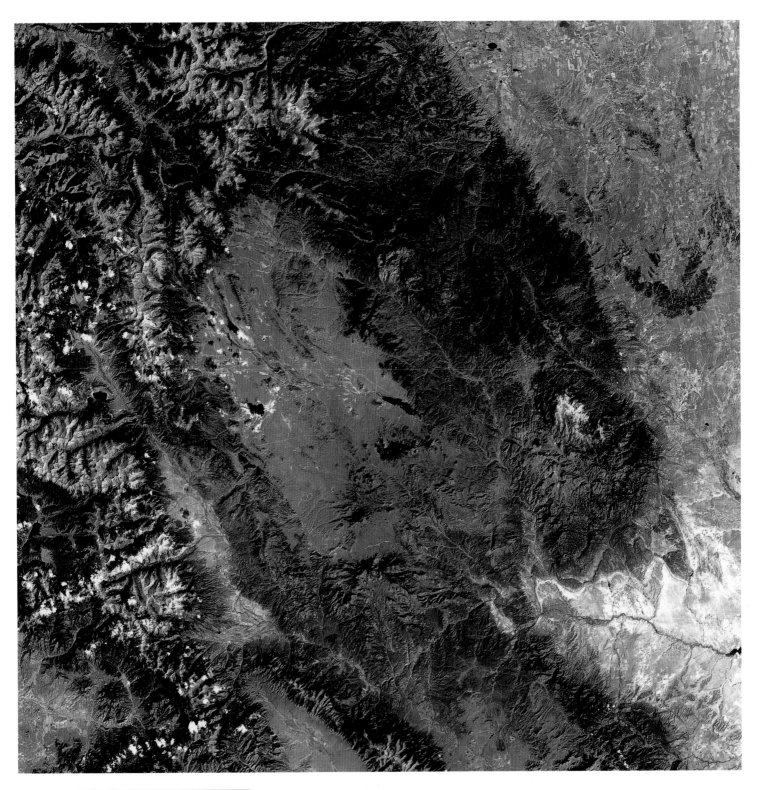

HEART OF THE ROCKIES

Mountains 7,000 to 14,000 feet high enwrap this corner of Colorado. Pikes Peak, the snow-glazed mountain at right center, rises 14,110 feet; it was named for its discoverer, U.S. Army Captain Zebulon Pike. East of the peak a red cluster marks Colorado Springs; another cluster to the south marks Pueblo on the Arkansas River. Farther west along the river is Salida, which is surrounded by the Collegiate Peaks to the west, the Mosquito Range to the east, and the Sangre de Cristo Mountains to the south.

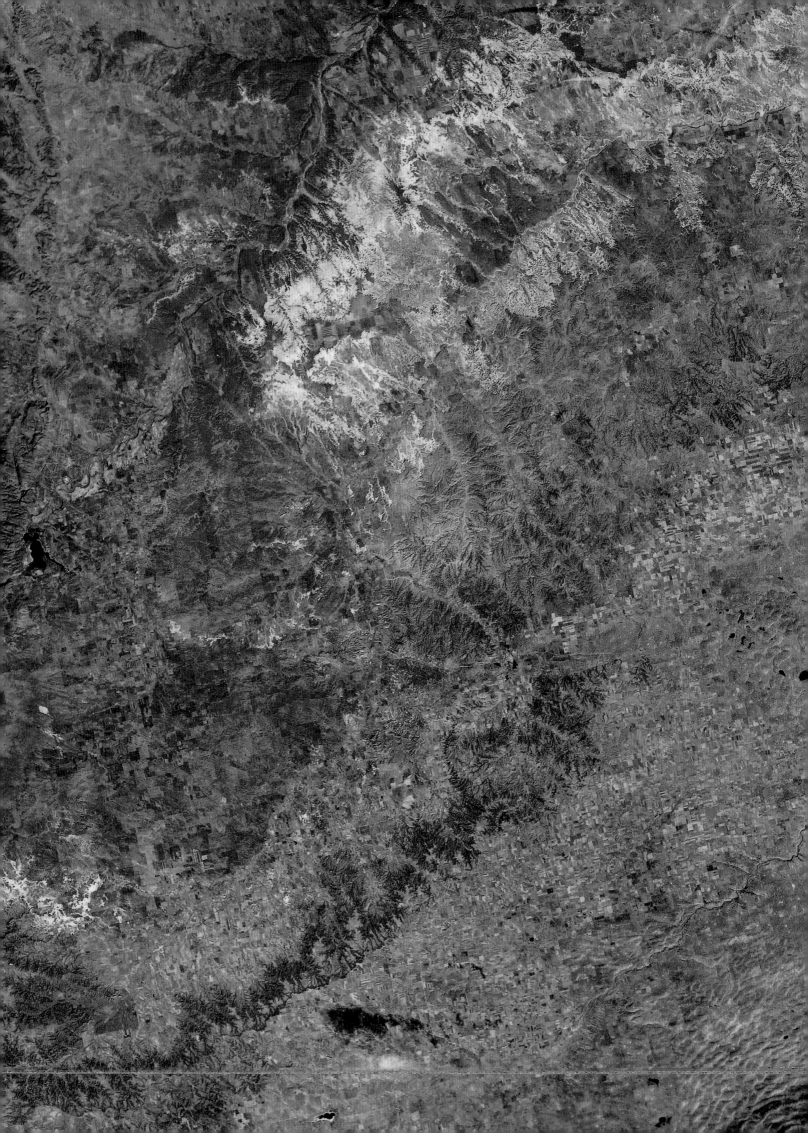

The Heartland

WHAT WE NOW call Middle America — the Heartland — once was the Wild West, the home on the range for cowboys and cattle rustlers, marshals and stagecoach robbers. Here was wicked Dodge City and quick-on-the-draw Deadwood, the home of Calamity Jane and the town where Wild Bill Hickok was killed at a poker table. General George Armstrong Custer called this land "the fairest and richest portion of the national domain," and he probably would have lived a longer life if he had stayed here. But he moved westward to his fate, and so did the frontier.

Across the lone prairie, heading ever westward, went the Oregon Trail, the Pony Express, the cattle trails, the railroads. To the traders, explorers, pioneers, and railroad builders, this was the portal to the west. They are remembered today by the Gateway Arch, a gleaming stainless steel memorial that soars 630 feet above St. Louis.

In frontier days, the Great Plains were called the Great American Desert, a place rarely touched by road or town. Today, towns still are fewer here and spaced farther apart than anywhere else in the nation.

To geologists, the Great Plains cover about 1.125 million square miles, stretching from the Rio Grande into arctic Canada. To most people, the plains are flatlands stretching west of the Mississippi River through Oklahoma, Missouri, Kansas, Iowa, Nebraska, and South and North Dakota.

But the Heartland is not entirely flat. Kansas, usually thought of as tableland, slopes upward from sea level, beginning at about 700 feet and rising to 4,000 feet. From the flood plains of the Mississippi River, the land tilts up to the woodlands in the realm of the Great Lakes and westward to mile-high rangeland at the edge of the Rocky Mountains.

Pioneers found a land that defied the plow. They had to break a sod so thick and matted with roots that it sometimes took two years before the land could be tilled. But the pioneers were hardy and patient, and they knew what riches this land held. (Of all the U.S. topsoil rated as the best, about 25 percent is spread across Iowa.) In dry soil, where short buffalo grass grew, wheat could thrive. Where tall grass grew, the Corn Belt was born — a fertile span from western Ohio to eastern Nebraska. U.S. farmers grow one out of every four bushels of corn grown in the world, and most of that corn comes from the cornucopia called the Heartland.

INDIAN COUNTRY

In the Badlands at the southwest corner of South Dakota, a stain of white shows why this region got its name: washed-out clay in parched hills that offer little chance for farming or grazing. Here, at Wounded Knee, U.S. troops massacred Sioux in 1890. Today, on the 2-million-acre Pine Ridge Indian Reservation, live about 25,000 people, mostly Sioux and Lakota. Irrigation lines, visible along the lower edge of the image, provide water to farms and rangeland, indicated by stretches of red.

[PAGES 90–91]

FARMLAND FORT

Rich Kansas farmland covers an image laced by small rivers and creeks near Fort Scott, named in honor of General Winfield Scott. The fort, established in 1842 to protect the "Permanent Indian Frontier," became one of the largest cities in eastern Kansas. Pinks, reds, and greens indicate varying crops and harvest stages in this fall portrait of the countless grids of Kansas. West of the Mississippi River, land was laid out by grids, a development pattern not found in the east.

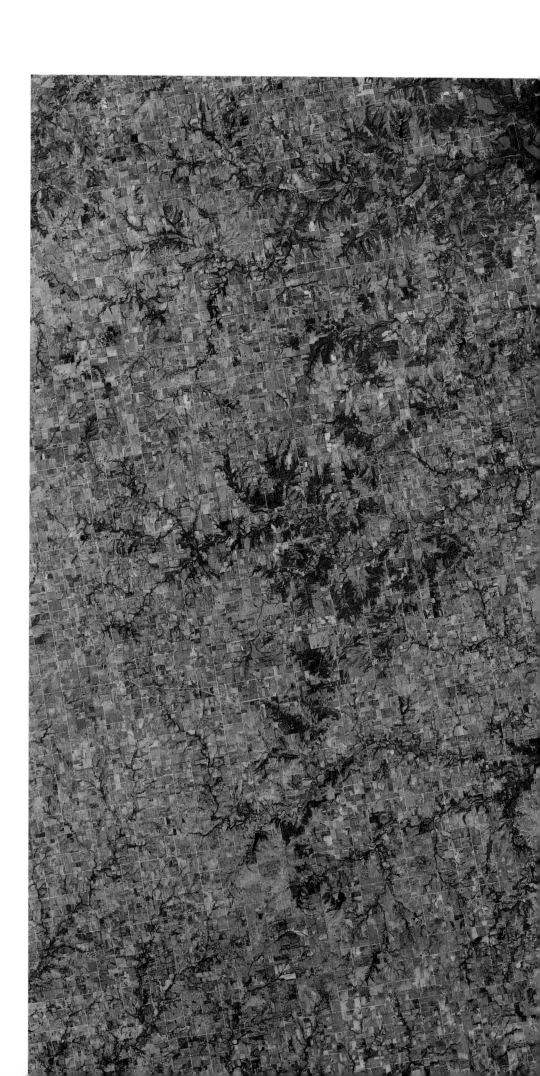

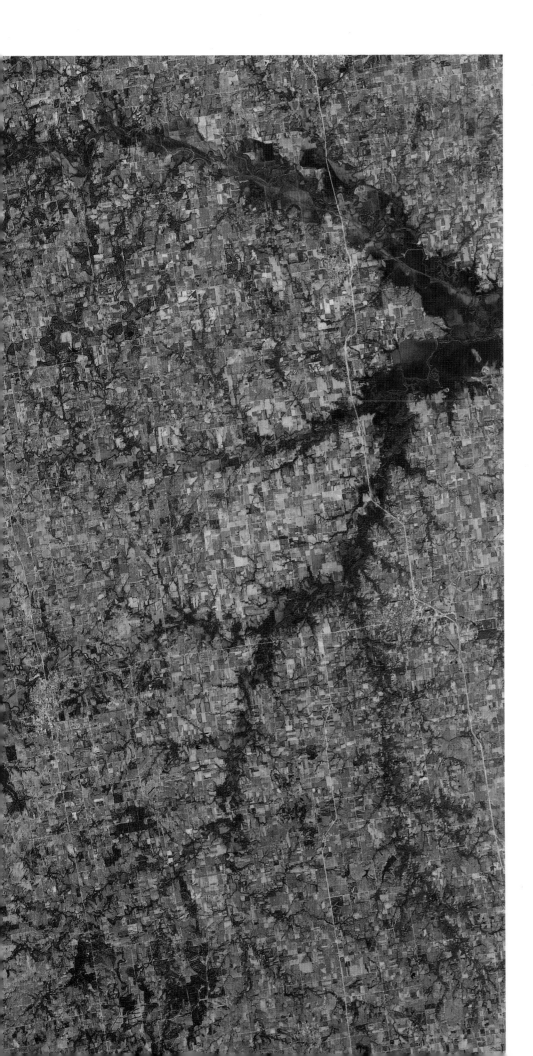

[PAGES 92–93]

SWIRLING OKLAHOMA
Tightly coiled ridges of the Ouachita Mountains whirl around Antlers, Oklahoma, a small town in the midst of a region checkered with farms and ranches. The jagged Kiamichi River cuts into the ridges. The mountains, 1,000 to 2,800 feet high, are deeply folded layers of sandstone, shales, and slate. Millions of years ago, sand and silt eroded from rocky outcroppings and were washed into rivers. Muddied with sediment, they emptied into what was a shallow sea. Sandstone and shale formed from the sediment and became the backbone of the rising mountains.

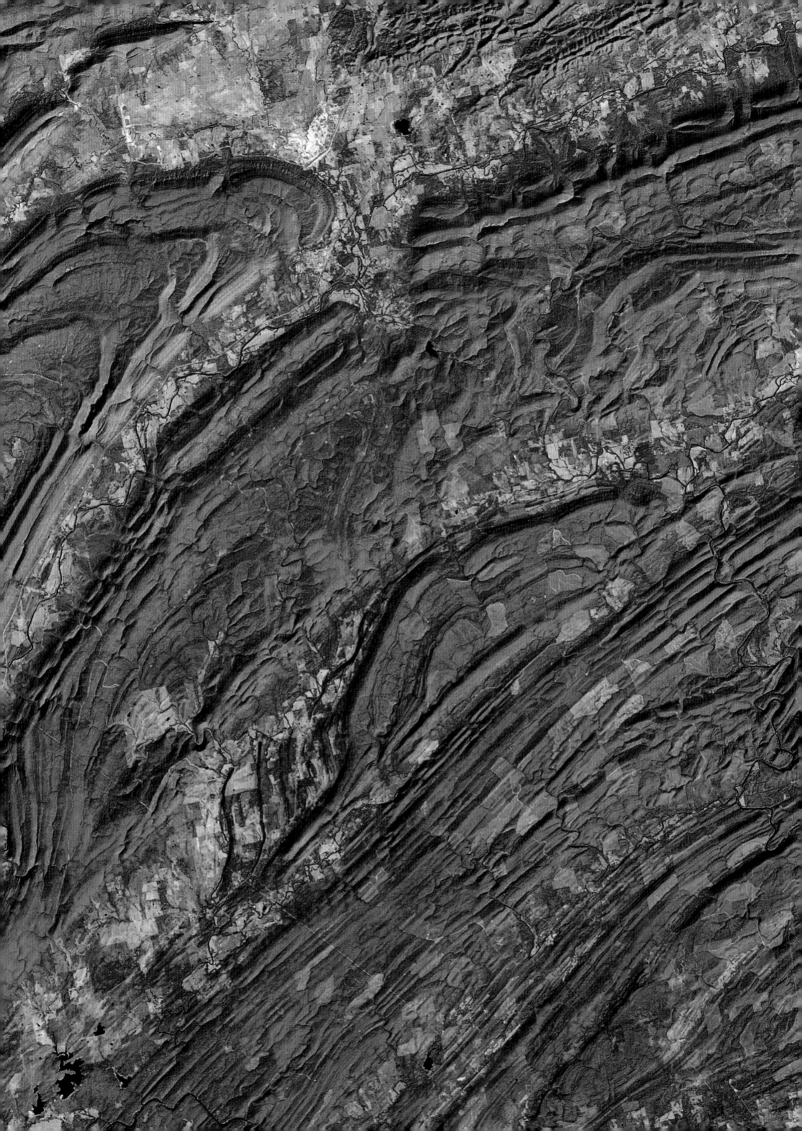

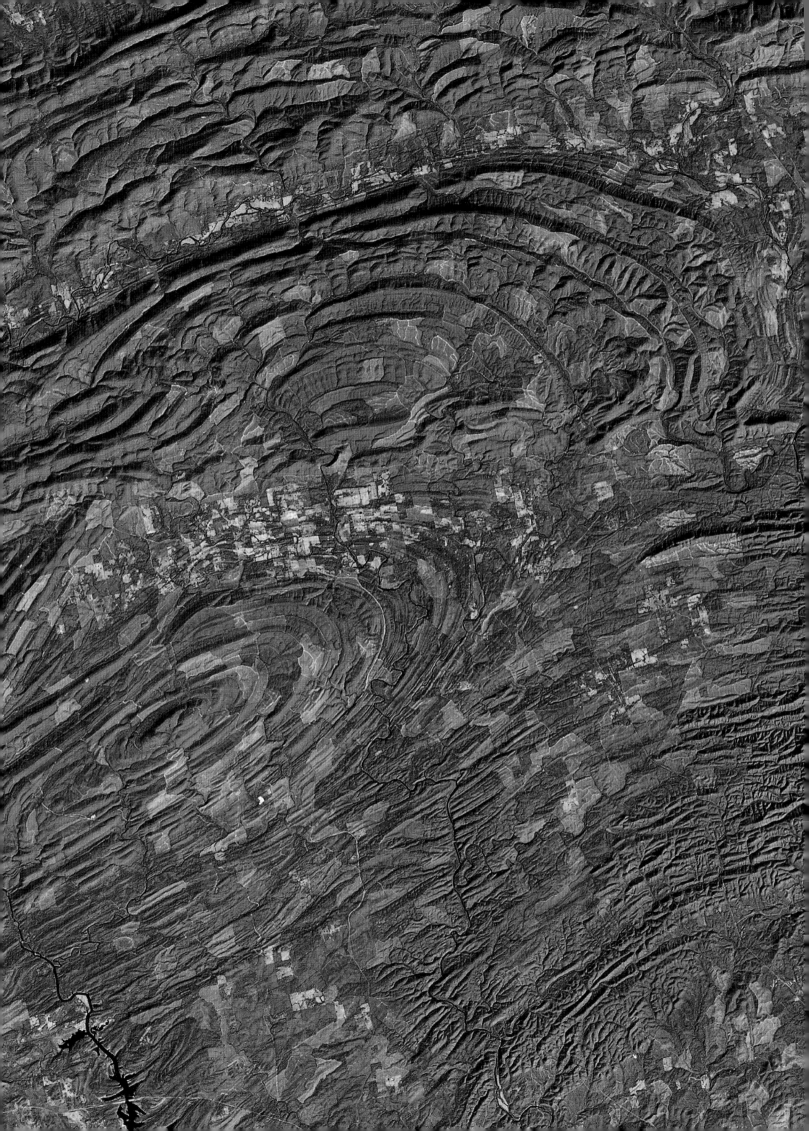

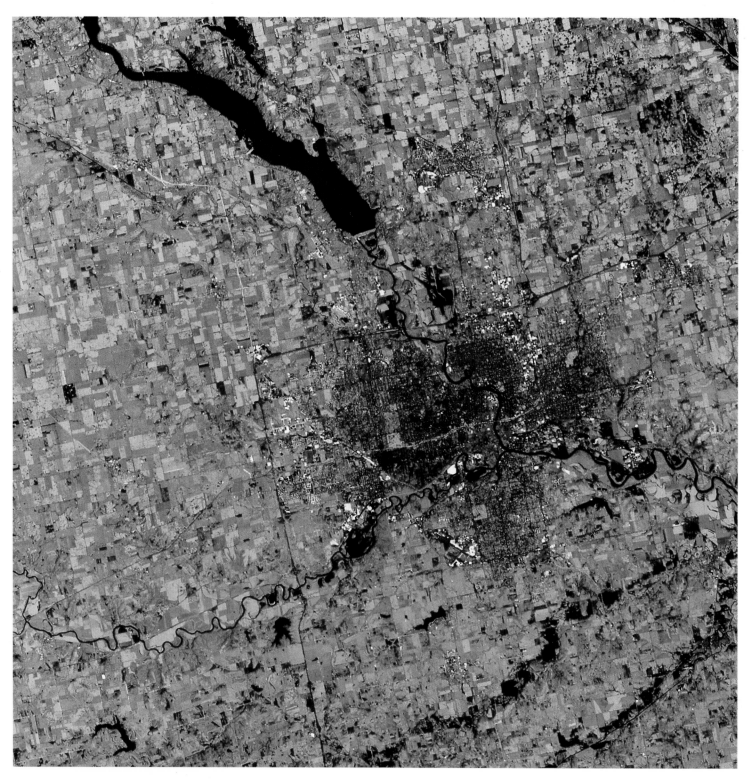

DES MOINES

Iowa's capital and largest city appears blue-gray on an immense checkerboard of cornfields. Interstate highways run arrow-straight through Des Moines, one heading north-south, the other east-west. The city lies on the Raccoon River and the Des Moines River. To the north of the city is Saylorville Lake, created by the U.S. Army Corps of Engineers as part of a flood-control project. The city may get its name from the mound-building Indians who once lived in the area and called the Des Moines River "Moingona" River of the Mounds.

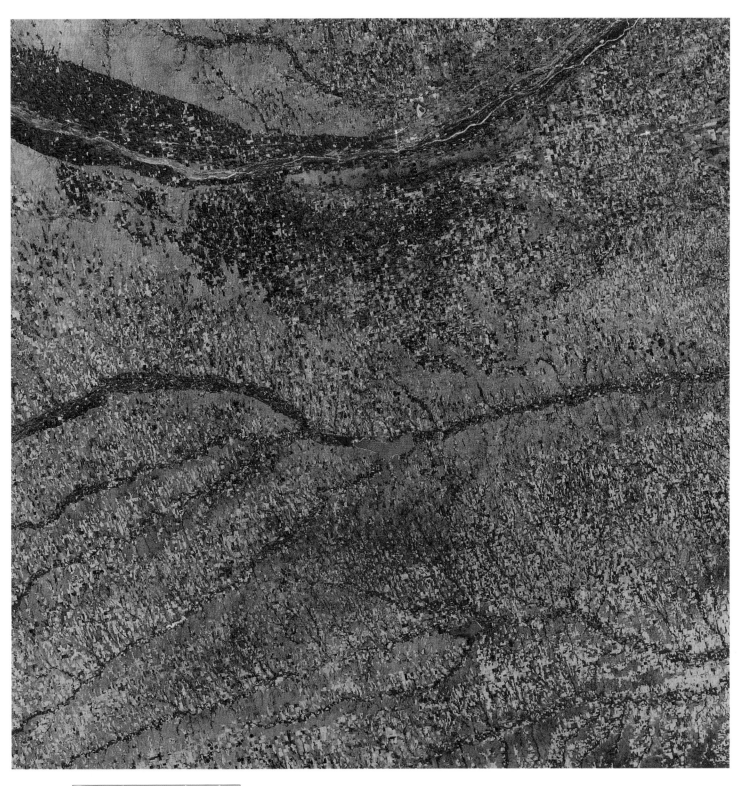

IN ANOTHER SPECTRUM

The Platte River swoops across a
Nebraska landscape shown in
unearthly colors because of a
manipulation of satellite data.
The false spectrum reduces the
effect of sunlight and, by
enhancing contrasts, gives
geologists clues to the land's
composition. Verdant meadows,
shown in purple, border the great
curve of the Platte, which
both the Oregon Trail and the
Mormon Trail paralleled. Rich
prairie land appears in yellow and
green, depending upon the state of
fall harvest. South of the Platte,
the Republican River courses
through Harlan County Lake.
Farther south roll the well-
watered farmlands of Kansas.

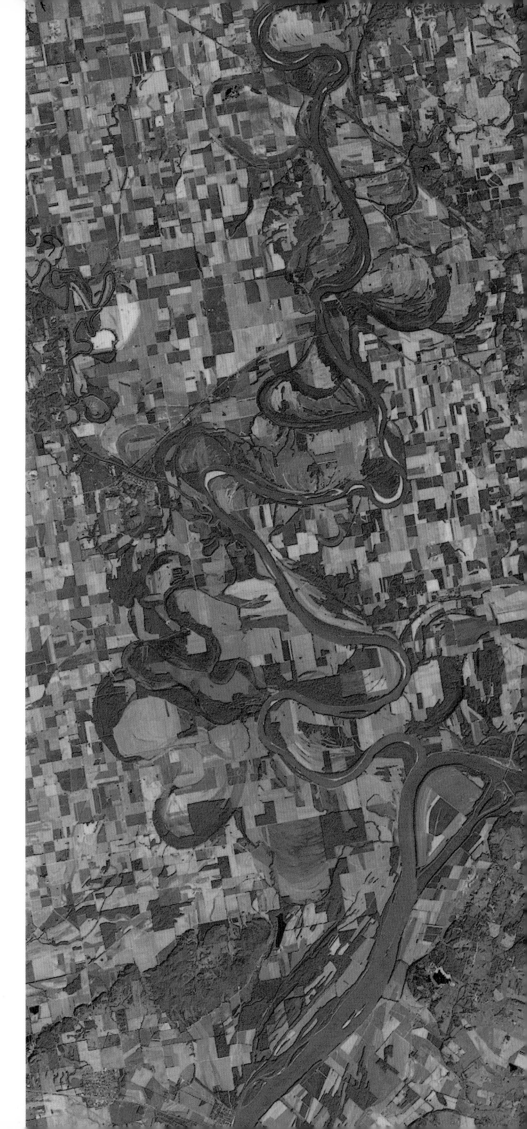

RIVER-FRAMED LAND

On a sharp curve of the Ohio River sits Evansville, Indiana, economic and social hub of a region that reaches across the river to Kentucky. Loops — some shaped like U-turns, others like question marks — contain rich farmland created by river silt. Farms are squared off by well-tended boundaries. Some plots show the red of growing crops; varying shades of green indicate land not yet tilled or in early stage of growth. The sinuous Wabash River, flowing at left, marks the Indiana-Illinois border; the Ohio separates Indiana and Kentucky.

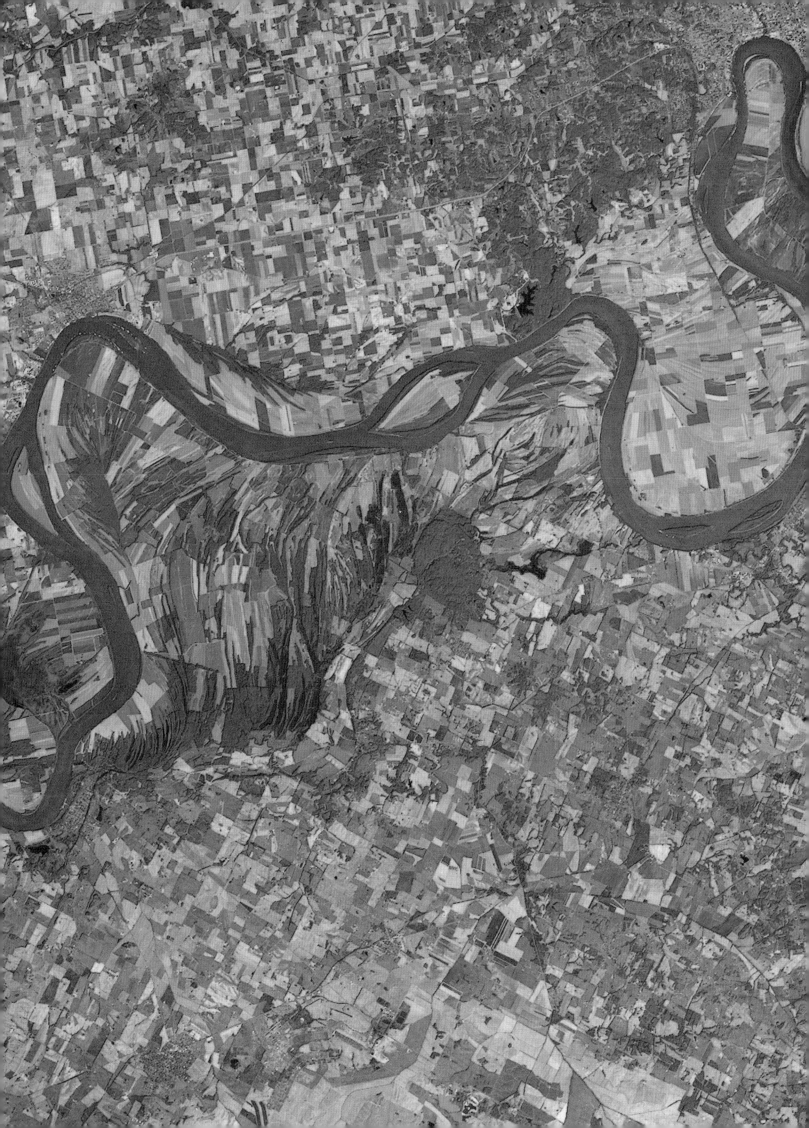

[PAGE 98 AND PAGE 99]

RIVERS MILD AND WILD

In a graphic demonstration of satellite flood monitoring, these two images show St. Louis dry and catastrophically wet. The city (shown in a drought year) lies at the confluence of the Mississippi River, at top, and the Missouri River, just below. The rich land between the rivers is heavily farmed. Periodic flooding lavishes new soil — but major flooding, surging across the flat land, can be devastating. In the 1993 flood shown here, 50 people died, livestock herds were wiped out, and the area suffered more than $10 billion worth of damage to property and crops. Satellite images of flooding buttress arguments for restoring wetlands along river paths so that the natural flood plain keep heavy rains from suddenly washing into rivers and causing overflows.

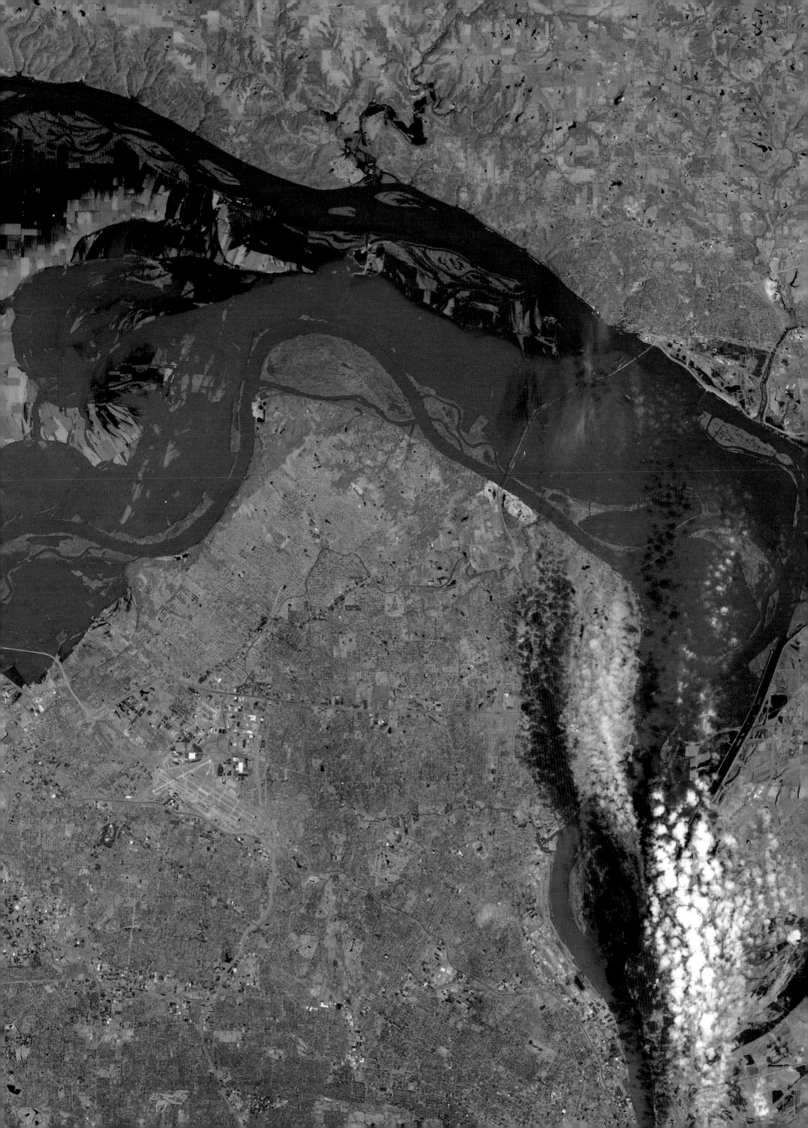

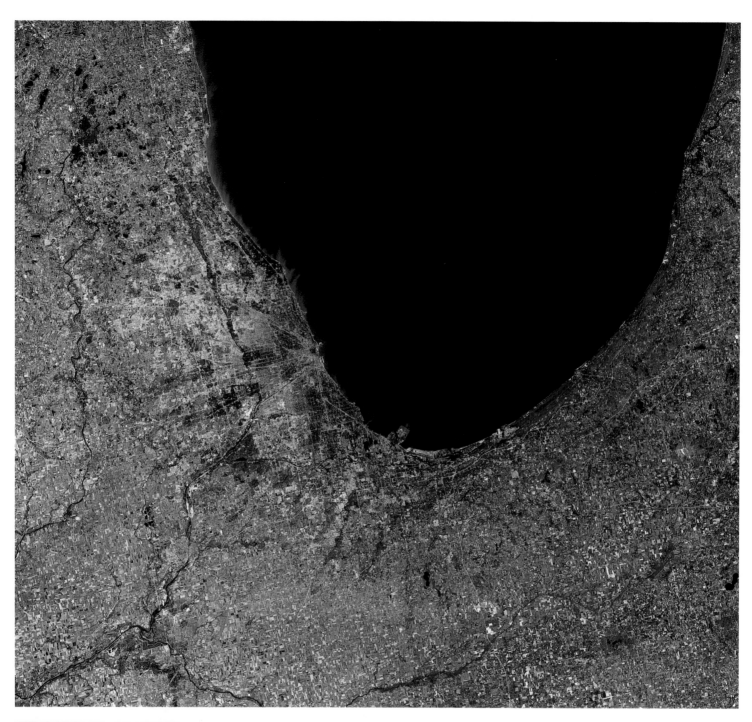

CHICAGO

The third largest city in the United States, Chicago shows itself as a wide, blue band along the densely-populated southern shore of Lake Michigan. Since the railroad- and canal-building days of the 19th Century, Chicago has been one of the nation's leading commercial and transportation centers, largely due to geography. The city, spreading nearly 30 miles along Lake Michigan, radiates out from the mouth of the Chicago River, which splits and enters a complex of canals. These waterways tie Chicago to the Illinois and Mississippi Rivers and make the city a commercial link between the Mississippi Valley and the Great Lakes. Growth spurred by Chicago's economic clout made the city the center of a metropolitan area encompassing three states — from Kenosha, Wisconsin, to Gary, Indiana, which appears at the tip of the lake in this image. The blue line snaking southwestward from the lake is the Des Plaines river. It joins the Kankakee river, which zigzags across Illinois and Indiana and some of the richest farmland in the United States.

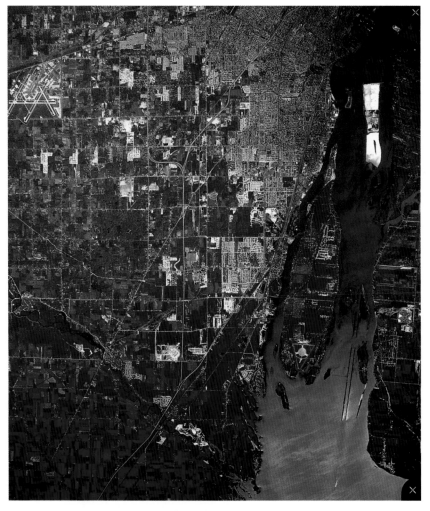

URBAN PORTRAIT
A closeup from 59,000 feet reveals the differing population densities of Detroit, Michigan, and neighboring Windsor, Ontario. The cities face each other across the Detroit River, which flows southward into Lake Erie, at bottom right. Detroit's population of about one million is some ten times that of Windsor, a port of entry linked to Detroit by bridge and tunnel. The image encompasses southwestern Detroit and suburban Lincoln Park and Wyandotte. The largest island is Grosse Ile.

A STUDY IN COLORS
Satellite imagery changes nature's colors in a composite image of the land dominated by the Detroit-Windsor urban area. Healthy crops and trees appear in varying shades of orange or pink; suburban areas with sparse vegetation are light pink; barren areas are shown in light gray; urban and industrial areas are dark gray. The St. Clair River and the lakes — Huron at upper center, St. Clair in center, Erie at lower center — appear in shades of blue. Toledo, Ohio, is at the lower left on the shore of Lake Erie.

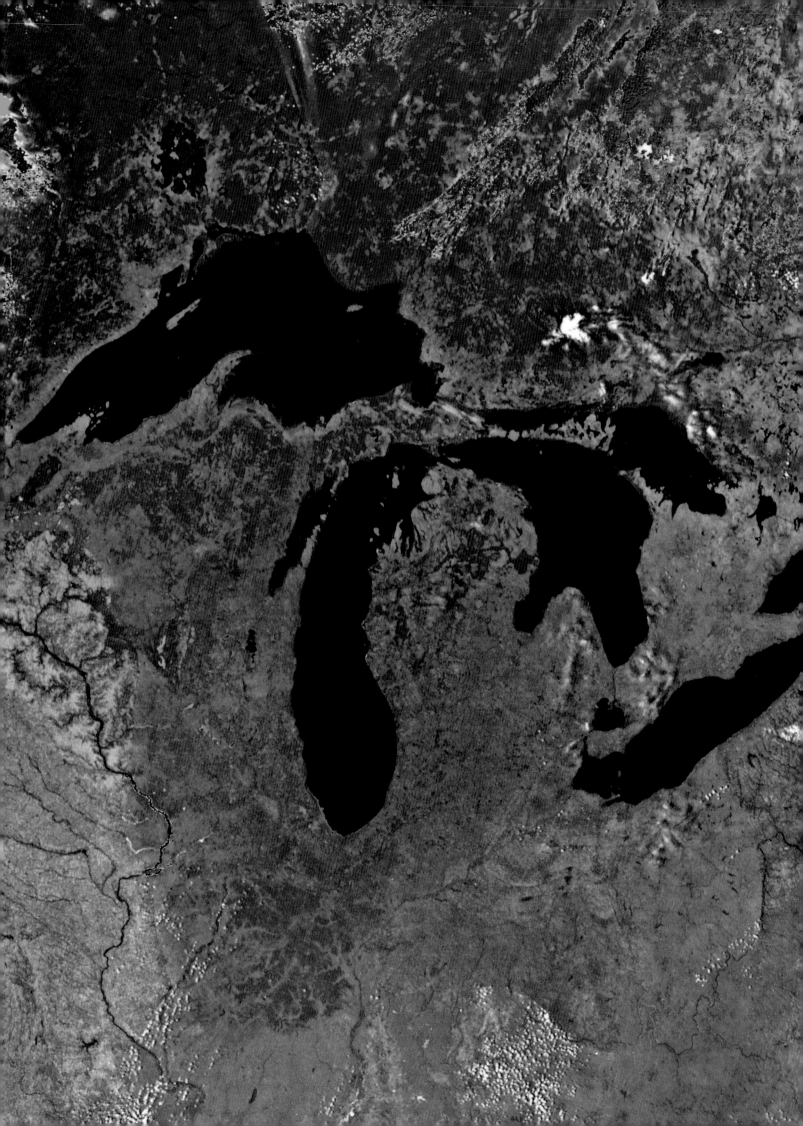

The Land of Lakes

WE CAN THANK Ice Age glaciers for thousands of lakes that glisten in the landscape of North America. Nearly half of the world's lakes are in Canada. Thousands of other glacier-formed lakes are south of the border, particularly in Minnesota, Michigan, Wisconsin, and other northern states once crushed under tremendous burdens of ice.

When glaciers coursed down the continent, they scoured hard rock. In weaker rock the glaciers scooped out huge basins that became lake beds. Sometimes the glaciers' load of rock and soil was so massive that the debris blocked former river valleys, producing yet more lakes. As glaciers began to melt, the water was trapped in river valleys that had been dammed by glacial rubble.

Glacial scars still can be seen along Lake Superior's granite shore, reminders of the ice that scraped through the area as recently as 14,000 years ago. As the glaciers melted, the released water filled much of Lake Michigan and portions of Huron and Erie. When the lake-making era ended and the glaciers began their slow withdrawal, the glaciers left behind ridges formed by the glaciers' burdens — heaps of boulders or other debris called moraines.

The Great Lakes formed the pathway for explorers who could reach the center of the continent by canoeing up the St. Lawrence River and then portaging and paddling though the wilderness. After the explorers, the first settlers came and carved rich farmland out of this watery realm. Next were the entrepreneurs who saw the lakes as an American Mediterranean. Steel magnates used the lakes to haul the iron ore of Minnesota, Wisconsin, and Michigan to Pittsburgh and Detroit steel mills. Coking coal for making steel came by railroad from Pennsylvania, West Virginia, and Kentucky.

Upper Michigan's Keweenaw Peninsula contributed copper just when the new marvel of electricity needed copper wiring to power and light the nation. The cities of the lakes forged railroad links to the farmlands of the Midwest and the South. Out of this hardworking region has come more than 20 percent of the nation's worth in farming, mining, and manufacturing.

The Great Lakes cover nearly 95,000 square miles. Lake Superior is the deepest as well as the largest. Lake Ontario, at 7,340 square miles, is the smallest, and Lake Erie, with an average depth of 62 feet, is the shallowest. Lake Huron has the longest shoreline. From Lake Superior in the west to Lake Erie and Lake Ontario in the east, the lakes form a natural boundary between the United States and Canada. Only Lake Michigan lies wholly inside the United States.

THE GREAT LAKES

The largest cluster of freshwater lakes on Earth, the Great Lakes cover much of this image of deep waters and fertile lands. Three — Superior, Huron, and Michigan — rank second, fifth, and sixth in size among the Earth's lakes. Michigan's Upper Peninsula thrusts into Lake Michigan on the left and Lake Huron on the right. The thread of water entering Lake Ontario at the far right is the St. Lawrence Seaway, the lakes' artery to the Atlantic Ocean.

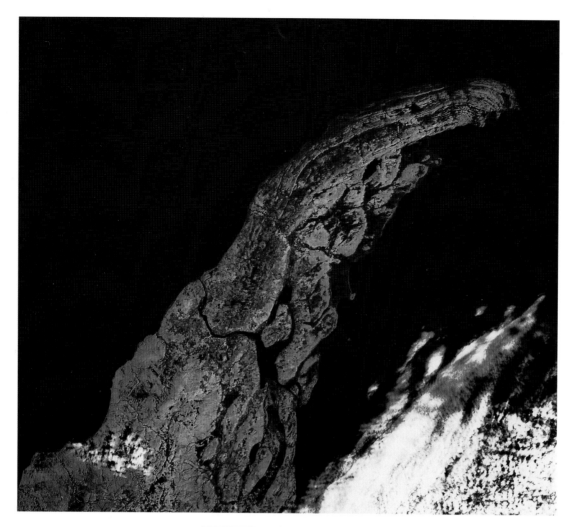

[PAGE 104]

COPPER COUNTRY

Coppery tones symbolically highlight the wealth of Upper Michigan's Keweenaw Peninsula, jutting into Lake Superior. On the peninsula is the only place in the world containing commercially abundant quantities of pure, native copper. Here is the oldest metal-mining heritage in the Western Hemisphere, dating back 7,000 years. Some mine shafts here are more than 9,000 feet deep. In this image, thematic sensors produce false colors to emphasize the folded terrain.

[PAGES 104–105]

LANDS AND LAKE

Clouds streak across the upper reaches of Lake Michigan and Wisconsin's Green Bay, an arm of Lake Michigan. Jutting into Lake Michigan is Door Peninsula. Opposite is Grand Traverse Bay, with Traverse City at the southern end of the bay's west arm. Along the eastern shore of the lake is Dunes National Lakeshore, where shifting sand dunes reach 400-foot heights. Green Bay, founded in 1634 as a French trading post and mission, was the gateway to the French domain that became America's upper Midwest.

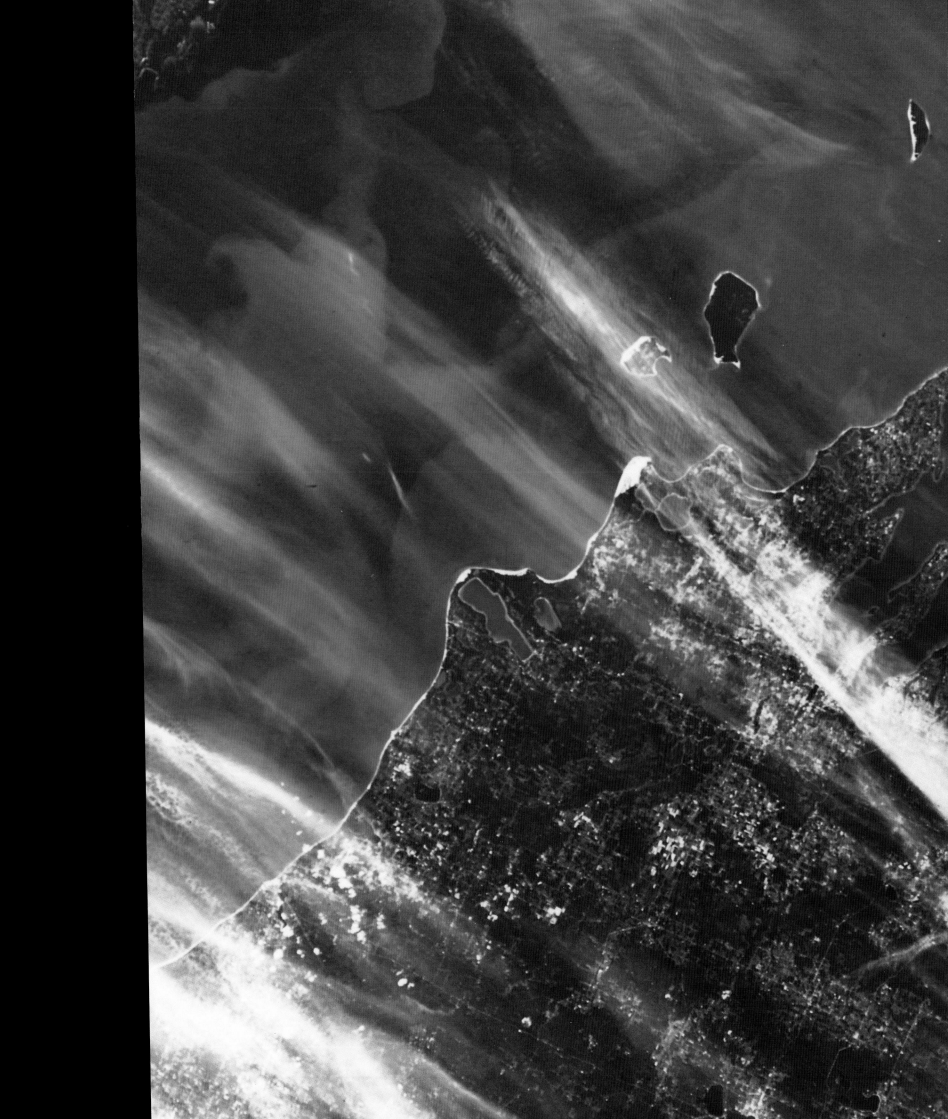

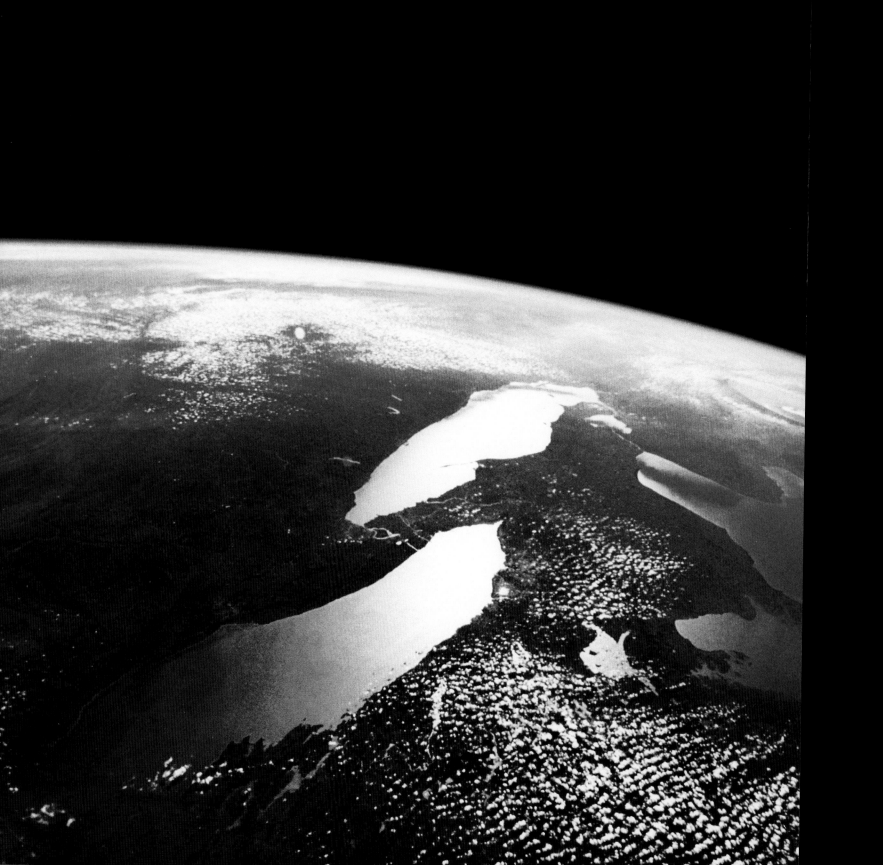

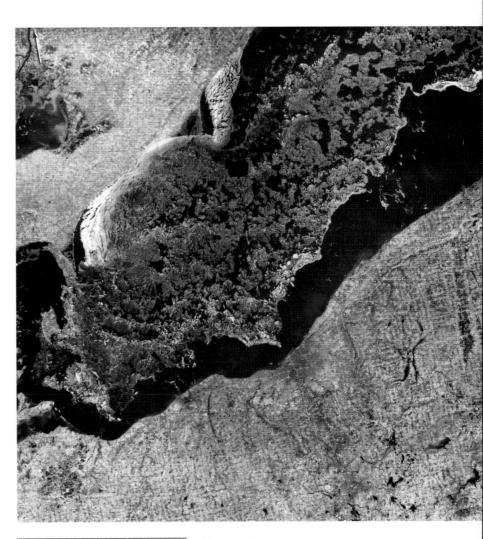

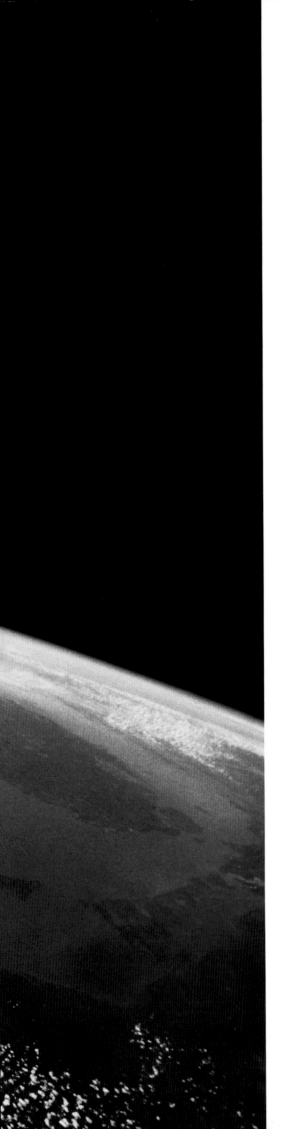

[PAGES 106–107]
GREAT VIEW, GREAT LAKES

In a panorama that goes beyond the blue horizon to the curve of the Earth, a Space Shuttle photo encompasses all of the Great Lakes. In the foreground is Lake Ontario. Just below the center of the photo, the glint of the sun illumines the area around Niagara Falls, the thundering tourist attraction on the U.S.-Canadian border. Detroit and its suburbs sprawl across the thrust of land visible just above the center.

[PAGE 107]
SPRING FLOWS IN

March brings the first stirrings of spring to Lake Erie. Much of the ice in the center of the lake has melted, but sheets and slabs of ice stubbornly blanket much of the black water. On the Canadian (upper) and U. S. sides of the lake, suburban areas appear as light pink, barren lands as light gray. The Cleveland metropolitan area fans out from the lake shore. The Cuyahoga River flows past Akron, Ohio, then turns abruptly northward through Cleveland as it empties into Lake Erie. Winter's desolate look still holds the land, which shows the grid of township and farmland. Narrow bands of trees — beech, maple, oak, and ash — show up as borders between neighboring farms.

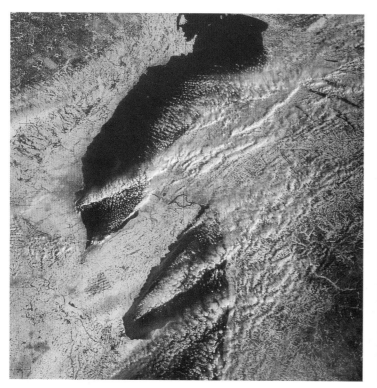

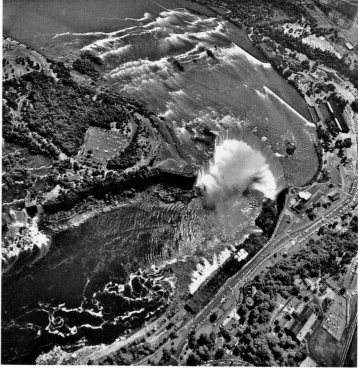

[PAGE 108 LEFT]
NIAGARA SNOWFALLS
With Niagara Falls as the hub, a huge part of lake country appears in this oblique view that has Lake Erie in the foreground and Lake Ontario in the background. The snow-covered scene includes portions of Pennsylvania, New York, and Ontario, Canada. Etched on the chill landscape are streams, rivers, and roads. Buried under the layers of clouds and snow are the streets of two major cities: Toronto and Buffalo.

[PAGE 108 RIGHT]
NIAGARA FALLS
An infrared photograph from 2,500 feet sharpens the image of the mighty Niagara Falls. The Niagara River view is southward. The land at right is Ontario, Canada, and the land at left New York's Goat Island, which divides Niagara Falls into American Fall and Canada's more spectacular Horseshoe Fall, churning water on the right. American Fall is 1,000 feet across and drops 167 feet; Horseshoe Fall measures 2,600 feet across and drops 162 feet. The falls move back as much as four feet a year as the torrents, tumbling over a shale lip, wear it away.

[PAGE 109]
BUFFALO
Under scattered clouds, Buffalo, the Queen City of the Great Lakes, reigns at the eastern end of Lake Erie. The Niagara River, center, flows out of the lake. Densely populated areas are Lackawanna, near bottom right, and North Tonawanda, opposite Grand Island in the middle of the river. White patches, where the river sharply turns, mark the churning waters of Niagara Falls. All land on the west, or left side, of the image is Canadian. Brown tones indicate the barren fields of February.

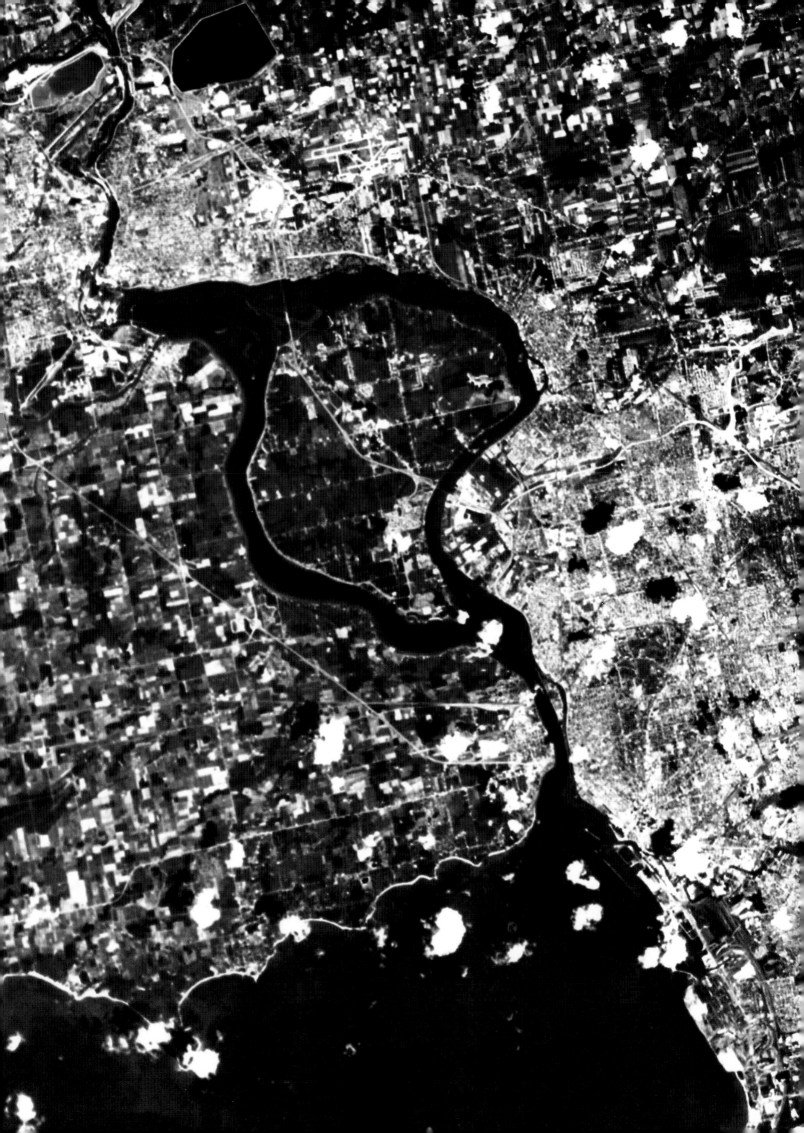

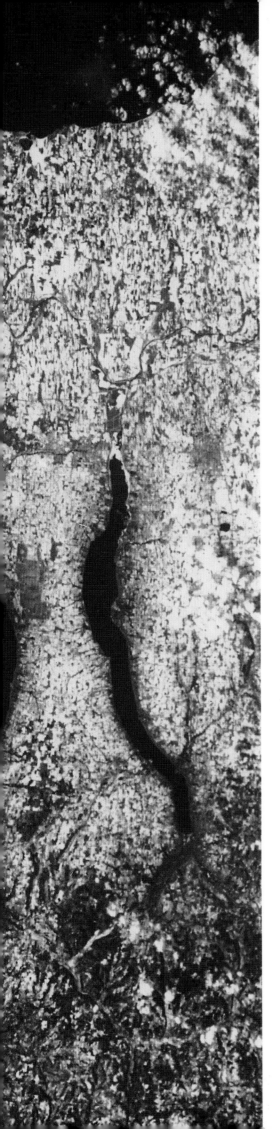

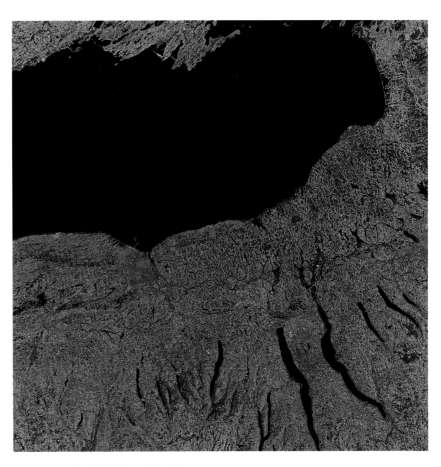

[PAGE 111]
THE FINGER LAKES

Long, narrow lakes in New York State produce an image that looks like the digits of a spectral hand — the Finger Lakes. Glaciers oozing southward along valleys left these lakes behind. The two largest here are Seneca, left, and Cayuga. Seneca, the largest of all the lakes, covers only 67 square miles but is as much as 617 feet deep. Lake Ontario, half in Canada, fills the image to the north. Greens and blues reflect urban development along Lake Ontario; reds point out the farmlands, orchards, and vineyards in one of New York's richest agricultural regions.

[PAGES 110–111]
THE WINTER LAKES

Lakes show up clearly against the snow-covered ground in this view of upstate New York. The outline of Rochester shows as a grid of urban gray snow in a notch of Lake Ontario where the Genesee river enters the lake. The Finger Lakes — the largest, from left to right, are Canandaigua, Seneca, Cayuga — were gouged out by glaciers. Running east-west across the top of the image is the New York State Thruway. North of the Thruway courses the Erie Canal, built in 1817-1825 to connect Buffalo, on Lake Erie, with Albany on the Hudson River.

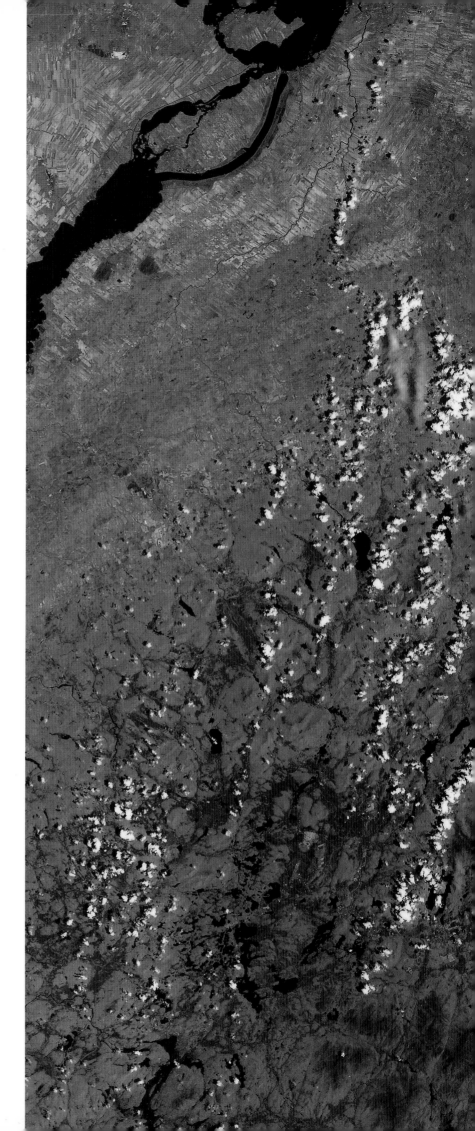

LAKE CHAMPLAIN

Long and many-shored, Lake
Champlain enhances two countries
and joins two states. The 125-mile
lake begins in Canada and forms
part of the boundary of New York
and Vermont, passing between the
rumpled green of the Adirondack
Mountains on the west and the
Green Mountains on the east.
The lake was discovered by and
named for the French explorer
Samuel de Champlain, founder of
Quebec, the first permanent French
settlement in North America. In
the upper corner of the image, the
St. Lawrence River threads its way
past the south side of Montreal
Island. A 1998 U.S. law briefly
designated Champlain a "Great
Lake" so that it could be considered
one of the Great Lakes and thus
compete for federal research money
earmarked for the only U.S. lakes
that had previously been called
"Great." Congress later rewrote the
law, taking away the "Great" status
but giving Vermont access to the
research funds. The initiative to
make Lake Champlain "Great" had
come from a Vermont senator.

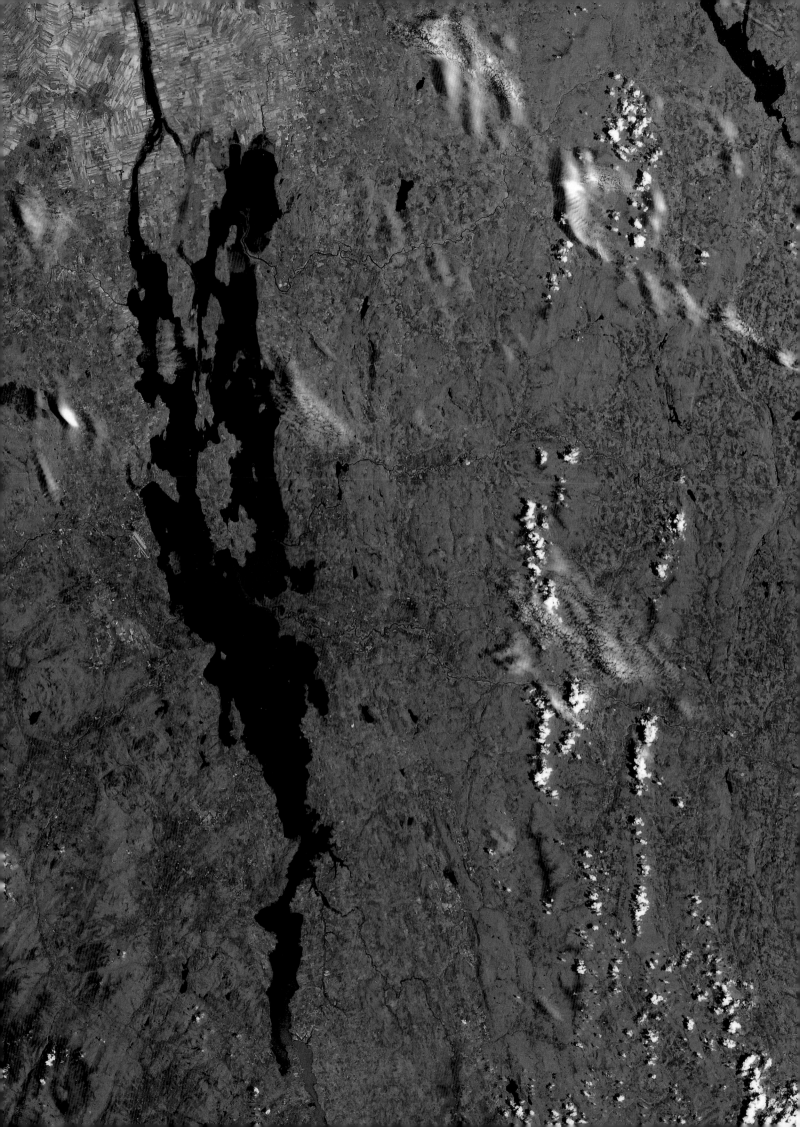

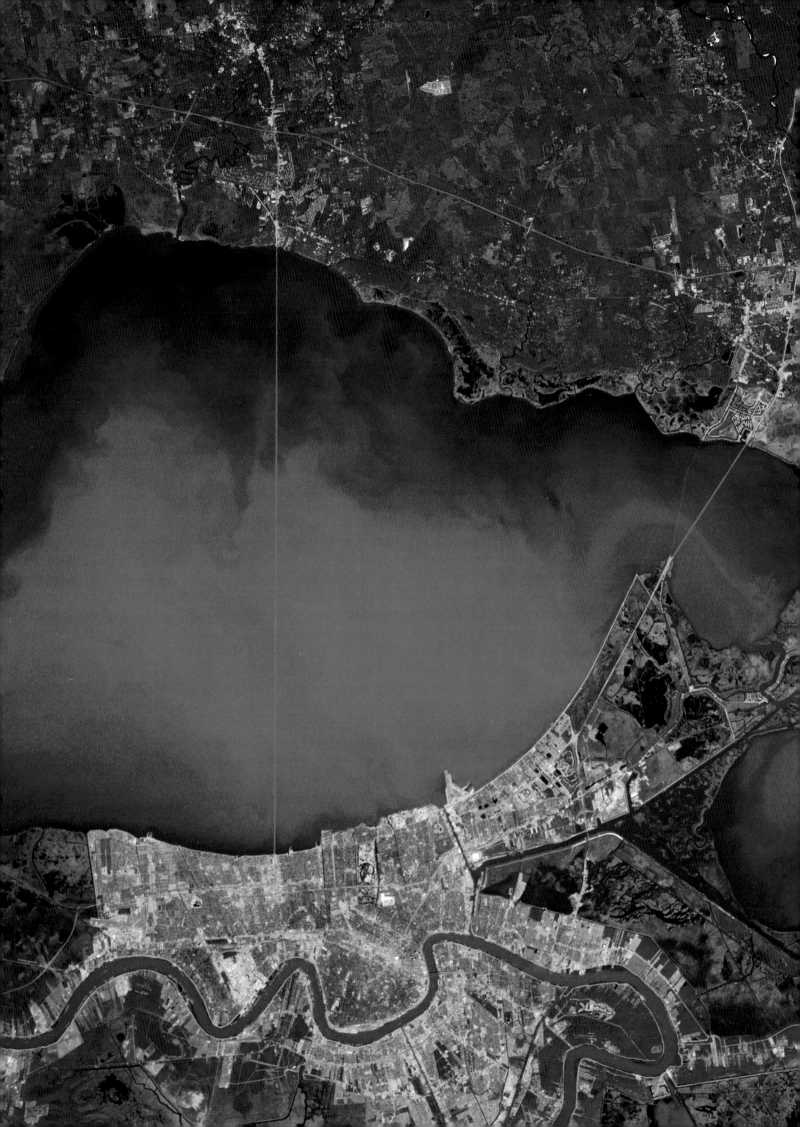

The Southland

WONDROUS ANIMALS and plants dazzled Europeans who explored and settled in the southern region of the New World. There were alligators and armadillos, black walnut trees seven feet in girth and sycamores that sheltered black bears, huge flocks of Carolina parakeets, and clouds of beautiful butterflies.

Why did the "New Eden" of the New World have so many animals and plants not found in Europe? The answer came from studies of the great glaciers that shaped so much of the northern United States. Although the glaciers had not reached the south, they produced a rich legacy in the south. Before the glaciers came, plants and animals living in the higher latitudes had habitats that encompassed the Asian, European, and North American continents. As the glaciers began to grind southward around the globe, plants and animals retreated down valleys of mountain ranges that ran north-south. The refugees from the glaciers found new habitats in the North American southland. But they were trapped and died off on the flanks of mountain ranges that ran east-west, such as the Alps and Pyrenees of Europe.

When the glaciers retreated in North America, such retreating animals as the red squirrel and the water shrew, with habitats that included the southland, joined the alligators and armadillos and other native animals. And species of trees once found in Europe and North America survived only in North America. In the Great Smoky Mountains National Park, which lies athwart Tennessee and North Carolina, there are as many varieties of trees as can be found growing in all of Europe.

Rising from Georgia to West Virginia are the Blue Ridge Mountains, the fir-thatched rooftop of southeastern America. The ridges were created by the folding of layers of sedimentary rocks that resisted erosion. The valleys emerged where more-easily weathered rocks could be carved away. Rivers cutting through the ridges became highways for travelers in the rough terrain.

Eastward of the mountains, the land drops toward the piedmont, a word that means "mountain feet," and then becomes the coastal plain, which forms the continental shelf. The shelf drowned when glacial meltwater raised the sea level. The broadest part of the above-water plain is in the Carolinas and Georgia. It then courses farther south to the coastal plain of the Gulf of Mexico.

Here, in the deepest south, are the youngest parts of the United States. New Orleans frolics on a delta build up only about 1,000 years ago.

NEW ORLEANS
New Orleans, the Crescent City, appears as a pink arc on the southern edge of Lake Pontchartrain. The faint line bisecting the lake is a 24-mile causeway that connects New Orleans, five miles below sea level, with higher Louisiana land. The Mississippi River winds through the city's levees and sharply turns south to the Gulf of Mexico. The thick blue line at right is part of a system of channels. A ship using the channels can shave 40 miles off a voyage to the Gulf.

RIVER OF THE RIDGES

The squiggling Tennessee River flows 652 miles in a great U shape, south into Alabama, then turning north to pass through western Tennessee and Kentucky, where it joins the Ohio River near Paducah. Since the establishment of the Tennessee Valley Authority (TVA) by President Franklin D. Roosevelt in 1933, the river has been extensively dammed for flood control and power production. Oak Ridge, on the right side of the image below the red circle of mountains, was founded as part of the secret Manhattan Project in World War II to develop the atomic bomb. In 1925 at Dayton, the Scopes or "Monkey Trial" tested the state law making it a crime to teach the theory of evolution. The trial attracted nationwide attention and school teacher Scopes was eventually fined $100.

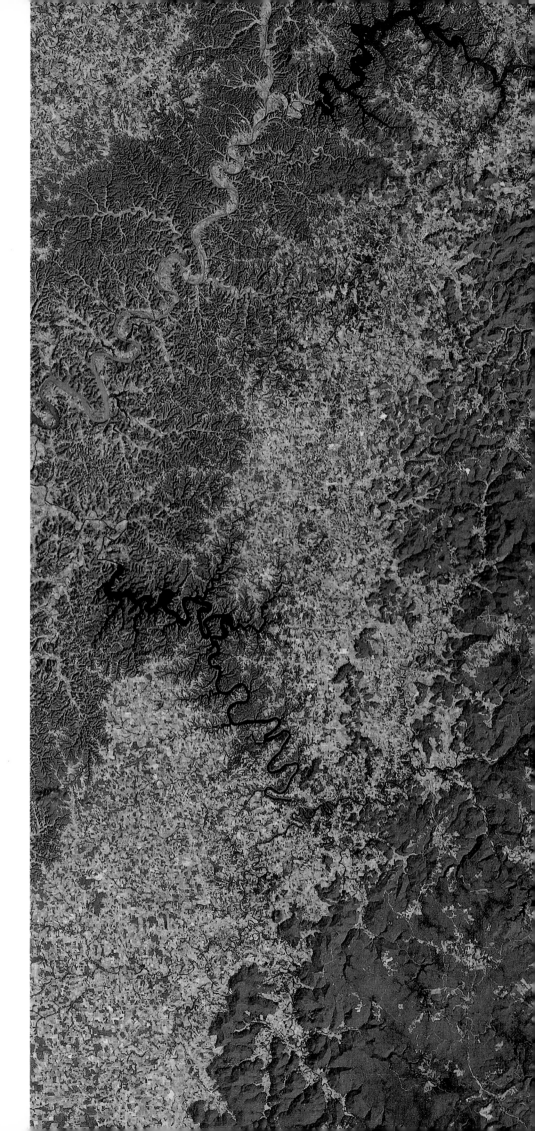

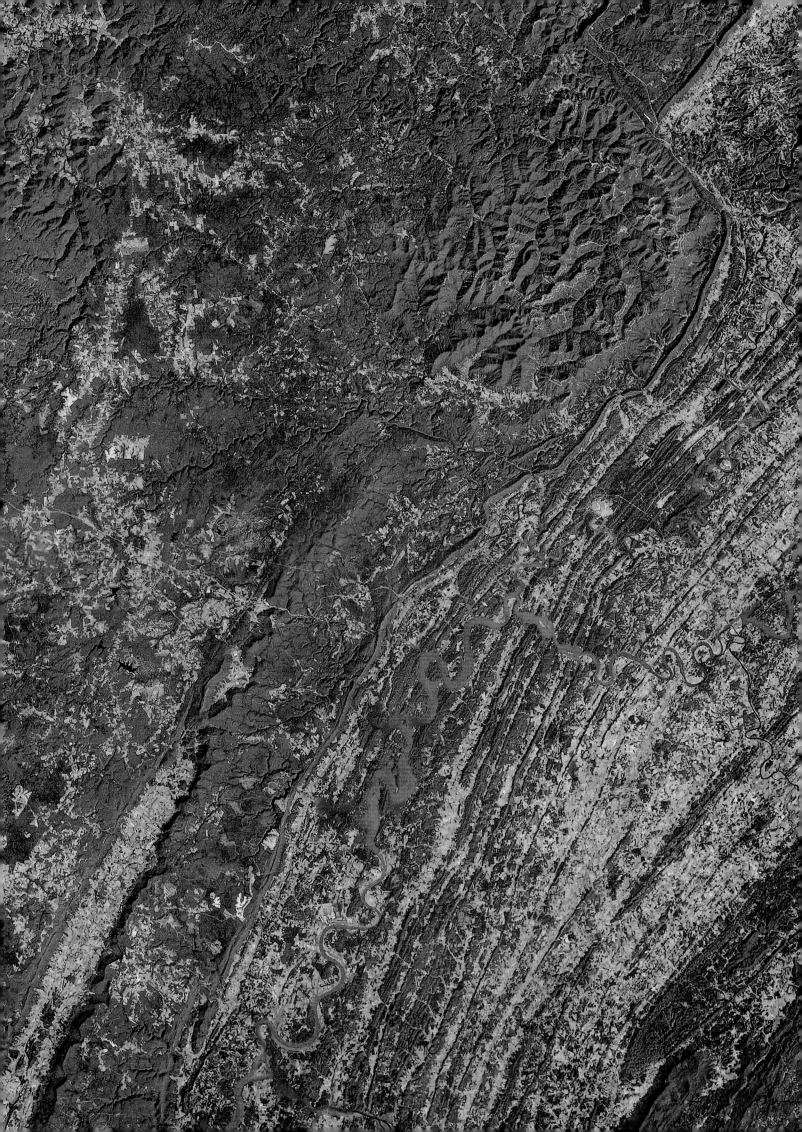

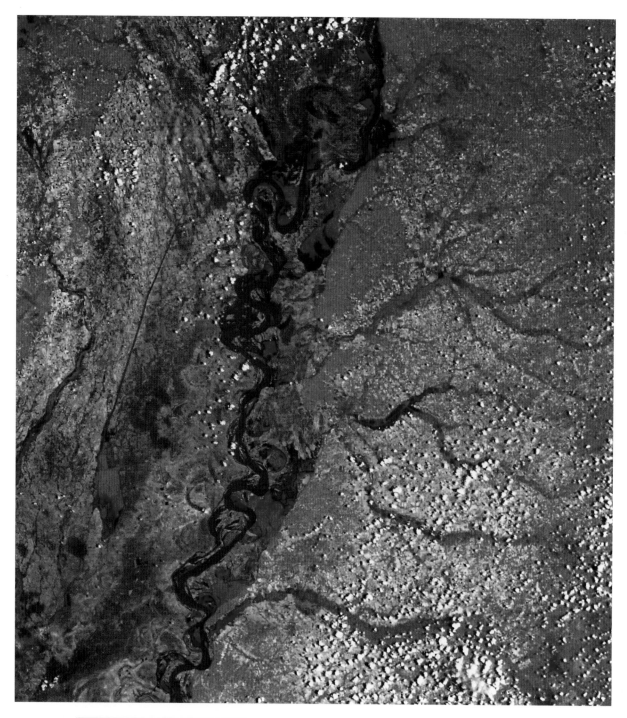

MEANDERING MISSISSIPPI

The mighty Mississippi twists and curves as it forms the border between the states of Mississippi, Arkansas, and Louisiana. Along the river's wiggling course, half-circles and loops mark "meander belts," where the river shifts its channel, especially when it floods. Grayish areas are urban. Red, indicating farmland, colors the aptly named flood plains that flank the river. Land within loops, though especially vulnerable, is also especially fertile. Although the flood plain periodically washes out farms, the land is rich and draws back its victims to challenge the river again.

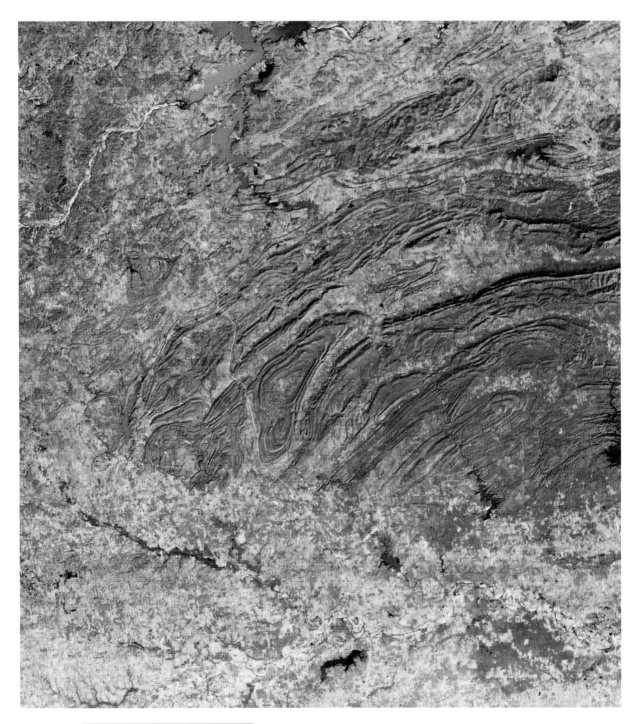

RIVERLAND

The Mississippi River, rolling from upper center to bottom right, forms the border between Louisiana and Mississippi. The Arkansas River is at extreme upper center, Bayou D'Arbonne at lower left. Farmlands and forested areas show in bright red. Gray and pink show cities: Vicksburg, Mississippi, at right center; Greenville, Mississippi, at right center north of Vicksburg; Monroe, Louisiana, at extreme lower left center. Interstate 20 runs along the bottom of the image. Near-circular and crescent-shaped bodies of water are former Mississippi River channels.

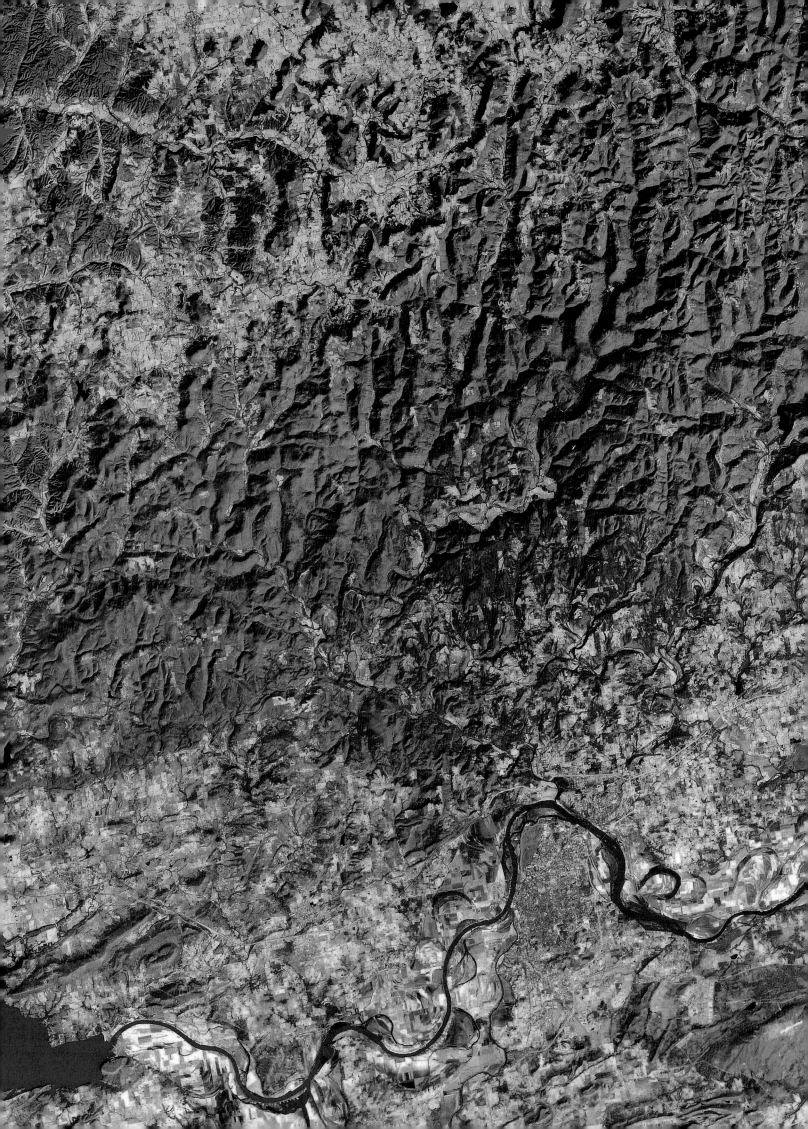

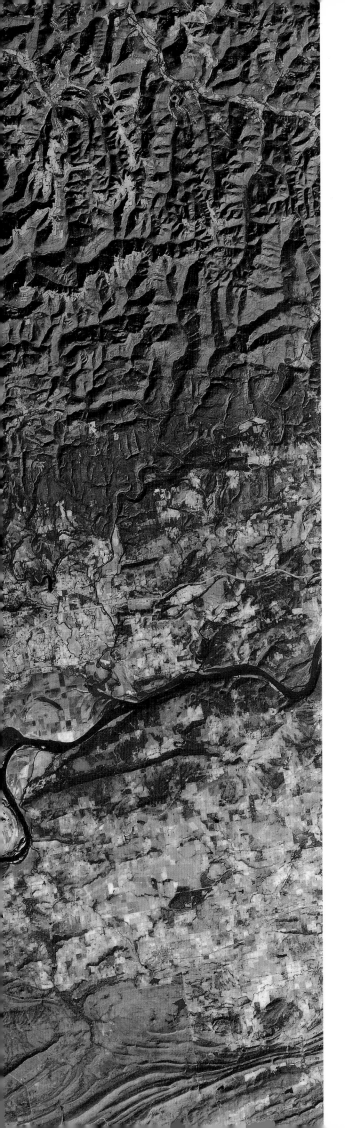

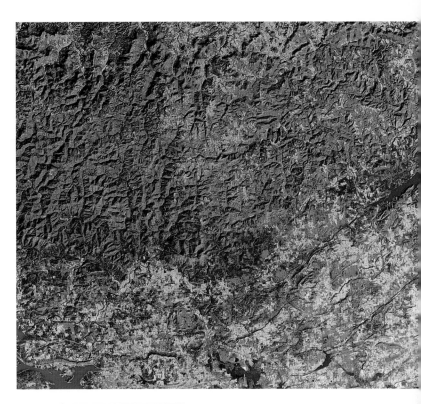

120–121 121

[PAGES 120–121]

ARKANSAS TRAVELER

The 1,450-mile-long Arkansas
River flowing out of Oklahoma's
Kerr Reservoir, at lower left, loops
around Fort Smith, Arkansas, as it
flows eastward toward the
Mississippi. Filling most of the
image north of the twisting river
are the rugged, heavily wooded
Boston Mountains, the highest
stretch of the Ozarks, reaching a
height of about 2,700 feet. Steep
ridges and gorges, some more than
1,000 feet deep, produce this red-
tinted pattern. In many places in
the Ozarks, water has dissolved
underlying limestone, creating
caves, depressions, and
underground river channels.

[PAGE 121]

OZARK MIRAGE

In Arkansas, a big lake with big
native trout is not the work of
nature. What look like lakes in
the craggy Ozarks are reservoirs
created by dams. Arkansas has no
large natural lakes. At right is
Greers Ferry Reservoir, stocked
with lake trout that grow to 25
pounds or more in the deep, cold,
well-oxygenated water. At the
lower left, on the Arkansas River,
is 34,000-acre Dardanelle
Reservoir, site of Mount Nebo
State Park, named after the
mountain from which Moses saw
the Promised Land.

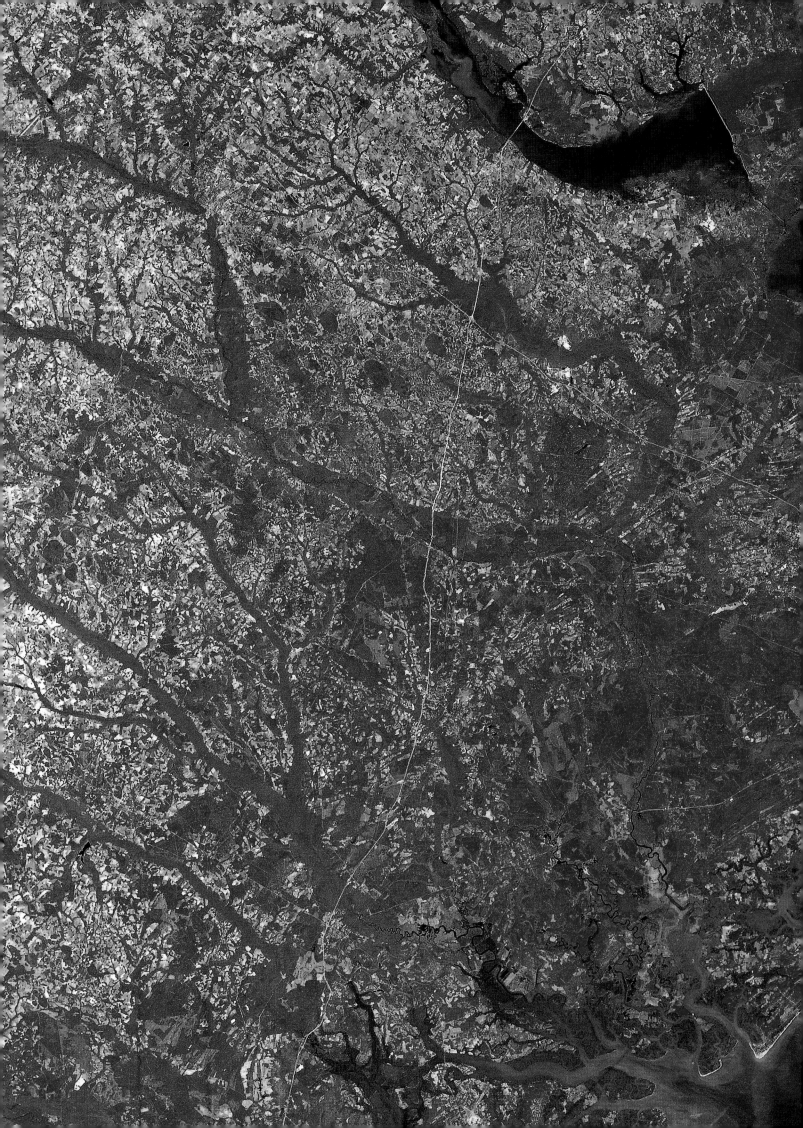

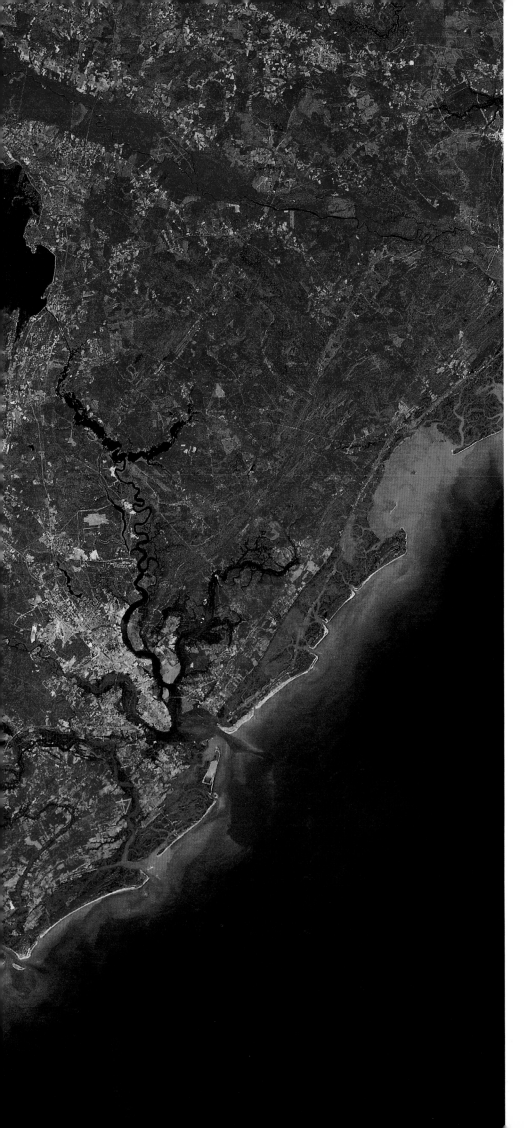

COASTAL PLAIN

Rivers and wetlands lace the coast of South Carolina, where an immense coastal plain slopes to the sea. Silt and shallows tint the shore. Gray marks the urban peninsula of Charleston, between the Ashley and Cooper Rivers. Barrier islands flank the broad bay that makes Charleston a leading Atlantic port. Lake Moultrie appears to the north of the city; farther inland is curving Lake Marion, formed by the damming of the Santee River. Southward along the coast, a filigree of river mouths and inlets cluster around Beaufort, South Carolina.

[PAGE 124]

FLORIDA PORTRAIT

Pieced-together satellite images show Florida's 8,426 miles of coastline and the Florida Keys extending out from its southern shore. Okeechobee, largest of the state's lakes, looks like a hole in the land. On the southeast coast, Miami and its urban satellites border the dark green of the Everglades. Clouds float off the Gulf coast, where St. Petersburg lies at the outer arm of Tampa Bay and the city that names it. Dark green patches on the panhandle are protected forests and wildlife refuges; the gray and pink splotch is Tallahassee, near the Georgia border.

[PAGES 124–125]

HURRICANE!

High above the Atlantic Ocean, Hurricane Florence sucks up clouds and whirls toward Bermuda in this 1994 image from space. Low-lying Florida is susceptible to tropical storms, which can evolve into hurricanes when the winds rise above 74 miles per hour. Although dozens of hurricanes threaten Florida every summer and fall, few hit the land. In a hurricane, as this photo shows, the winds spirals counter-clockwise toward the low-pressure center, or eye of the storm.

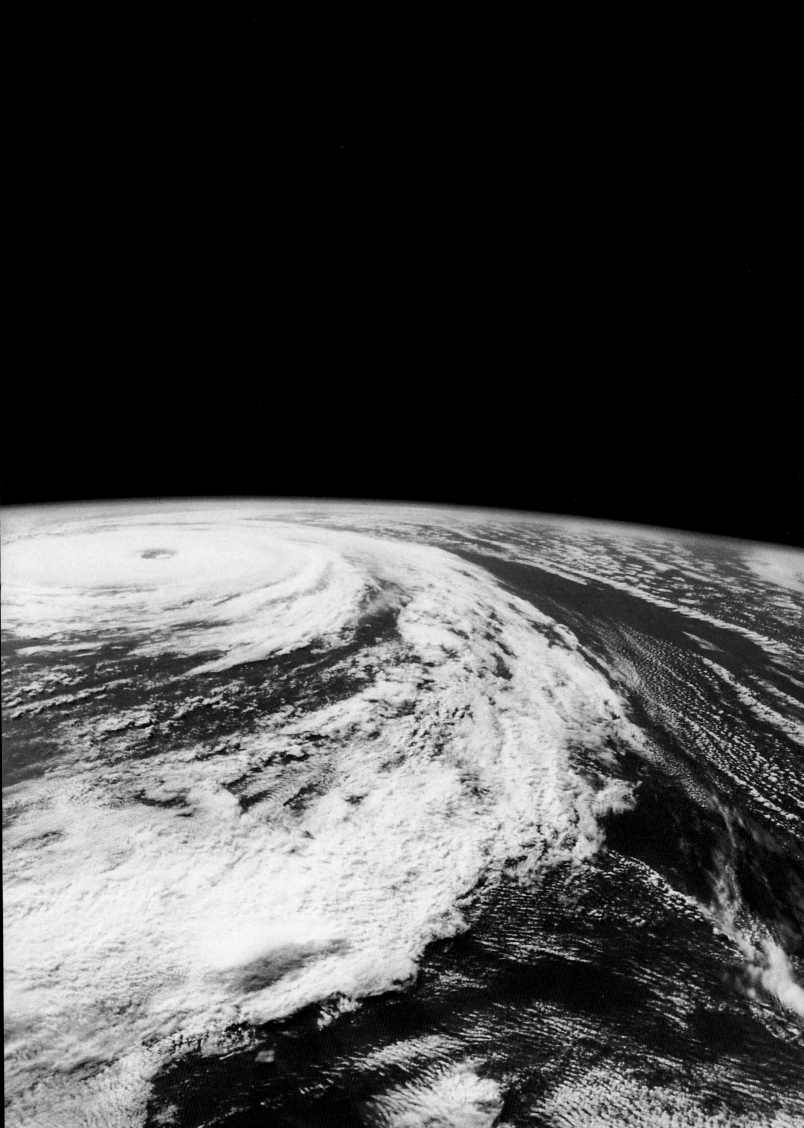

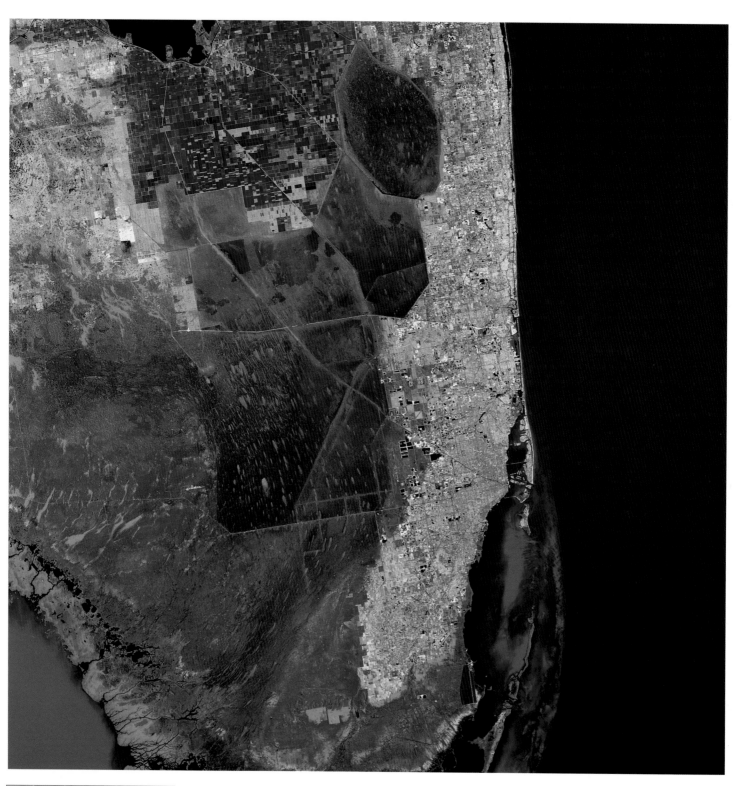

EVERGLADES MOSAIC

Florida possesses a unique "river of grass," the Everglades, a vast expanse of sawgrass and slow-flowing water, which appears as a green and red region west of Miami. The black arc at the top of the image is the lower shore of Lake Okeechobee, source of the Everglades' water. Bright green rectangles south of the lake are sugarcane plantations and farms.

Along the eastern coast, Miami and its environs sprawl and glitter. Diagonal red lines are part of the waterway system supplying farmers and city dwellers, tapping water before it reaches the Everglades. Red teardrops are hummocks, which rise only a few inches above the water but sustain hardwoods with humus-rich soil. Shown in deep red at the bottom

of the image are mangroves, trees that send out high roots and form dense masses along rivers and the coast. Everglades National Park preserves the southern and southwestern end of the Everglades. The park is home to alligators, panthers, eagles, and such other birds as herons, ibises, pelicans and spoonbills.

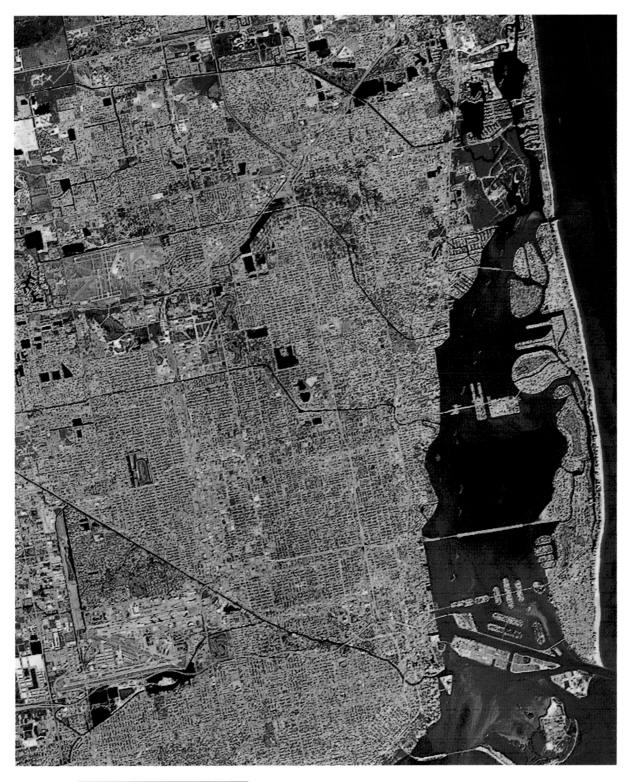

MIAMI

A tight grid of city blocks graphically portrays the population density of Miami. Canals cut across the grid, which occasionally gives way to lakes and pools (black and blue). The white strip of Miami Beach's sandy shore fronts the Atlantic; the barrier island protects Biscayne Bay, which bristles with bridges and piers. Once a small southern city and now a megalopolis, Miami is the center of a 100-mile urban corridor where more than 4 million people live and some 6 million tourists annually visit.

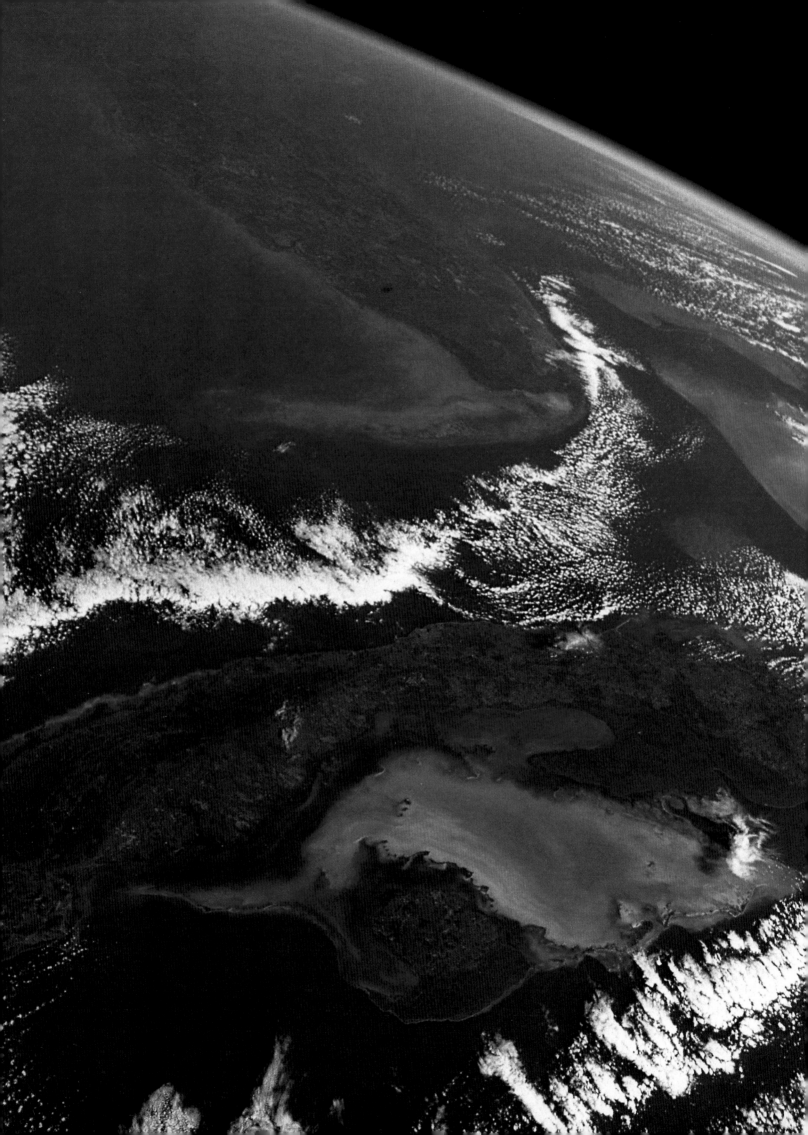

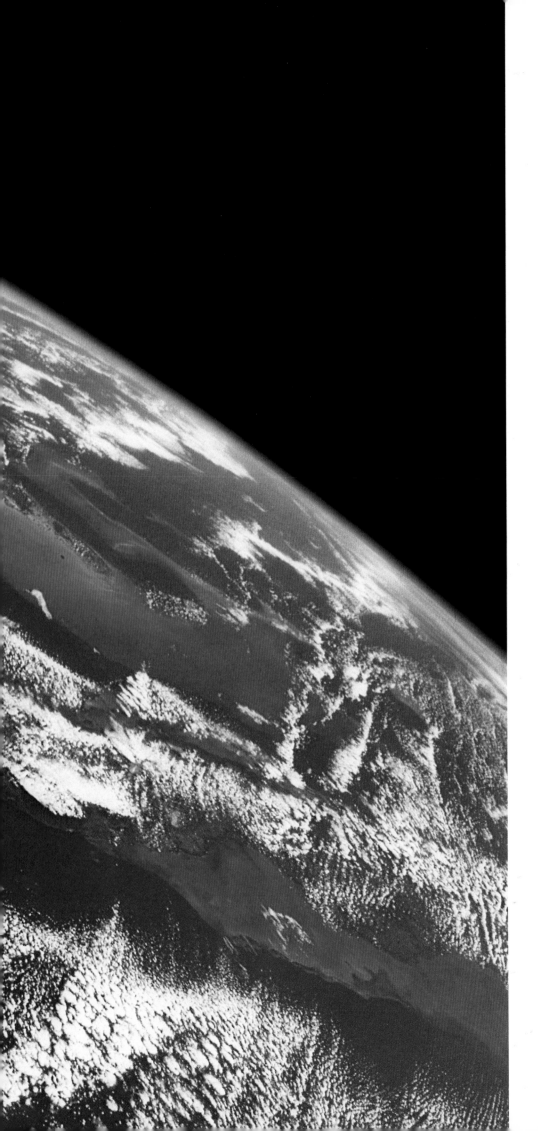

FLORIDA AND CUBA

From space, Florida shines in the Caribbean sun, dramatically showings its proximity to Cuba. Also appearing in the Caribbean panorama are some of the 700 islands and cays of the Commonwealth of the Bahamas on the northwestern edge of the West Indies. The westernmost island of the Bahamas is only 60 miles off Miami. Offshore breezes keep coasts clear of clouds. Turquoise, shallow water surrounds those islands and the Florida Keys, contrasting with the dark-blue waters of deeper seas. Even at this distance can be seen two Florida landmarks — Lake Okeechobee and the grayish urban band centered on Miami.

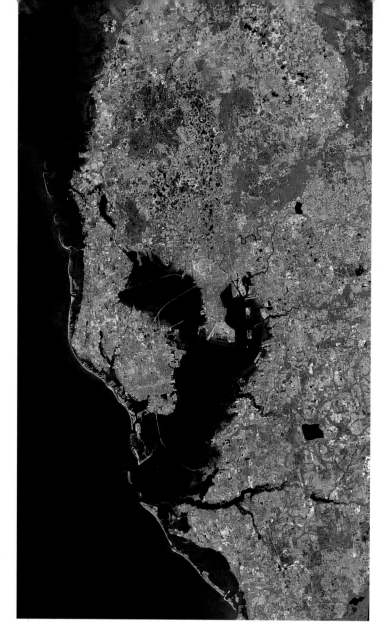

[PAGE 130]

GULF COAST

Smooth and jagged stretches of shore mark the long Gulf Coast of Florida. At the top of the image, red-tinted masses of mangroves, wetlands, and wildlife refuges line the coast. Inland, squares and rectangles grid miles of farmland. Farther south, Clearwater, Largo, and St. Petersburg jam the large peninsula that curves into Tampa Bay. MacDill Air Force Base occupies the smaller peninsula. Near the bottom of the image, barrier islands guard Bradenton and Sarasota in a region laced with rivers and lakes.

[PAGES 130–131]

SPACEPORT, U.S.A.

Roads and causeways link the complex parts of the huge Kennedy Space Center, launching site for U.S. spacecraft. Space Shuttles travel from the Vertical Assembly Building, the large structure at upper right, along rails that lead to the two circular launch pads on the coast. At the end of the longest causeway, which crosses the outer Banana River, is the Cape Canaveral Air Station, where the Air Force launches satellites. The congestion of streets and highways along the mainland shore reflect the intense development of the Orlando area, Florida's prime tourist hub.

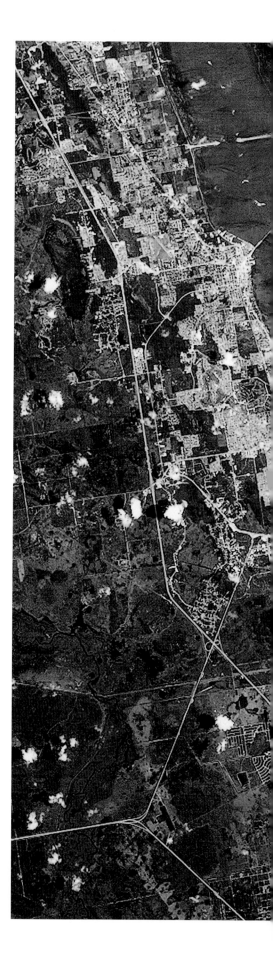

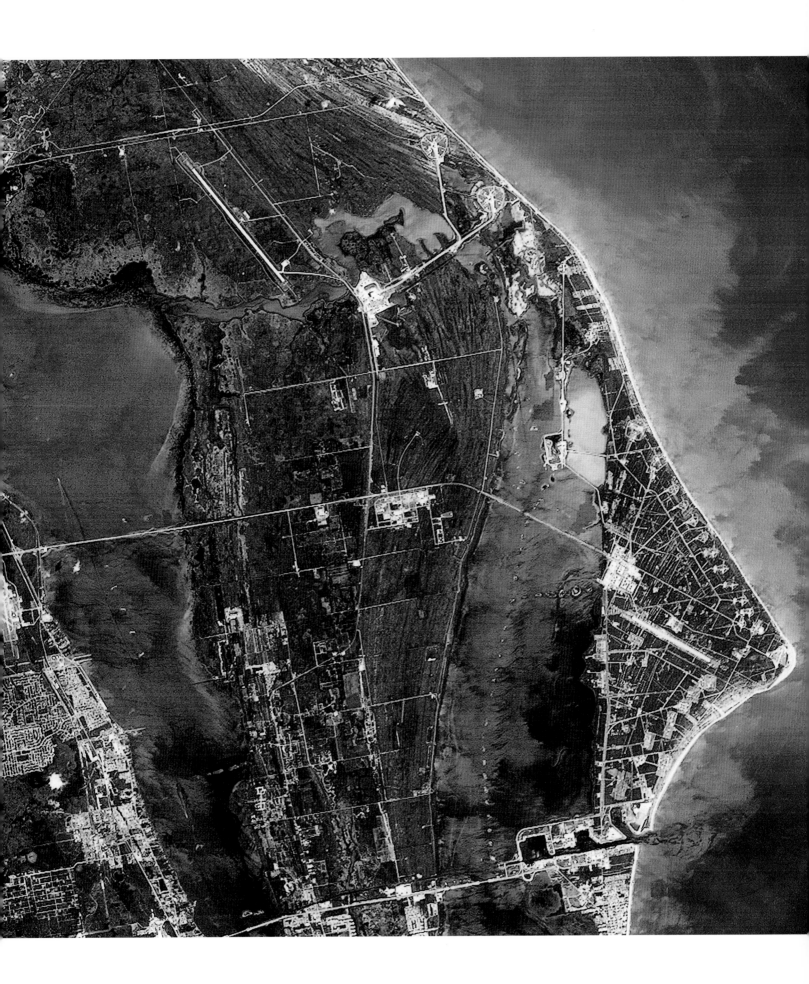

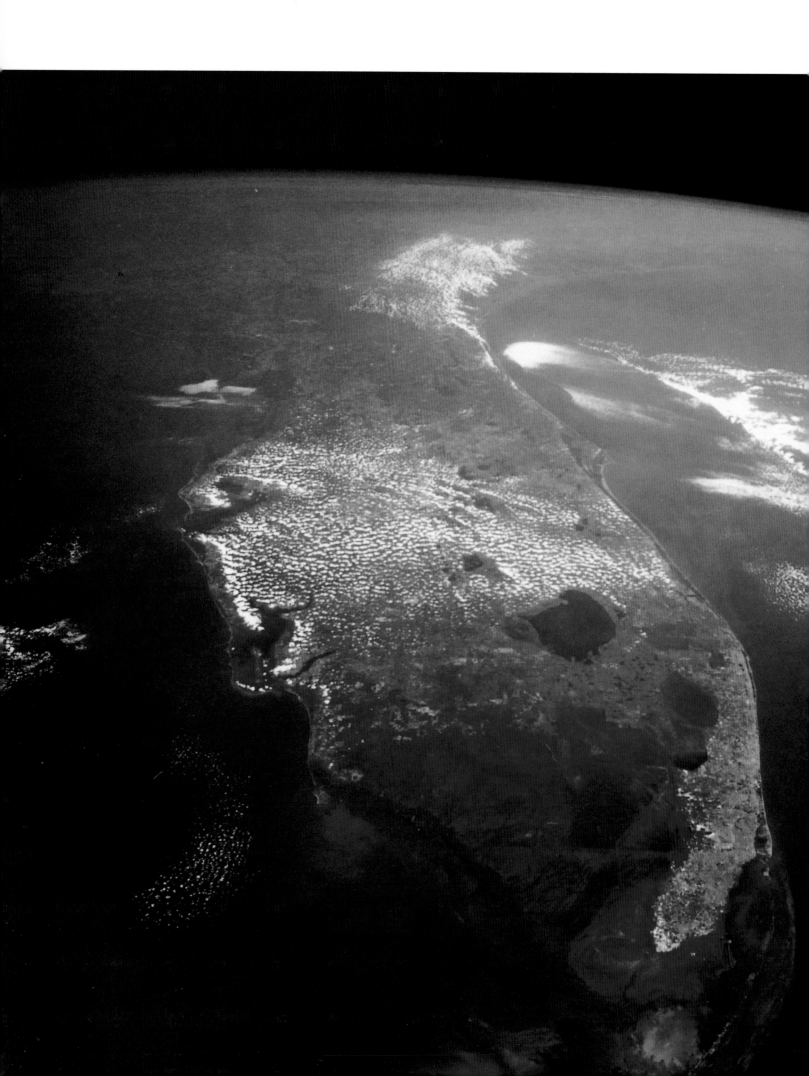

THE FLORIDA KEYS

Strung together like jewels, the
Florida Keys adorn the blue sea.
The Keys, formed mostly of
limestone and coral, arch for
about 225 miles across the
southern tip of Florida, linked
by the Overseas Highway. At
the end of the string is Key West,
the southernmost settlement
within the continental limits of
the United States. Other keys,
reefs, and islets, mostly
unnamed and unoccupied,

parallel the linked keys. Beyond
Key West are the Marquesas
Keys and the crescent of Dry
Tortugas, coral islets that hold
an historic fort and a bird
sanctuary.

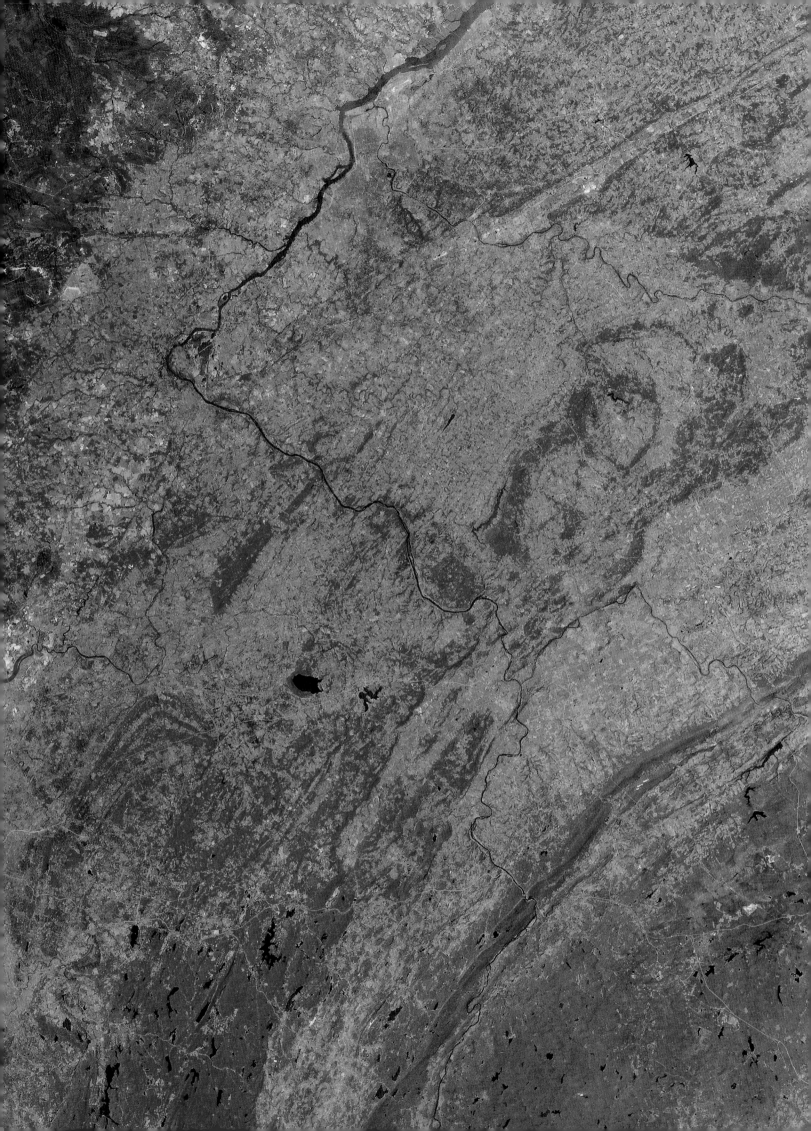

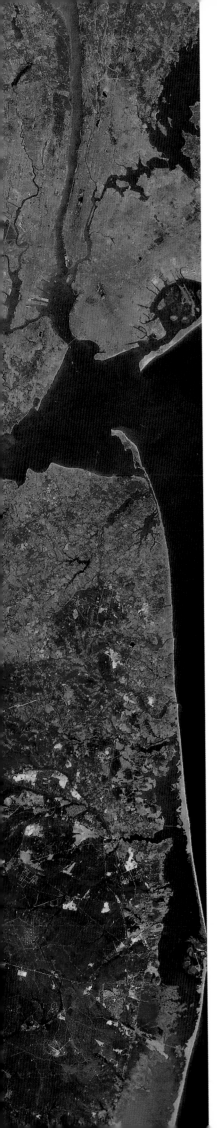

The Northeast Corridor

L OOK AT THE eastern seaboard from space, and you see what appears to be one long city, stretching from Boston and its suburbs to Washington, D.C., and its suburbs. This fusing of metropolitan areas results less from political planning than from the happenstance of how people get together: They spin transportation and communication webs over the natural terrain. For the eastern seaboard, that natural terrain has been a geologic phenomenon called the "fall line."

The fall line runs along the piedmont, a region lying or formed at the base of mountains. At the fall line, rivers tumble over hard rock as falls and rapids. The rushing water at the waterfalls provided the power to spin the wheels of grist and textile mills, and thus that spot near the falls became a good spot to found a settlement. And below the rapids on the calmed river, ships could come and go, connecting the fall-line town to the sea.

"On a night flight down the eastern edge of the continent — from, say, New Jersey to Virginia — you can see an electrical display of the fall line," wrote geologist Edward S. Deevey, Jr. "A twinkling string links cities of the inner seaboard: Trenton, Philadelphia, Wilmington, Baltimore, Washington. . . . More vividly than a mark on a map, that band of light shows the fall line."

Deputy Postmaster General Benjamin Franklin used a network of fall-line roads to expand mail service from New England colonies to Virginia. The principal mail road, known as the Post Road, evolved into the modern highway, U.S. 1. The railroads also used the fall line as a route southward. There the coastal plain broadened so that the fall line was farther inland than in New England. In our time, U.S. Interstate 95, the highway of the Northeast Corridor, also follows the fall line.

But, if the roads of the fall line united the edge of colonial America, another part of the northeast's geography, the Appalachian Mountains, blocked the outer part of the colonies from the inner. Not until about 1780 did Daniel Boone's Wilderness Road through the Cumberland Gap open the way to significant migration westward.

Along the New England coast, rocky soil and a short growing season meant that wealth would not come from the land. The terrain that would bless the Northeast would be seashore, a place of commerce and finance. From the big, busy ports of Boston and New York came the first stirrings of the Boston-New York-Washington megalopolis.

NEW YORK-PHILADELPHIA
Urban development makes a virtually unbroken blue belt from the New York metropolitan area southward along the Northeast Corridor. Sandy Hook, New Jersey, points like a crooked finger to The Narrows, gateway to New York Harbor, where the Hudson River meets the Atlantic. The Delaware River, forming the Pennsylvania-New Jersey border, sharply turns southwestward at Trenton, curves at Philadelphia — making both cities freshwater ports — and courses along as a northern boundary of New Jersey. Red arcs are Appalachian ridges.

MOUNT DESERT

In a satellite portrait of Maine's island-flecked northern coast, vegetation shows up as red and the Atlantic Ocean as black. Acadia National Park covers much of Mount Desert Island, a large island nearly split by the only fiord on the U.S. Atlantic coast. Eastward across Frenchman Bay thrusts the granite tip of Schoodic Peninsula, another piece of the park. Isle au Haut, the long island at lower left, also is part of the park.

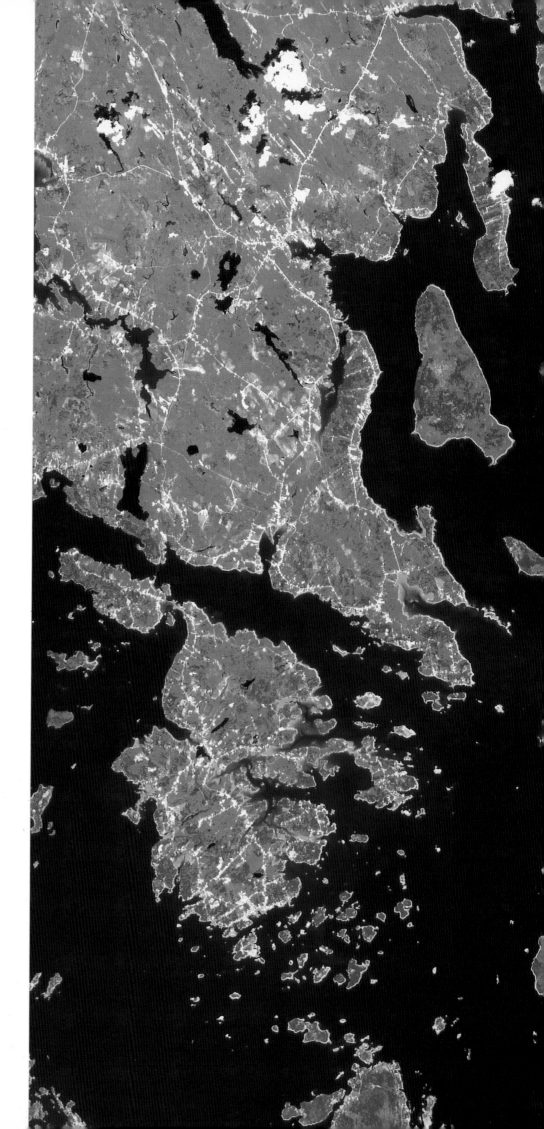

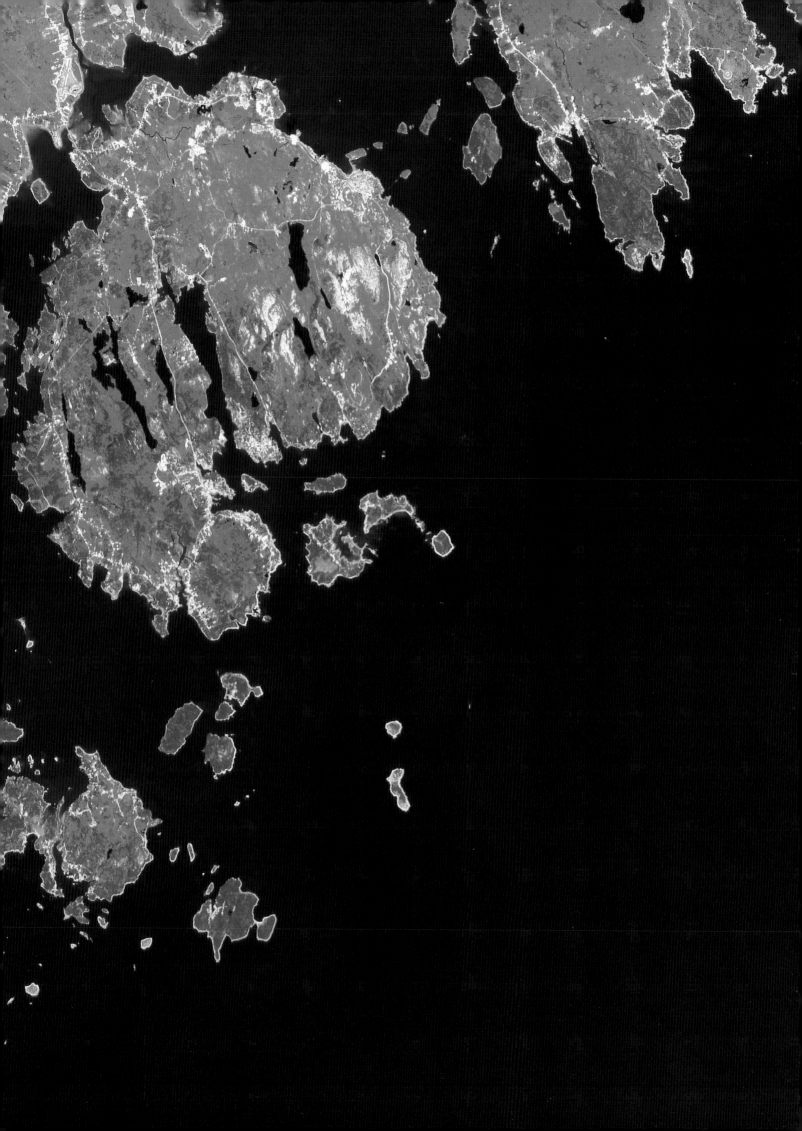

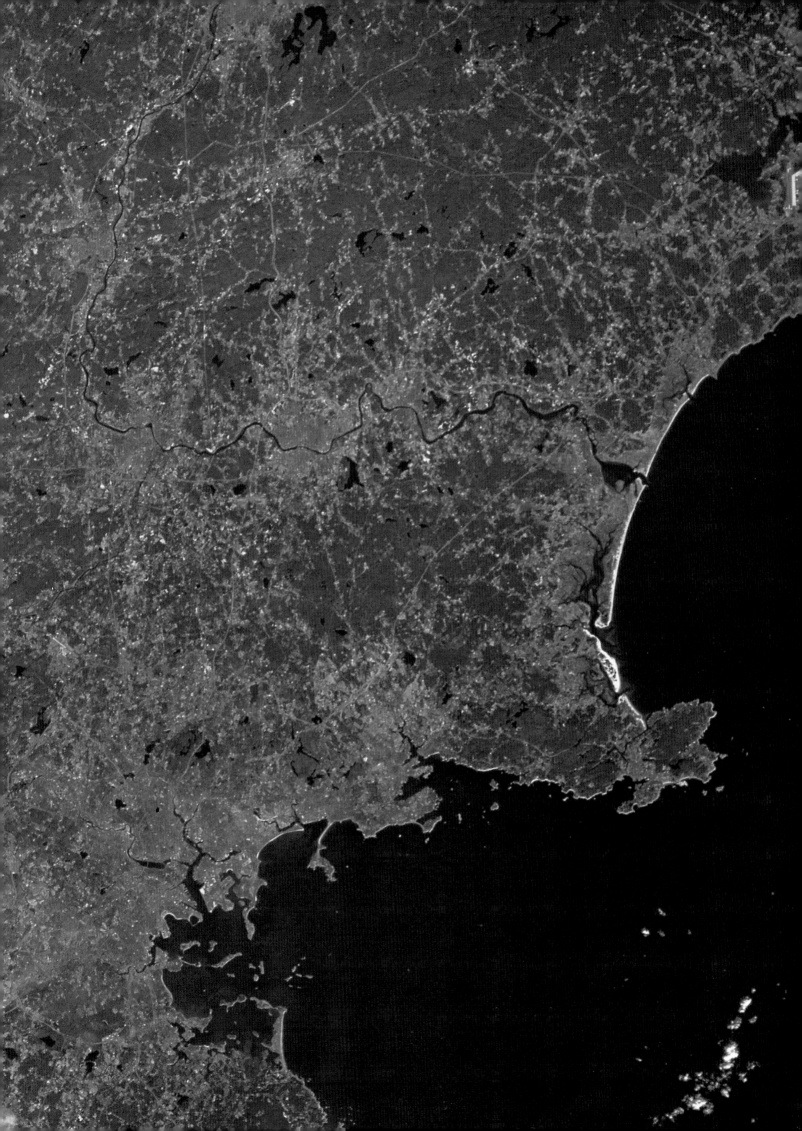

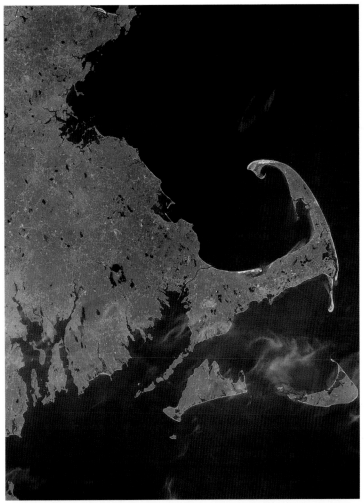

[PAGE 138]
THE HUB CITY

Boston lives up to its nickname in this photo that takes in a large part of New England. Boston, which appears as a large blue area, radiates out to other Massachusetts' cities, including those strung along the Merrimack River: Newburyport, at the mouth (near Plum Island, a wildlife refuge); Haverhill and Lawrence; then Lowell, where the river turns north to New Hampshire's Nashua and Manchester. On the coast, Portsmouth, New Hampshire, lies across the Piscataqua River from Kittery, Maine. To the south, Cape Ann, site of Gloucester, juts into the Atlantic.

[PAGE 139 TOP]
CAPE COD

Cape Cod arches into the Atlantic, a legacy of Ice-Age sculpture. Named by an early explorer who caught "a great store of codfish" here, the peninsula extends 65 miles into the Gulf Stream. Its creation began when early glaciers swept down, then retreated, leaving gravel, sand, clay, and boulders. This debris hardened into the backbone of Cape Cod. When the last glacier left 12,000 years ago, some parts, called lobes, lingered long enough to form the thin, arm-like end of the cape. The two islands beneath the cape, Martha's Vineyard on the left and Nantucket on the right, mark the southernmost edge of the glacier.

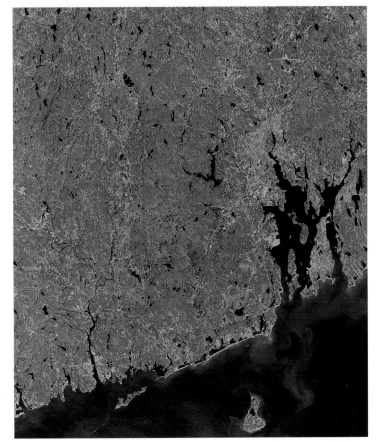

[PAGE 139 BOTTOM]
NARRAGANSETT BAY

The Atlantic Ocean reaches deep into Rhode Island at Narragansett Bay, which brings the sea to Providence, appearing here as the image's largest bluish spot. Other blue-tinted cities are Newport, on the island near the mouth of the bay; Fall River, Massachusetts, on the bay's eastern-most arm; New London, Connecticut, near the mouth of the Thames River at the lower left. The town-lined Connecticut River is at farthest left. Much of Boston sprawls in the upper right corner; to the west is Worcester, Massachusetts. Off Rhode Island lies pear-shaped Block Island, named for a 1614 Dutch visitor.

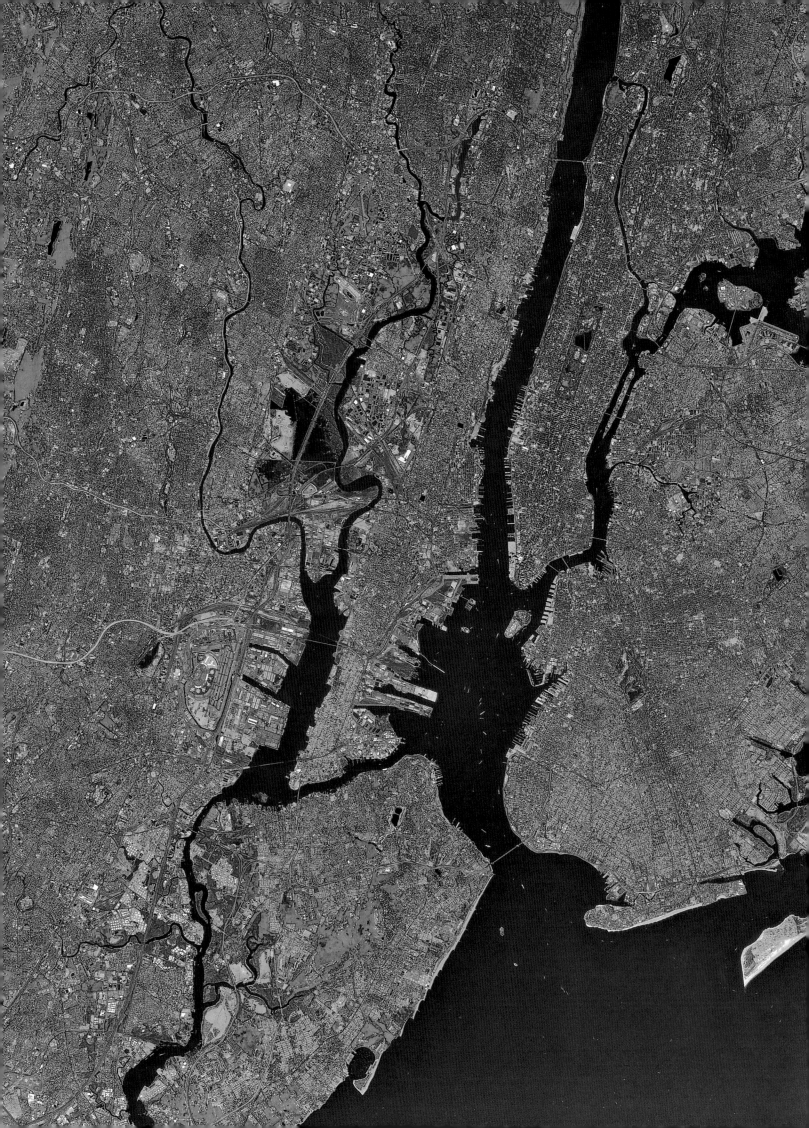

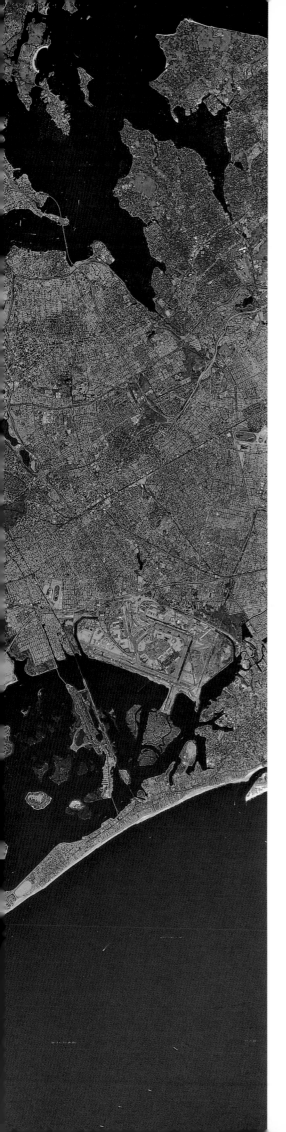

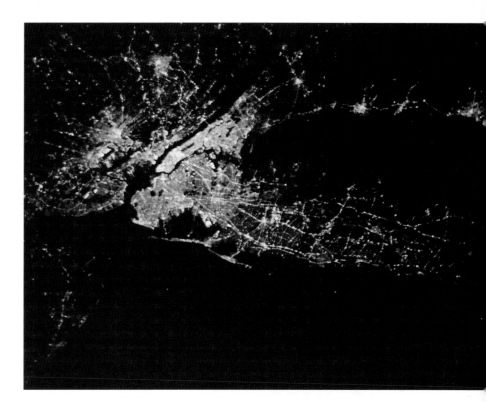

[PAGES 140–141]
NEW YORK CITY

Bits of red, indicating fragments of open land, sprinkle the greater New York City area, which in this view includes the city's five boroughs and parts of New Jersey. Central Park appears as a rectangular oasis in the middle of Manhattan. The runways of La Guardia Airport can be seen thrusting into the black water of Long Island Sound. At Kings Point, the Throgs Neck Bridge connects the Bronx and Long Island. Bulging Brooklyn links Staten Island via the thin line of the Verrazano-Narrows Bridge. Farther north, the George Washington Bridge spans the Hudson River, which flows into the 750 miles of waterfront that make up New York Harbor. Two container terminal docks thrust from the New Jersey shore. At extreme right, John F. Kennedy International Airport skirts Jamaica Bay, sheltered from the Atlantic by the long arm of Rockaway Beach. At the mouth of the bay is Coney Island, its beach shown in white.

[PAGE 141]
NEW YORK BY NIGHT

"The City that Never Sleeps" lights up for an astronaut photo. Manhattan, the Bronx, and Brooklyn glow in a blaze of light. Beyond, night life dims. But clusters of light become beacons on the Connecticut shore, where Stamford, Bridgeport, New Haven, and smaller coastal cities shine. Across Long Island Sound, a grid of highways and towns reflects the major sites of Long Island's population. Light fades to the east, where population density thins.

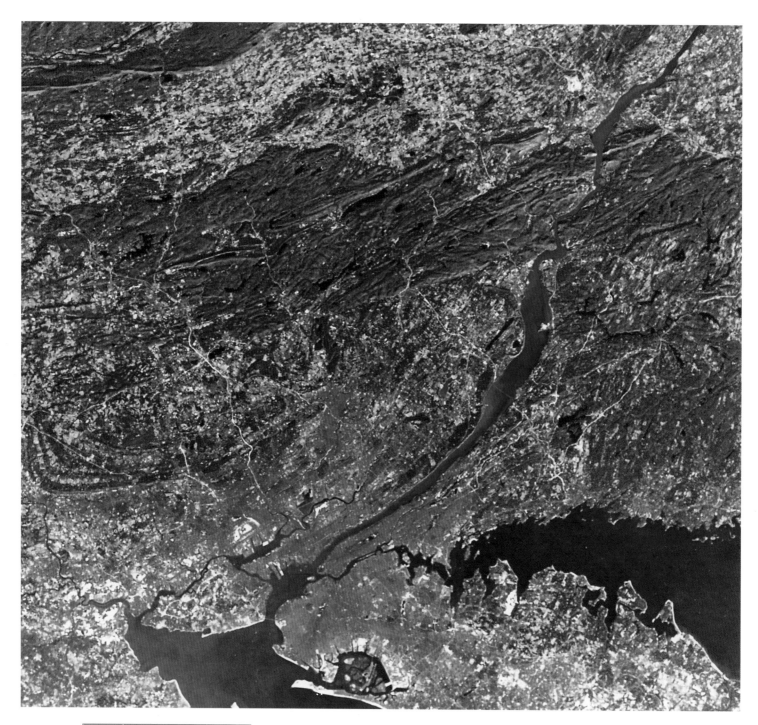

TRI-STATE PANORAMA

The sculptured ridges of the Catskill Mountains and the diagonal thrust of the Hudson River dominate a region that is also one of the most densely populated areas in the nation. As the river flows south, blue tints indicate intensifying urban development, which reaches its peak in the New York City metropolis. On the New Jersey coast to the left, Newark and Elizabeth add their urban contribution. Blue urban points also dot the Fairfield County coast of Connecticut, on Long Island Sound at lower right. On the New York State side of Long Island, the New York City borough of Queens adjoins populous Nassau County.

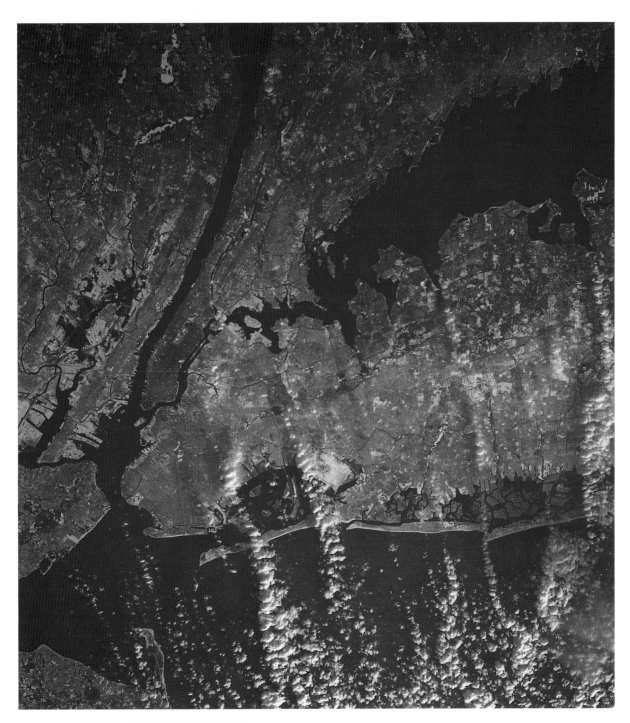

WINTER ETCHING

Snow cloaks the New York metropolitan area, but landmarks are still apparent. Under cloud-streaked skies, Central Park's outline imprints the New York City borough of Manhattan; cleared runways of La Guardia and Kennedy Airports emerge in the borough of Queens. Reservoirs, the Hudson, and the sea remain uncovered. And throughout New York, snow-plowed streets come forth to display the city's underlying grid.

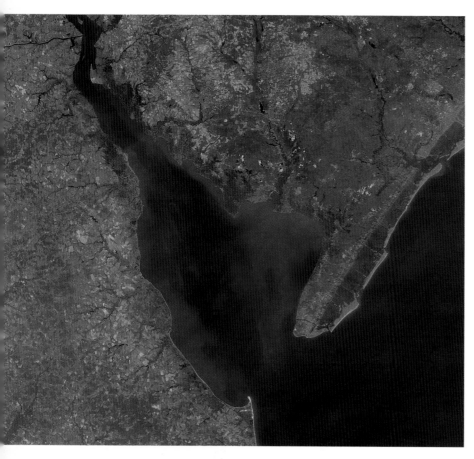

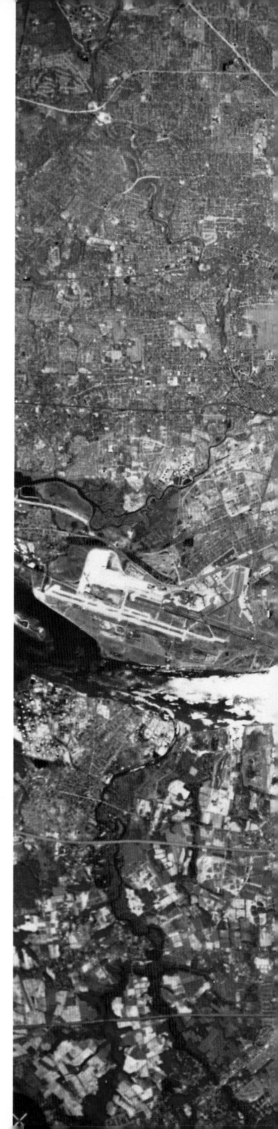

[PAGES 144–145]

PHILADELPHIA

A city of two rivers, Philadelphia lies at the meeting place of the Delaware and the Schuylkill. The Atlantic Ocean is about 100 miles down the broad Delaware River. A busy port halfway between New York City and Washington, D.C., Philadelphia was a commercial center even before the Founding Fathers gathered here to sign the Declaration of Independence and the Constitution. Clouds sweep over the waterfront of the city, whose grid of streets is the first such U.S. urban layout. Suburbs spread to the west and northwest. Across the Delaware lies Camden, New Jersey, and its stretch of suburbs.

[PAGE 144]

CAPE MAY

New Jersey reaches out toward Delaware, the states' terrain red with farming. Cape May, New Jersey's long arm, stretches 20 miles out to sea. Some of America's oldest seashore resorts rose along these ocean beaches (showing the gray and blue of development). Atlantic City's casinos line the boardwalk just south of the wide Mullica River, which flows through a state forest (brown) and enters Great Bay. Opposite Cape May across Delaware Bay is Cape Henlopen, whose ocean shore is also lined with resort beaches. The Delaware River, at the top of the image, flows past Wilmington on its western shore.

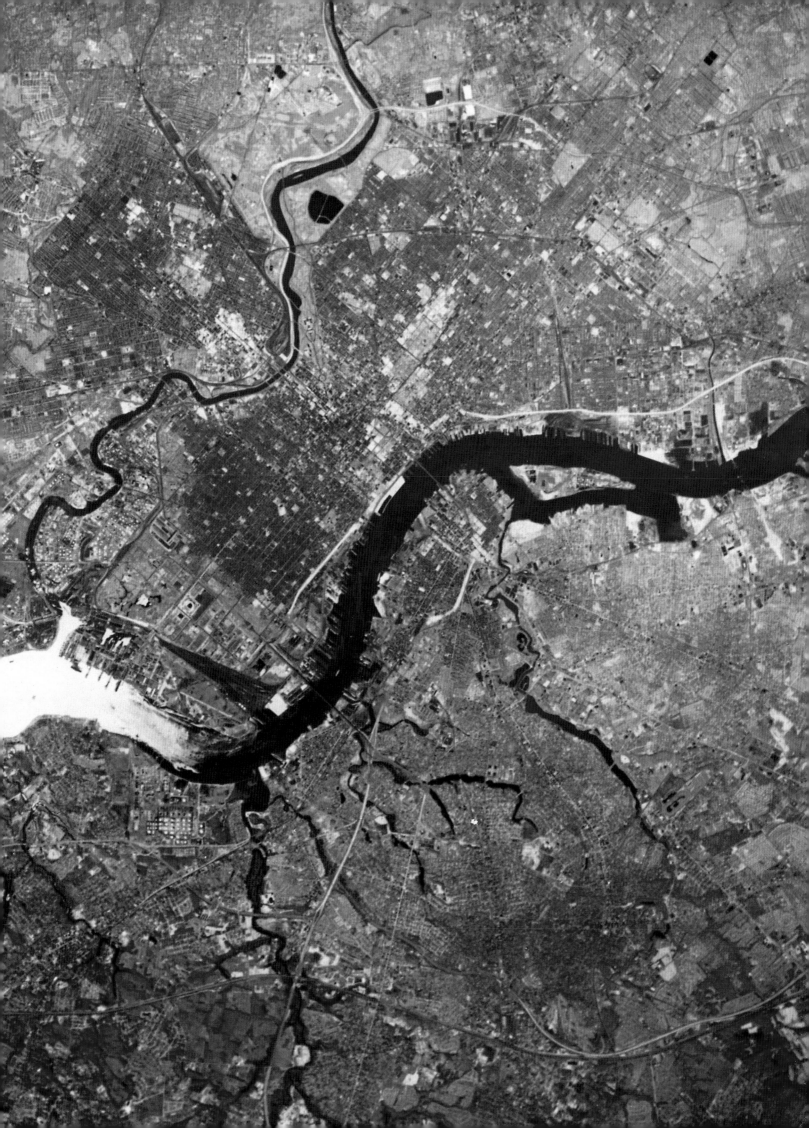

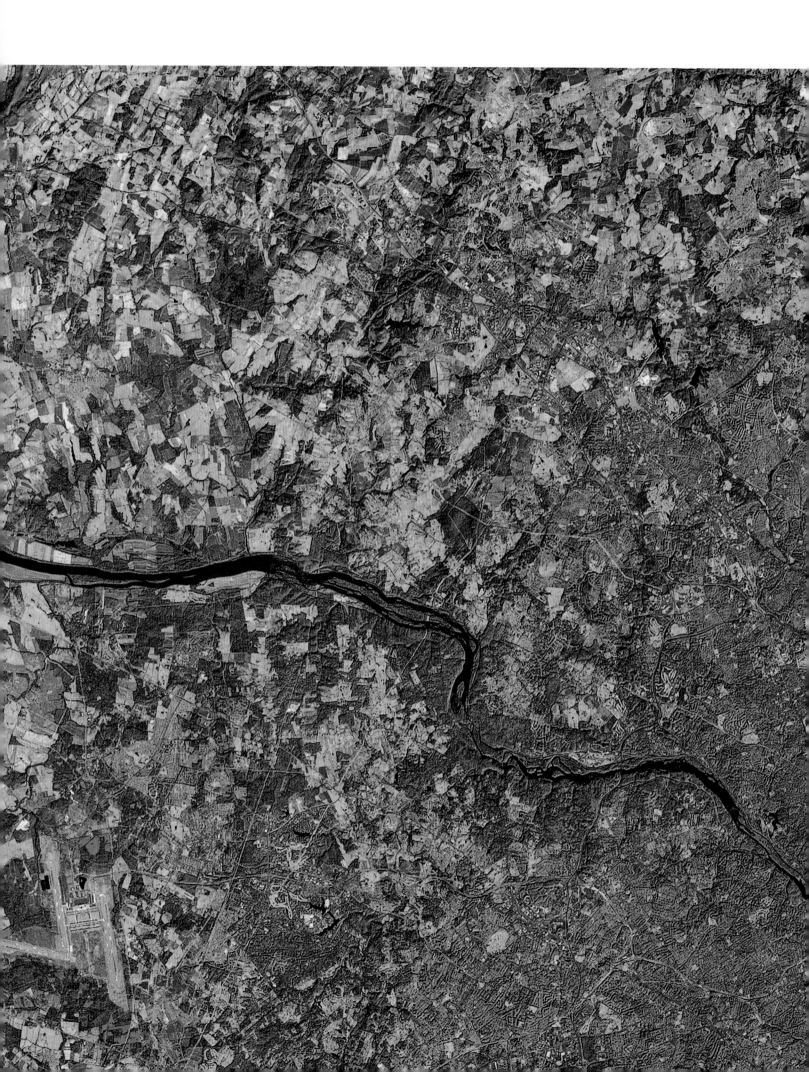

[PAGE 148]

WASHINGTON, D.C.

The nation's Capital appears
postcard-perfect in this photo
made 50,000 feet above the city.
"Tourist Washington"
encompasses the green rectangle
of the Mall, home to the
Smithsonian, and the green
Ellipse that enfolds the White
House and its grounds. At one
end of the Mall is the clearly
visible Washington Monument; at
the other is the U.S. Capitol and
its grounds. The Anacostia River
runs along southeast Washington.
The boundaries of the city of
Washington coincide with those
that form the 68.2 square miles of
the District of Columbia.

[PAGE 149]

SEA CORRIDOR

The northeast coast, a corridor of
intensely developed land, courses
southward from New York City.
New Jersey's southern bulge is
fringed with beaches. Across
Delaware Bay is the shore of the
Delmarva Peninsula, whose name
is formed by abbreviations of its
three states. The broad
Susquehanna River, crossing
Pennsylvania, empties into the
top of Chesapeake Bay, north of
Baltimore, one of the seaboard's
busiest ports. The peninsula
reaches across the bay to Norfolk,
Virginia, via the Chesapeake Bay
Bridge-Tunnel.

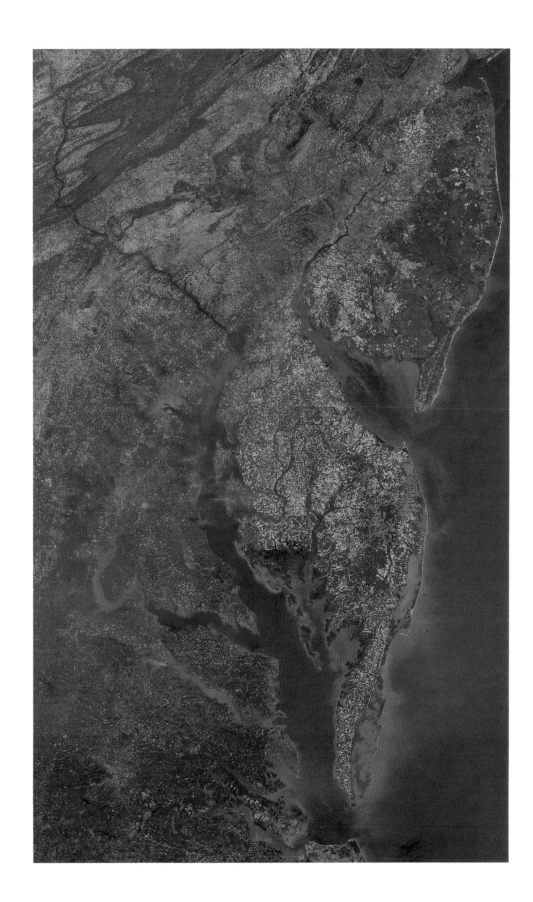

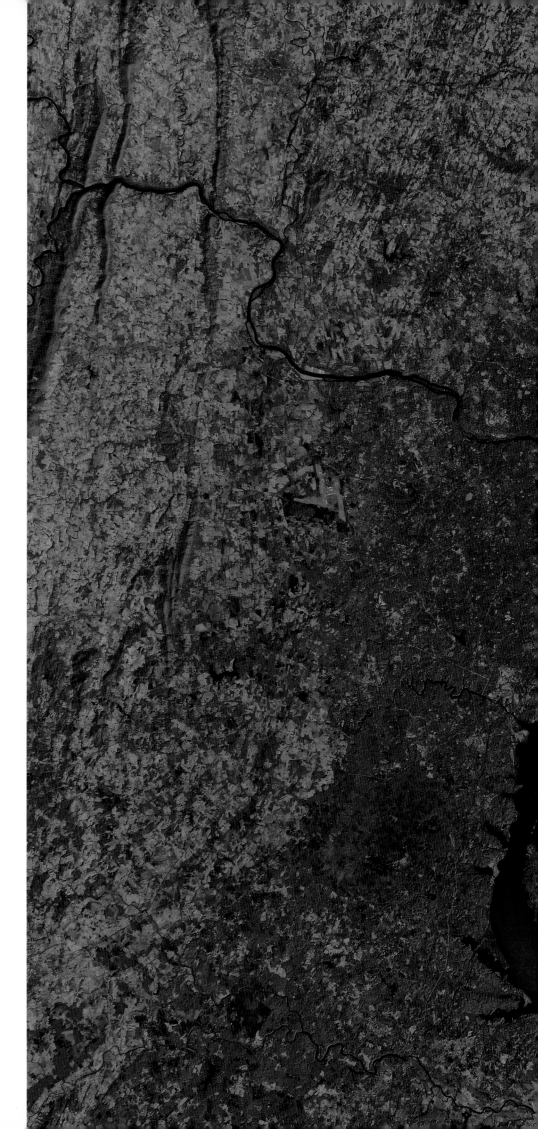

Chesapeake Bay

The Atlantic Ocean reaches deep
into the lacy shores of Maryland
and Virginia, forming Chesapeake
Bay, the largest inlet in the
Atlantic Coastal Plain of the
eastern United States. A mix of
salt water and the fresh water of
hundreds of streams and rivers,
the bay provides an ideal
environment for oysters: a salinity
high enough to sustain them but
so low that it is not attractive to
oysters' predators, sea stars
(formerly called starfish) and
oyster-boring snails. H. L.
Mencken, bard of Baltimore,
called the bay an "immense
protein factory" from which his
city "ate divinely." Baltimore
appears bluish gray on the bay's
western shore. The green of
farmland flecks the eastern shore.
The Potomac River, narrow at
Washington, D.C., broadens and
sweeps into a great curve as it
enters the bay at the bottom of
the image.

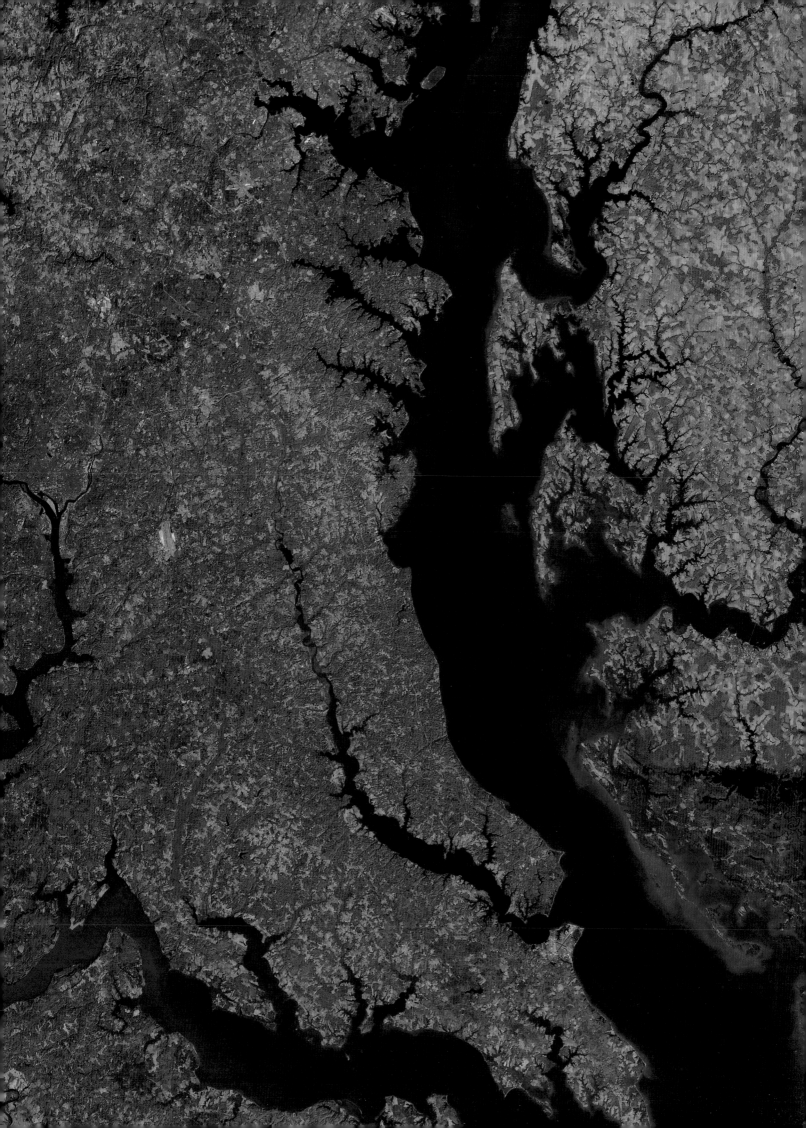

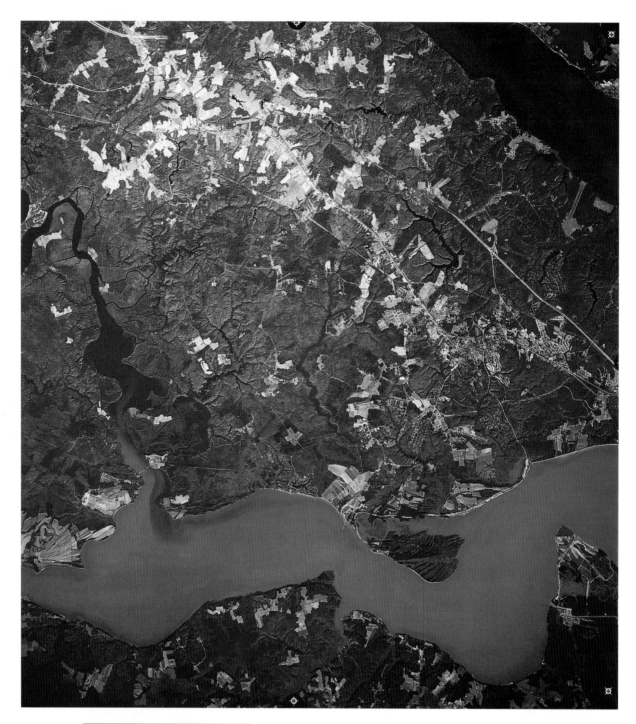

AMERICA'S BIRTHPLACE

On the island strung on a causeway in this aerial photo is Jamestown, Virginia. What is now an island was in 1607 a wooded peninsula 45 miles up the James River when colonists founded here the first permanent English settlement in North America. Now a causeway links the remains of the settlement, an historic site, with Colonial Williamsburg on the Virginia mainland. Named in honor of King William III, the capital also became the cultural center of the Virginia Colony and a hotbed of revolutionary ideas. Here in 1765, Patrick Henry gave his historic speech against the British Stamp Act and urged the colonial legislature to make laws independent of England's parliament. Williamsburg had lost much of its colonial appearance by the 19th Century. But in 1926 restoration began. Nearly 150 major buildings have been restored or reconstructed, and costumed craftpeople demonstrate old ways to visitors.

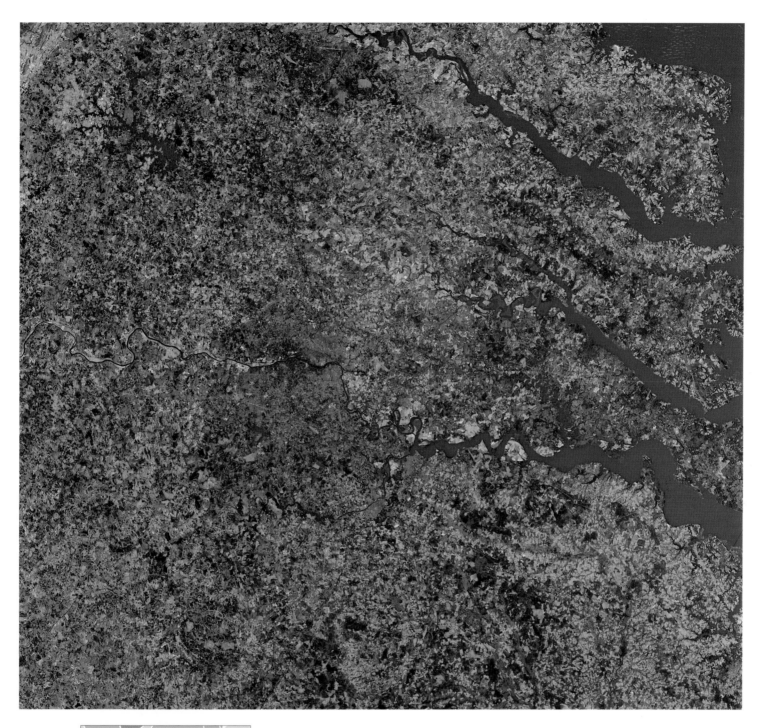

RIVERS OF HISTORY

American history flowed through these rivers. George Washington spent much of his life in the Tidewater region of Virginia — the peninsula formed by the Potomac River, whose mouth appears at the top of the image, and the Rappahannock, the river to the south. At Yorktown on the York, the next river south, Washington won the climactic battle of the American Revolution. The meandering James, the southernmost river, narrows and forms a crescent at Richmond, capital of the Confederacy during the Civil War and capital of Virginia today. In 1864, when the Union Army of the Potomac fought its way to Richmond, the most decisive campaign of the war was fought on this river-laced land. The tidewater land shown in the image, once the site of vast tobacco plantations, remains sparsely populated with relatively few towns beyond the suburbs of Richmond.

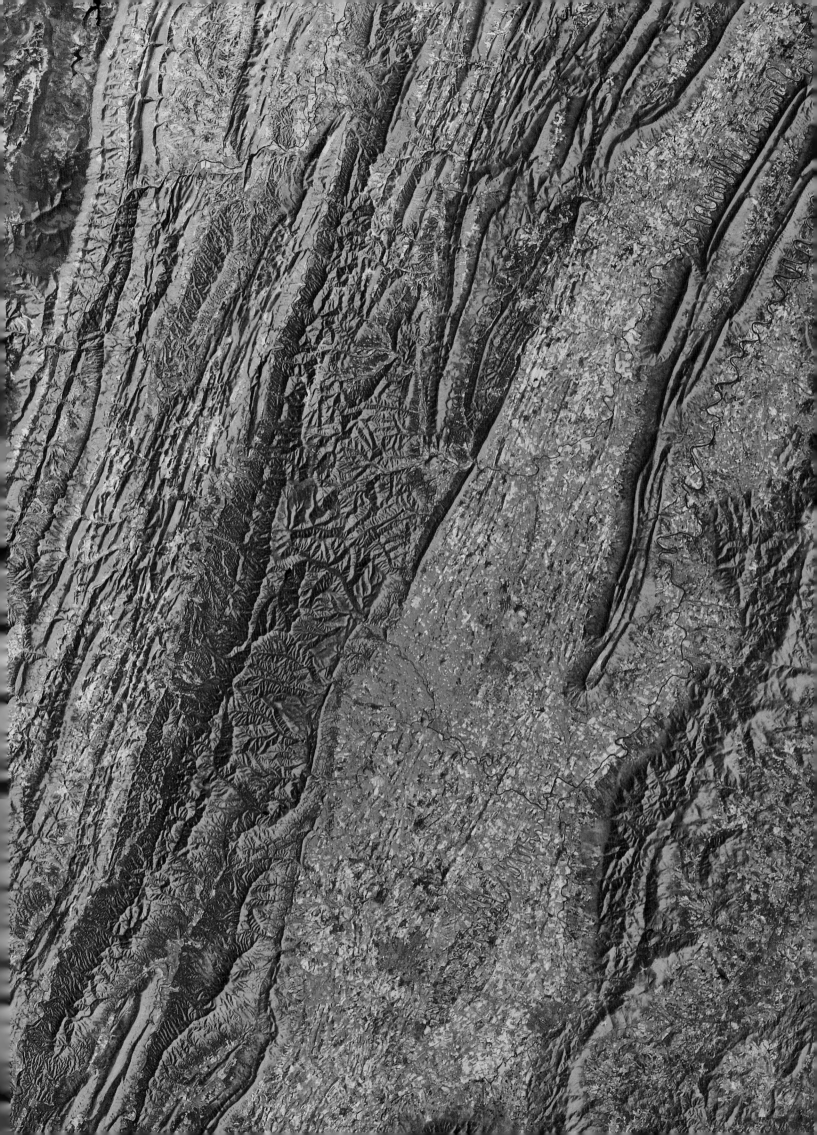

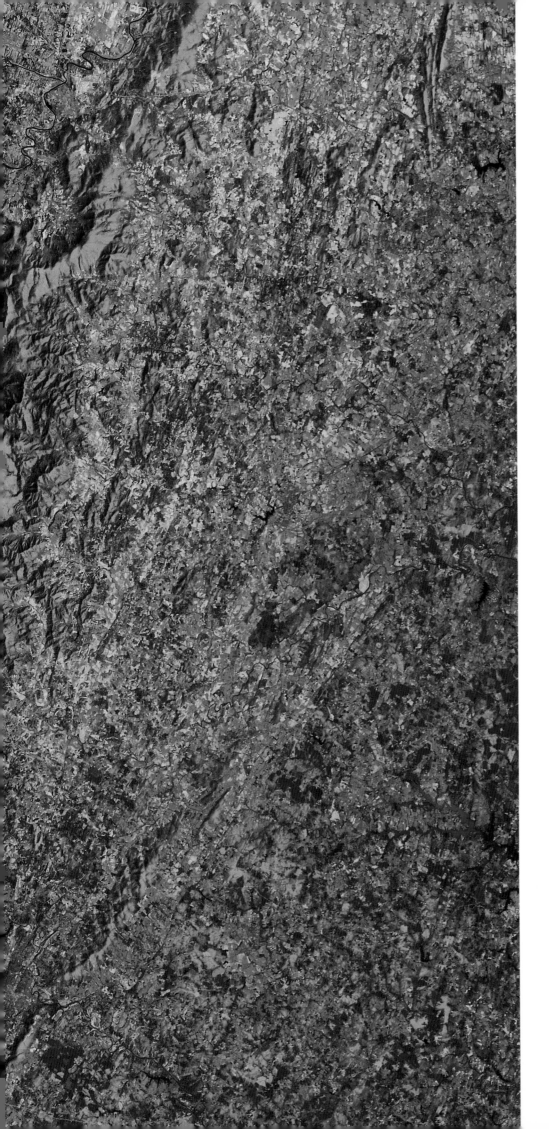

MOUNTAIN BARRIER

The ridges of the Appalachian Mountains frame Virginia's Shenandoah Valley, embattled breadbasket of the Confederacy during the Civil War. The mountains, standing as a formidable wall, slowed westward movement for early colonists. Even today, as the image shows, roads are few. The original roads were built along the routes of Indian trails. In the image, a short spur ridge, the Massanutten Mountain, rises alongside Shenandoah National Park. The spectacular Skyline Drive runs through the park along the crest of the Blue Ridge Mountains. Rare bluish patches mark cities, such as Front Royal at the extreme right center, and, to the south, Harrisonburg, Staunton and Waynesboro.

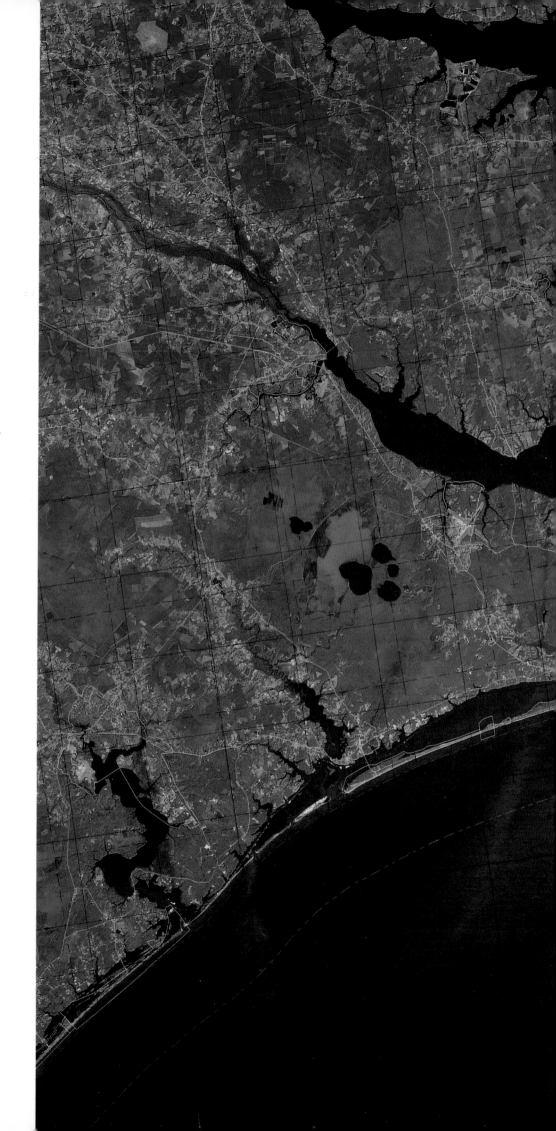

FLOOD EVIDENCE
Satellite imagery of the North
Carolina coast gives the Federal
Emergency Management Agency
insights into post-hurricane
claims of damage. Reds and blues
indicate the varying impact of
flooding; yellow indicates sites
where flood-damage claims
originated. New Bern, at the
confluence of the Neuse and Trent
Rivers, upper right, has many
claims, as does Jacksonville, on the
broad New River to the south.
Also hard hit were barrier islands,
which stretch in a long, thin line,
with Cape Hatteras at upper
right. Barrier islands, built by the
sand-bearing sea, form a rampart
that protects the land. But storms
can surge over the barrier and
smash seaside communities.

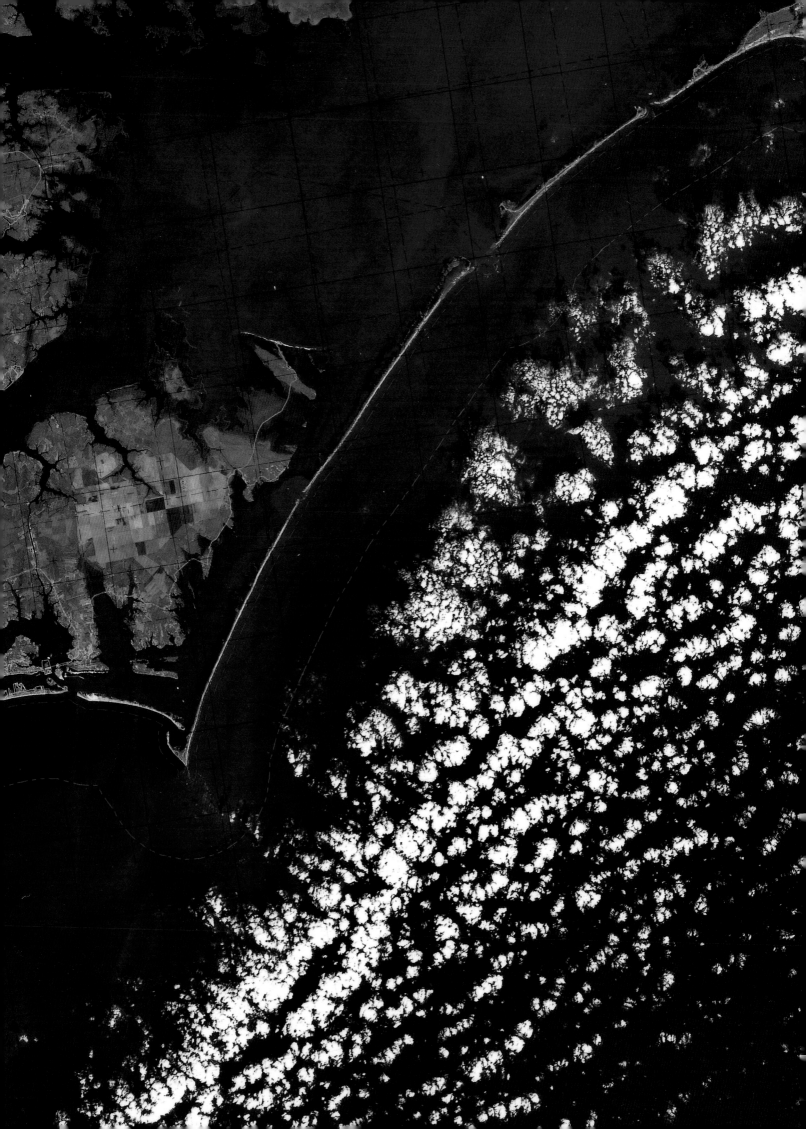

Index

POTOMAC RIVER

The Potomac River forms a curving border between Virginia and Maryland on its 500-mile journey to Chesapeake Bay from West Virginia, where it also becomes a state border with Maryland. The District of Columbia wedges into the V formed by the broad Potomac and the narrow Anacostia Rivers. The city's East Potomac Park greens the island between the Potomac and Washington Channel; the cross-shaped water is the Tidal Basin, overlooked by the Jefferson Memorial. Across the Potomac can be seen the Pentagon and the runways of Ronald Reagan Washington National Airport. Highways radiate out from Washington, westward into the suburbs of Virginia, northwestward into the suburbs of Maryland. Highways heading northeastward aim toward Baltimore. The Patuxent River courses diagonally near the center of the image.

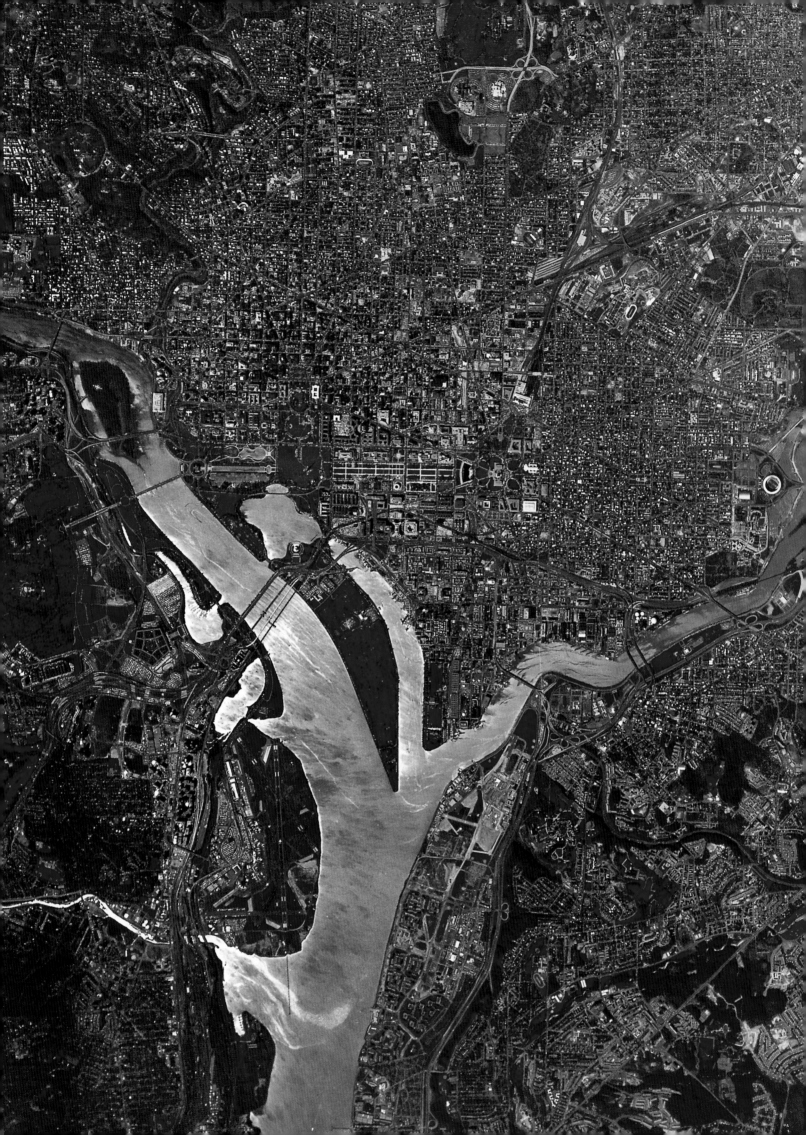

ILLUSTRATION CREDITS

EARTH SATELLITE CORPORATION Back Cover, 1, 6–7, 12–13, 16–17, 22–23, 24, 26–27, 27, 30, 30–31, 34, 36–37, 39, 40, 41,42–43, 46–47, 48, 50–51, 52–53, 54–55, 56–57, 58–59, 60–61, 62, 64, 66–67 67, 68, 70–71, 72–73, 74, 75 top, 75 bottom, 76, 78–79, 80–81, 83, 84–85, 87, 88–89, 90–91, 92–93, 95, 96–97, 98, 99, 100, 102–103, 111, 112–113, 116–117, 120–121, 121, 122–123, 124, 127, 130, 130–131, 133, 134–135, 139 top, 139 bottom, 144, 146–147, 149, 150–151, 153, 156–157

EOSAT 44–45, 114–115, 126, 154–155

NOAA/ NATIONAL GEOPHYSICAL DATA CENTER 8–9

NASA Front Cover, 2–3, 14, 15 top, 20, 21, 24–25, 28, 32–33, 35, 38, 47, 49, 61, 62–63, 65, 68–69, 76–77, 82, 86, 94, 101 left, 101 right, 104, 104–105, 106–107, 107, 108 left, 108 right, 109, 110–111, 118, 119, 124–125, 128–129, 132–133, 138, 141, 142, 143, 144–145, 148, 152, 160

SPACE IMAGING L.P./ EOSAT 11

SPOT IMAGE 15 bottom, 18–19, 29, 33, 136–137, 140–141

TRIFID CORPORATION 54

U.S. GEOLOGICAL SURVEY/ EROS DATA CENTER 10

AN EYE ON EARTH

Landsat 2, the second of four Earth resources satellites, circles the planet in this artist's conception. The satellite was launched in 1975 from NASA's facility at Vandenberg Air Force Base in California. A camera system provides images in four spectral bands. Data sent back to Earth aids studies in geology, hydrology, agriculture, land use, and the monitoring of water resources. A satellite typically makes about 14 orbits a day and takes 233 orbits to return to the same spot.